Pocket Guide to
Digital Printing

Frank Cost

Delmar Publishers

an International Thomson Publishing company I(T)P®

Albany • Bonn • Boston • Cincinnati • Detroit • London • Madrid
Melbourne • Mexico City • New York • Pacific Grove • Paris • San Francisco
Singapore • Tokyo • Toronto • Washington

Cover design: John McDonald

Delmar Staff
Publisher: Robert D. Lynch
Senior Administrative Editor: John Anderson
Production Manager: Larry Main
Developmental Editor: Michele Roulos Cannistraci
Art & Design Coordinator: Nicole Reamer

COPYRIGHT © 1997

By Delmar Publishers Inc.

an International Thomson Publishing Company

I(T)P® The ITP logo is a trademark under license

Printed in the United States of America
For more information, contact:

Delmar Publishers Inc.
3 Columbia Circle , Box 15015
Albany, New York 12212-5015

International Thomson Publishing
Berkshire House
168-173 High Holborn
London, WC1V7AA
England

International Thomson Editores
Campos Eliseos 385, Piso 7
Col Polanco
11560 Mexico D F Mexico

Thomas Nelson Australia
102 Dodds Street
South Melbourne 3205
Victoria, Australia

International Thomson Publishing
Kyowa Building, 3F
2-2-1 Hirakawa-cho
Chiyoda-ku, Tokyo 102
Japan

Nelson Canada
1120 Birchmont Road
Scarborough, Ontario
M1K 5G4, Canada

International Thomson Publishing GmbH
Konigswinterer Str. 418
53227 Bonn
Germany

Singapore 0315
221 Henderson Bldg. #05-10
International Thomson Publishing Asia

1 2 3 4 5 6 7 8 9 XXX 02 01 00 99 98 97 96

Library of Congress Cataloging-in-Publication Data

Cost, Frank
 Pocket guide to digital printing / Frank Cost.
 p. cm.
 Includes index.
 ISBN: 0-8273-7592-1
 1. Printers (Data mprocessing systems) 2. Image processing-
-Digital techniques. I. Title
TK7887.7.C67 1997 96-28463
686.2—dc20 CIP

Table of Contents

Foreword

HOT OFF THE PRESS

When Johannes Gutenberg invented a method of printing from reusable metal type in the middle of the 15th century, his simple aim was to speed up the process of copying manuscripts that had up to that time been the work of the scribes. His type font comprised 299 metal elements designed to mimic the subtle style of the formal handwriting of the day. His new process of printing reduced the labor required to make a book or document. Little did he realize that his invention would profoundly transform his culture.

Before Gutenberg, most of the information assets of humanity were stored in the collective gray matter of the population, preserved from generation to generation by oral transmission. Only a small minority of the population was literate, and hand-produced books were limited to a few classics, mostly from the ancient world. Printing enabled a new kind of culture to emerge, where a living person could speak across great distances to many listeners simultaneously. This was the beginning of what we now call *cyberculture*, a culture that transcends the level of person-to-person physical contact. The only equipment required to tune into this new medium was literacy.

Until the middle of the 19th century, the printed word was unchallenged by other media, and literacy meant only one thing—the ability to read. Since then, there has been a proliferation of media requiring some form of technology to enable the reader to access the information. Radio and television signals can only be decoded with radio and television receivers. The World Wide Web is only accessible to those who have a personal computer and a modem.

Print remains the only medium that is directly accessible to humans. This point of distinction between print

and the other media began to blur less than two decades ago, however, with the advent of digital printing. The first digital printers were crude devices that were restricted to low-resolution character-based printing. But I can still recall the thrill of acquiring my first nine-pin dot matrix printer along with my first personal computer—a DEC *Rainbow 100*. The fact that I could create an electronic document, store it on a floppy disk, then print it with a few keystroke commands was almost too amazing to be true! The addition of a modem a few years later made it possible to send and receive documents from remote computers and print them out locally on my noisy little desktop printer.

This was, in retrospect, the beginning of a new age, when print would begin to mimic other electronic media, and when documents would require sophisticated technology to be rendered visible before they could be read.

The descendents of my first dot matrix printer are a vast array of impressive devices capable of converting electronic documents into high-quality print in a variety of formats and in volumes from one to thousands. Tens of millions of low-end digital printers are purchased each year for use in homes and offices around the world. For a few hundred dollars, you can buy a high-resolution color ink jet printer that is capable of printing any document that may appear on your computer monitor. At the other end of the spectrum, digital presses such as those manufactured by Xeikon, Indigo, Xerox, and others are making it possible to produce short runs of full-color printing with variable image content from piece to piece.

How these new printing technologies will coexist with other media, including traditional print media, remains to be seen. About all we can predict for certain is that we will be able to get information into print closer and closer to the point where it will be read, and that we will be able to be increasingly selective about what information is printed and to whom it is distributed.

This book surveys the technologies and applications that are changing the meaning of the phrase *hot off the press*—a status that the book itself cannot claim, having been printed more than an hour or two ago. I sincerely hope that the information contained herein will still be valid by the time you have it in your hands. In the meantime, I am busy working on the second edition.

About the author

Frank Cost is an Associate Professor in the School of Printing Management and Sciences in the College of Imaging Arts and Sciences at Rochester Institute of Technology where he teaches undergraduate and graduate courses in digital prepress technology management, and serves as coordinator of the Printing and Applied Computer Science baccalaureate degree program. He serves the graphic arts industry as a consultant specializing in strategies for new technology acquisition and process re-engineering. He also advises technology manufacturers seeking to understand the real needs of the industry. He is a regular contributor to industry seminars offered by the Technical and Education Center at RIT, and is a staff consultant at the RIT Research Corporation where he manages projects in the imaging and related fields. He serves on the technical advisory board of the Center for Integrated Manufacturing Studies Printing and Publishing Division at RIT. He has conducted industry seminars and consulted throughout the USA, as well as in Japan, Hong Kong, and Saudi Arabia. He is the author of the book Using Photo CD for Desktop Prepress, published by RIT Research Corporation

Acknowledgments

The following people contributed in some part to this project. I thank them all.

My family: Patty, Roger, Gus and Elaine Cost

Colleagues from Rochester Institute of Technology:

Owen Butler
Bob Chung
Dave Cohn
Art Frazier
Rab Govil
Adrienne Katz
Amber Little
Brad Paxton

Milt Pearson
John Peck
Jim Reilly
Harvey Rhody
Frank Romano
Burt Saunders
Miles Southworth
Steve Viggiano

Colleagues from industry:

Sandy Fuhs—Presstek
Julie Sabuda—Indigo
Alfons Buts—Xeikon
Steve Godin—Xerox
Tom Hoehn—Kodak
Dale Waldt—Lawyers Cooperative Publishing Company
Helmut Kipphan—Heidelberg
Ed Granger—Light Source
Bob Greene—Adobe
Bob Jersak—Deluxe
Grigoris Kokkoris—Dot Repro, Athens
Ernst Bischoff—Heidelberg
Patrick Bergmans—Barco Graphics
Doug Smith—Sandor Hoppenwasser, Mitch Amiano—Merlin International
Bob Barbera—Agfa
Stan Rosen—Scitex
Jenny Sanders—AGT
Mary Lee Schneider—R.R.Donnelley

Section One

Digital Documents

Chapter 1

DIGITAL PRINTING FUNDAMENTALS

We live in a world increasingly dominated by digital imaging. So it seems most natural to begin this discussion with a simple question: what exactly is a digital image? The term *digital* literally means "composed of numbers," so a digital image is an image that is composed of numbers.

"I'm a little confused! Am I a digital image?"

The irony is that the image above did indeed originate as a digital image–as an Adobe Illustrator file, to be exact. (Adobe Illustrator is a popular computer drawing program.) If we take a close look at this Illustrator file, we will find that at the lowest level, it is nothing more than a long string of binary digits (zeros and ones). In fact every file on every computer in the world, whether it be an image, a sound recording, a text file, or a program to calculate the behavior of the Chicago Mercantile Exchange, is nothing more than a long string of binary digits.

Pixel-based images

The simplest kind of digital images employ binary digits to represent image and nonimage picture elements or pixels. These are sometimes called *binary images* or *raster images*. By modern convention, the binary digit 0 is used to represent an image element and the binary digit 1 is used to represent a non-image element. The very simplest binary images consist of a rectangular matrix of zeros and ones representing the image and nonimage elements

respectively. This concept is illustrated by this crude representation of the author.

The image is crude, not because of any failing on the part of the subject, but because it comprises a relatively small number of pixels. By increasing the number of pixels, the information content of a binary image increases and the image appears to contain more detail. The four images on the next page illustrate this principle. The lower right-hand image contains 64 times as many pixels as the one on the upper left.

Digital images

Digital computers work with representations of images in the form of lists of numbers. These lists can be very long, consisting of millions of numbers. Inside a digital computer, at the lowest level, only two different digits (0 and 1) can be represented electronically. Binary digits are called *bits*. To represent numbers larger than 1, computers use multiple bits. A *byte* is a binary number represented by eight bits. A byte can have 256 possible values ranging from 00000000 to 11111111. Typically we assign decimal values 0 to 255 to the byte values 00000000 to 11111111. (From this point forward this book uses decimal numbers to represent byte values.)

Binary images

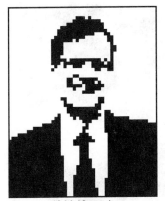

48 X 60 pixels

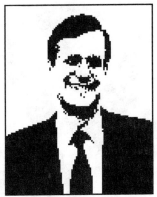

96 X 120 pixels

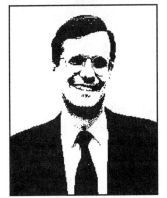

192 X 240 pixels

384 X 480 pixels

Very large numbers can be represented in a computer by using multiple bytes. For example:

- 1 byte yields 256 possible values
- 2 bytes yield 65,536 possible values
- 3 bytes yield 16,777,216 possible values
- 4 bytes yield 4,294,967,296 possible values.

In a computer, ordered lists of numbers are called *arrays* or *vectors*. Arrays can become very large and can be multi dimensional. For example, we might start with an array

binary image

contone image

48 X 60 pixels
each pixel = 1 bit

48 X 60 pixels
each pixel = 1 byte

of 1,000 bytes, and then create an array of 1,000 of these arrays. This would give us a two-dimensional array of 1,000 x 1,000 = 1,000,000 bytes. One feature of arrays is that each element in the array has a unique numerical location or address.

Arrays are very useful for representing digital images. They provide a way of organizing the long lists of numbers. A black-and-white photograph can be represented in digital form in a two-dimensional array of bytes, each byte representing a single sampled point in the original photograph.

Digitization of images

Images can be digitized by a process called *scanning.* Scanning a black-and-white photograph involves the sampling of an analog signal corresponding to the brightness of each point in the original photograph, and the conversion of the analog value of the sample into a digital value. If a single byte is used to represent each sample, then 256 different brightness levels in the original photograph can be captured. This is more than enough to

record all the visibly distinct tonal values from highlight to shadow in any black-and-white photograph.

If 1,000 samples are taken in the horizontal (x) dimension, and 1,000 rows of samples are taken in the vertical (y) dimension, the data can be stored in the array of 1,000 x 1,000 bytes referred to earlier. This large two-dimensional array of bytes is a digital representation of the original photograph. If the photograph is scanned such that only 500 samples are taken in both horizontal and vertical dimensions, the resulting array of bytes would be 500 x 500 = 250,000 bytes in size. Note that this is only 1/4 the number of bytes required in the previous example. Conversely, if the sampling were increased to 2,000 in both dimensions, the amount of image data would increase by a factor of four.

In color scanning, three separate signals are sampled from the same original image. These represent the amount of red, green, and blue (RGB) light reflected from or transmitted through each sampled point in the original. The three color components of each pixel are typically stored as single bytes. Thus, one complete RGB color pixel requires a minimum of three bytes of storage. If the image is converted from RGB to CMYK (cyan, magenta, yellow, and black) for printing, each pixel typically requires four bytes of storage. The following chart summarizes the four different pixel-based digital image types in common use.

Digital image type	Pixel size	Tones/colors
binary image	1 bit	2
grayscale image	1 byte	256
RGB color image	3 bytes	16,777,216
CMYK color image	4 bytes	4,294,967,296

Halftoning

The technique of reproducing photographic images by halftoning saw its first commercial use in 1880 when a photograph depicting a shanty-town on the outskirts of New York City appeared on the editorial page of the *New York Daily Graphic*. Before this, printed reproductions of photographs had only been possible via wood engravings

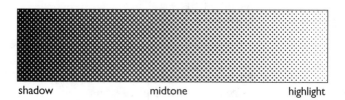

shadow midtone highlight

carved by hand. The wood engraver used a cartoon draw-
ing derived from the original photograph as a guide,
reproducing gray tones with fine lines that varied in
width and spacing. The New York Daily Graphic photo-
graph was the first machine-made reproduction of a pho-
tographic original.

 In all binary printing processes, the reproduction of
intermediate tonal values between dark and light is
accomplished by halftoning. In conventional halftoning,
the image is formed by a regular pattern of dots that vary
in size. The larger the dots, the darker the printed tones.
The number of rows of halftone dots per linear inch is the
halftone screen frequency or screen ruling.

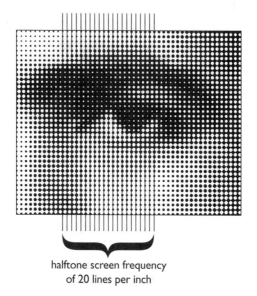

halftone screen frequency
of 20 lines per inch

The screen frequency should ideally be high enough to hide the dot pattern from view. This is a function of both the capabilities of the human visual system and expected viewing distance. Most of the images reproduced in this book have a screen frequency of 150 lines per inch (lpi), which is a standard for publications of this type. There is seldom reason to exceed a screen ruling of 200 lpi, because even Superman would need optical augmentation before he could detect the dot structure. Even so, commercial printers or press manufacturers will sometimes employ halftone screens of 300, 400, or even 500 lpi to impress their clients and potential customers with their printing prowess.

The limits of normal vision

15 cycles per inch

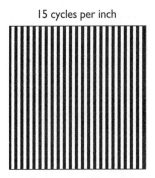

60 cycles per inch

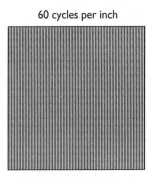

MTF of the visual system

As screen frequency increases, our ability to distinguish the black bars from the white background decreases. This is shown in the curve to the right, sometimes called a modulation transfer function or MTF curve. At some point, the frequency is high enough for the curve to fall below the visual threshold. There is no need for halftones to exceed that frequency.

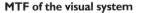
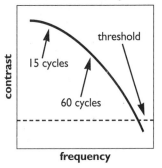

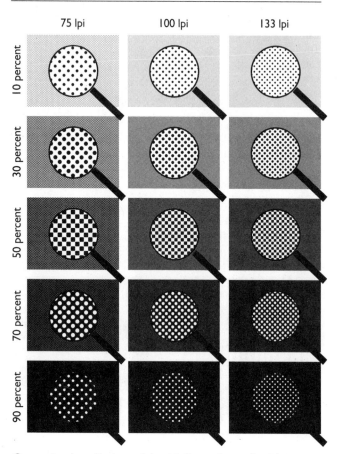

Conventional amplitude-modulated halftones have a fixed frequency. At 85 lines per inch (lpi), the halftone screen is visible at a normal reading distance. At 150 lines per inch, the screen is not visible. So why not always use the highest screen ruling possible? There are two primary reasons: 1. In most printing processes, higher screen frequencies result in fewer printable gray values. 2. The cost of halftone reproduction increases as the screen frequency increases. This is because at higher screen rulings there is a need for more image data, more space to store the data, and more time to process the data. Note in this illustration that as the screen frequency increases from 75 to 133, the tones at each percentage appear darker. This phenomenon, called *dot gain*, is fully explained in Chapter 7.

Color reproduction

Television screens and computer monitors are additive color reproduction systems. They stimulate your eye and brain into seeing a large range or *gamut* of colors by varying the amount of red, green, and blue light emanating from each part of the screen. The tiny circles or bars are so small and so closely packed that your eye cannot distinguish them from each other at a normal viewing distance. You can only see them if you use a magnifier.

Additive color systems produce color sensations by striking the cones in your retina with varying amounts of red, green, and blue light. Imagine that each tiny cluster of red, green, and blue phosphors on your television screen is like three tiny colored flashlights shining into your eye. If all three flashlights are turned off completely, no light will enter your eye, and you will perceive no color. If the red flashlight is turned on to full intensity, and the other two are off, you will see a bright red. If you leave the red flashlight at full intensity and turn on the green flashlight so that it begins at a low intensity and slowly proceeds to full intensity, you will see a bright red at first; and then it will change to red orange, orange, and finally yellow. As you add green light to the red light, the effect is to stimulate the eye into seeing a color that falls

Color sensitivities of the eye

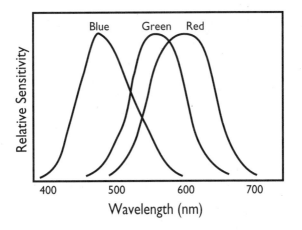

between green and red in the visible spectrum. In other words, the green light and the red light can be varied in relative intensity to stimulate your eye into seeing a continuous range of colors corresponding closely, although not exactly, to the intermediate spectral colors. Thus, even though you may actually be seeing a green light and a red light mixed together, your brain will have a strong sensation of yellow.

If you turned on both the blue flashlight and the green flashlight to full intensity, you would see a blue-green color called *cyan*. Now if you began to add light from the red flashlight, the cyan would appear to become lighter, as though white were being added. As the red flashlight approached full intensity, the cyan would be washed out completely, and the resulting color would appear white.

Subtractive (process) color reproduction

Color reproduction in printing uses a complementary approach to additive color mixing. Instead of adding varying amounts of red, green, and blue light together to produce color sensations, printing inks absorb or subtract varying amounts of red, green, and blue light from the white light striking an image. The red, green, and blue light that is not subtracted is reflected by the paper substrate back into your eye.

Four inks are used in color printing. Three of them (cyan, magenta, and yellow) absorb light selectively. One of them (black) absorbs all wavelengths. Cyan ink absorbs red light. It also absorbs some green and blue light. Printing inks are mixtures of chemicals that have spectral properties that come as close as possible and practical to those desired. Magenta ink absorbs green light. Real magenta inks also absorb some blue light. Again, if we lived in a perfect world, magenta ink would not absorb any blue light, but in fact all magenta inks absorb some amount of blue (some more than others). Yellow ink absorbs blue light. Real-world yellow inks behave better than cyan or magenta inks in that they do not absorb much green or red light. The unwanted absorption of inks makes color matching between addi-

tive and subtractive color systems complex and difficult to accomplish. However, by compensating for unwanted absorption, color correction is possible. In Chapter 8, you will learn about how color management software accomplishes this.

Color gamuts

Process color printing uses either three (cyan, magenta and yellow) or four (cyan, magenta, and yellow plus black) inks to produce a wide range of colors by combining various amounts of each ink. This range of colors is called the *gamut* of the process. The sad fact of life is that the gamut of most printing processes is much smaller than the total range of colors that you can see, and significantly smaller than the range of colors in a typical photographic transparency or color monitor.

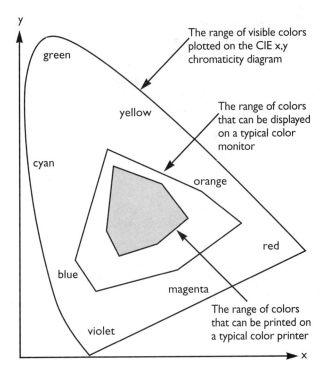

The range of visible colors plotted on the CIE x,y chromaticity diagram

The range of colors that can be displayed on a typical color monitor

The range of colors that can be printed on a typical color printer

Image quality

How good does it look? This simple question leads into a discussion of image quality–a subject that can be discussed on many levels. Imaging scientists have been known to spend their entire professional careers searching for ever more refined answers to this question. Systems have been devised for quantifying image quality so that images can be compared objectively and image quality can be discussed in numeric terms. They all come down to the same fundamental principles. How much information can be rendered in a unit area of print? Photographic reproduction processes are typically regarded as the highest resolution processes available, packing the most image information into a unit area of print. Low-resolution ink jet and laser printers are on the other end of the spectrum.

Spatial and tonal resolution of images

The overall resolution of an image reproduction system is a function of two separate characteristics. The first is the capability of the system to resolve fine detail in an image. This is called *spatial resolution*. High spatial resolution is necessary to render type and fine linework. The type you are reading has been rendered by the lithographic printing process, which has an extremely high spatial resolution. The printing plates that were used to print these words were imaged at a resolution in excess of 2,400 lines per inch. Lithography has such a high spatial resolution that it can be used to print features on security documents, such as checks and passports, that can be detected only under considerable magnification. (Observe the fine rules on a U.S. passport visa page sometime. You'll be surprised at what you see.)

The other dimension of resolution is the ability of a reproduction process to render a range of tones or colors. This is called *tonal* or *color resolution*. When referring to monochrome images, we sometimes use the expression *grayscale rendering capability* to describe the tonal resolution of a system.

It is important to realize that perceived image quality is also a function of viewing distance. The greater the dis-

Spatial and tonal resolution

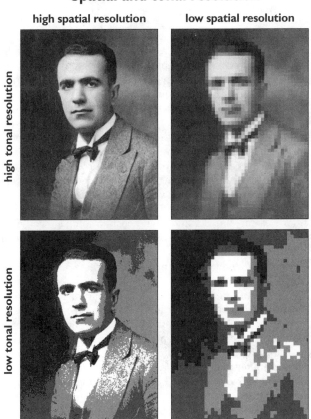

tance of viewpoint, the less information is needed per unit area of print. The relationship between viewing distance and perceived image quality is easily quantified. If you double the viewing distance, the amount of information needed per unit area of print is reduced to 25 percent to maintain the same perceived image quality. This is because doubling the viewing distance reduces the area of your retina impacted by an image to one -fourth its original size. This is why extremely low-frequency halftone

screens are used to print billboards that are intended to be viewed from great distances.

Visual thresholds

The human visual system also has limitations that establish image quality thresholds beyond which there is no need to go. At a given viewing distance, two images may appear to have the same quality, yet one may contain far more information in a strictly objective sense. Upon closer inspection, this will become obvious. However, if an image is intended to be viewed from a certain distance, the amount of information needed to satisfy the viewer is related to the ability of the viewer to perceive fine detail. There is no need, therefore, to expend resources for image quality that is beyond the visual threhold. Billboards, for example, could be printed at higher resolutions using finer screens, but the additional cost of doing so would be lost on viewers speeding by at considerable distance in their automobiles.

Some conventional printing processes are fully capable of producing image quality that exceeds the threshold requirements of the human visual system at a normal reading distance. Lithography and gravure are both in this category. In fact, lithography is capable of dramatically exceeding the perceptual thresholds of the visual system, producing images of stunning clarity even when viewed under magnification. Rarely are the capabilities of lithography exercised to their fullest. This would simply be a waste of money.

Image quality is a product of both spatial and tonal resolution. One printing process may combine a high spatial resolution with a low tonal resolution to produce the same composite result as another process with lower spatial resolution and higher tonal resolution.

A good example of this relationship between spatial and tonal resolution comes from a comparison between lithographic printing and dye sublimation printing. Both of these processes are capable of reproducing color images that appear to have very similar image quality. But lithography has an extremely high spatial resolution (as high as 3,000 dots per inch) and a low tonal resolution (1 bit

Digital sharpening

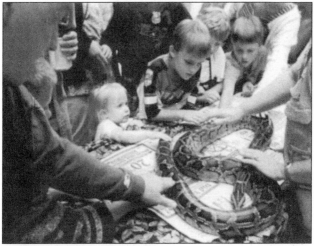

Original before sharpening

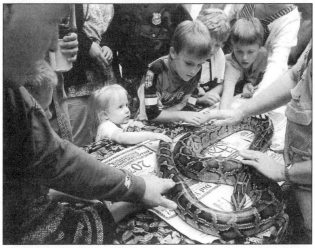

After digital sharpening using the Photoshop *unsharp masking* filter. Sharpening increases the apparent resolution of the printing process by exaggerating the tonal differences at the edges between lighter and darker areas of the image.

Adobe Photoshop unsharp masking filter

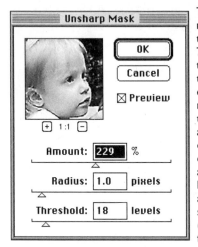

The Photoshop unsharp masking filter is controlled by three variables. The *amount* determines the degree of exaggeration applied to tonal edges. The *radius* determines how far out from the edge the effect is applied. The *threshold* determines the minimum difference between two adjacent pixels required before the effect is applied. This prevents subtle tonal differences (such as facial wrinkles) from being sharpened.

per color), whereas dye diffusion printing has a much lower spatial resolution (300 dots per inch) and a much higher tonal resolution 8bits per color).

Each printing process has a combination of spatial and tonal resolution that together determine whether it will produce images of a quality acceptable for a given use. We refer to this parameter as *resolution* when evaluating each digital process, because it is the overall effect that matters.

Photographic quality
One simple benchmark for image quality is the common color photographic print made from a 35mm negative. If a digital printing process produces images that a casual viewer will accept as a substitute for a standard color photographic print, the images are said to be of *photographic quality*. It may very well be that an objective comparison of two images will reveal that one contains more information than the other. Yet the viewer may still accept the lower resolution image as a substitute for the

Unsharp masking

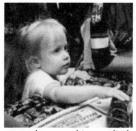

no unsharp masking applied

amount = 200%
radius = 1.0 pixels

amount = 200%
radius = 5.0 pixels

amount = 400%
radius = 1.0 pixels

higher resolution image because the differences are not visible at a normal viewing distance.

Images can also be processed so that they give the illusion of higher resolution. The most common image processing used to enhance the appearance of printed images is sharpening effected by the application of an *unsharp masking* filter. Unsharp masking is the most common and most indispensable digital process applied to images intended for print. Many others are available in applications such as Adobe Photoshop. With careful application of these processes, digitally-reproduced images often appear to be of higher quality than the originals from which they came. This opens up a whole new world of applications for digital printing, many of which we will learn about in the coming chapters.

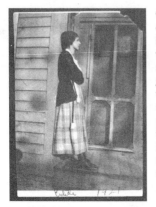

One of the most demanding applications for digital image processing is the restoration of old photographs. In this example, a snapshot of the author's maternal grandmother has been restored with a sophisticated combination of digital imaging tools. The original photograph was scanned on a flatbed scanner, and then repaired in Photoshop using a combination of rotation, retouching, sharpening, and tone-correction tools.

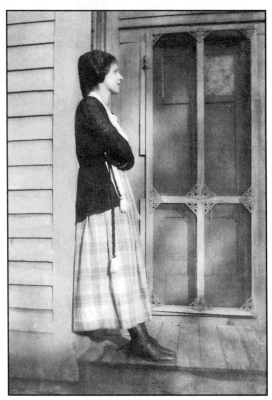

Chapter 2

ACQUIRING IMAGES FOR DIGITAL PRINTING

Look at the picture at the bottom of this page. Like all of the photographic images in this book, it is a halftone reproduction of a digital contone file. But where did the image originate, and what path did it take from that point to its final resting place on this page?

If this book had been published before about 1985, you would be fairly safe in assuming that the image began its life as a black-and-white print, and was photographed in a large graphic arts process camera to create a film halftone. This film would then have been used to create a printing plate. If the reproduction were printed in color, it would most likely have started its life as a color transparency, which was then scanned on a high-end drum scanner to produce a set of separation films.

Where did this image originate? This one actually started out as a color negative that was scanned onto PhotoCD. The PhotoCD image was imported into Adobe Photoshop using Kodak color management system software. It was then converted to gray scale, tone-corrected, sharpened, and output as a TIFF.

Few other options were available for getting images into print at the time.

The picture has changed dramatically since the mid-1980s. The number of paths that images take from point of origin to the printed page have multiplied exponentially. The image on the previous page could have originated as any of the following:

- a color transparency
- a color negative
- a black-and-white negative
- a Polaroid print
- a file produced by a digital camera

Scanning or digital photography is only the first step in the image reproduction process. The raw data captured by a scanner or digital camera must be processed before the image is ready for print. Processing steps include cropping and sizing, pixel editing, tone correction, sharpening, and color separation. In traditional high-end scanning, many of these steps are built into the scanning process itself. In desktop scanning and digital photography, these steps are normally performed after the digital image is created, and require a powerful workstation to be accomplished efficiently. In this chapter you will learn about the available options for capturing image data; in chapters 7 and 8 you will learn how this image data must be further processed to achieve the desired graphic effects.

Desktop color scanning

There are dozens of flatbed scanners on the market today priced anywhere from $500 to $20,000. What is the difference between a $1,000 scanner and one costing $3,000, or even $20,000? They all look similar. But there are important differences in the type, quantity, and quality of data these scanners will produce.

When you buy a flatbed scanner, there are three questions to ask. First, what is the maximum number of real samples the scanner can take from a unit area of an original image? Second, how many different tones and colors can the scanner detect in the original image? 3. Third, how productive is the scanner?

Digital line art should have the same dpi as the binary output device up to about 800 dpi. In most cases, higher resolution will not result in visible improvement in the appearance of the printed reproduction. This drawing was rendered from a 600 dpi binary image file.

The number of samples or pixels the scanner is capable of collecting from an original image is called resolution. But you have to be careful, because most scanners now possess two kinds of resolution. The first, called *optical* or *true resolution*, describes the actual sampling capability of a scanner. (Resolution is expressed in *dpi*, or *dots per inch*, which means *sampling frequency* when referring to scanners, and *marking frequency* when referring to printers.) The second kind of resolution is called *enhanced resolution*, which is accomplished by the addition of interpolated image data where there is no actual data. Some scanners feature hardware enhancement, others feature software enhancement, and many feature a combination of the two.

It is entirely possible to start with 300 dpi optical resolution, and enhance it up to 2400 dpi by simply adding lots of interpolated pixels to the scanned image. But don't be fooled! When you compare two scanners, always compare them on the basis of optical resolution. Enhanced resolution is more a matter of convenience and competitive marketing than an indication of the true capabilities

Both of these images were printed from digital files that are exactly the same size. The image on top was created by scanning an original print at the required optical resolution for this print application. The image on the bottom was scanned at a lower optical resolution and interpolated up to the required resolution by the scanning software.

of a scanner. Some scanners have an optical resolution that is different in the horizontal and vertical dimensions (400 by 800 dpi, for example), and usually feature hardware interpolation to equalize the two (to 800 by 800 dpi, in this example). By multiplying the horizontal by the vertical resolution and then taking the square root, a 400 by 800 dpi scanner can be normalized to a rough equivalent of 560 optical dpi for comparison to other scanners.

The higher the optical resolution, the greater the degree of enlargement you can achieve. A quick calculation of enlargement limits, based on research conducted at the Rochester Institute of Technology, is to divide the optical resolution of the scanner by 1.5 times the screen ruling of the printing process that will be used to reproduce the image. An original image scanned on a 600 dpi scanner and reproduced in a magazine at 133 lines per inch can be enlarged to a maximum of about 600/(1.5x133) = 300 percent. The following chart shows maximum enlargement limits for scanners with four different optical resolutions for output screen rulings from 85 to 175 lines per inch.

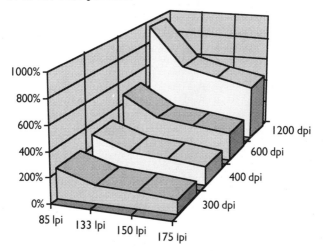

As a scanner's optical resolution increases, the maximum percent enlargement also increases. As screen ruling of the output process increases, the maximum enlargement factor decreases.

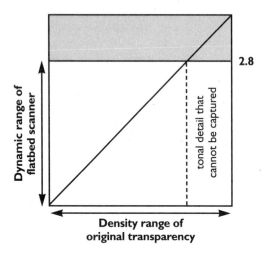

No matter how many gray levels a flatbed scanner can record, it may still be unable to capture image information from the deep shadows of a transparency. If the scanner cannot detect density differences above 2.8, for example, shadow details in areas of an original image that exceed 2.8 density will not be recorded.

In addition to optical resolution, scanners differ in their tonal or color resolution. The least expensive color scanners can record only 256 levels of red, green, and blue in each pixel. The most expensive scanners can record thousands of gray levels encompassing a larger range of tones and colors. Why is it necessary to record thousands of gray levels? The highest resolution printing systems available today can only reproduce 256 gray levels, and our eyes can only detect about half that number.

The answer is simply that if a scanner can extract higher fidelity data from an original image, there is more flexibility in the reproduction process. This is especially important when the reproduction process involves significant alteration of the tones in the original image. An 8-bit (256-gray-level) scanner performs well for normal-key originals that you intend to reproduce without much alteration of the tone curves. In some cases the under-$1,000 8-bit scanner may equal the performance of a 12-

bit scanner costing three or four times as much. Many of the low-end scanners are marketed effectively by making comparisons of this kind. Don't be deceived! Once you depart from straight reproduction of normal-key images, the higher resolution scanners will produce much higher quality printed results.

Do you need more than 12 bits of color resolution for scanning reflection copy? The answer is *no*. Because the density range of reflection artwork rarely exceeds about 2.0, none of the current generation of flatbed scanners will have a problem seeing the entire range of tones in any original you may want to scan. A 12-bit scanner will record more than 4,000 levels each of red, green, and blue light reflected from an original. Even if the original is a high key image with all its tones on the highlight end of the tone scale, most current 12-bit scanners will be able to detect all the subtle tonal differences in the original.

High resolution scanning

For scanning reflection copy, there are two reasons to go beyond the $3,000 to $4,000 cost of a good 12-bit flatbed scanner. If you are routinely planning to enlarge images beyond 200 to 300 percent, then you may have to consider a higher resolution scanner. Ironically, you may also find it necessary to go to a higher resolution scanner for reproducing simple linework. Whereas an optical resolution of 600 to 800 dpi may be all you ever need for color scanning of contone prints, you may need 1,200 to 2,400 dpi optical resolution for some linework applications. A typical example is when you want to scan an original piece of linework and enlarge it to 400 percent of its original size for output on a high-resolution film imagesetter. In this case it will be necessary to scan at a resolution above 2,000 dpi to avoid visible jaggedness or aliasing in the reproduction.

Transparency scanning

Should you buy a flatbed scanner with the idea that you will be able to scan both reflection originals and transparencies on the same device? The answer to this question depends on the size of the transparencies you intend to scan. Flatbed scanning is ill-suited for 35mm and 120

roll film formats. The maximum optical resolution of most flatbed scanners falls far short of what you will need when you start with a 35 mm or 120 frame.

With 4 by 5 and 8 by 10 inch transparencies, most 12-bit flatbed scanners will produce good results. But ask the following two questions before you make a decision. First, will the scanner be able to record the full range of tones in your transparencies? (Does the dynamic range of the scanner cover the density range of the films you intend to scan?) A 12-bit scanner may very well record more than 4,000 levels of red, green, and blue, but still be unable to distinguish subtle tonal differences in the darkest shadow areas of some transparencies. If you expect to work routinely with transparencies that contain important shadow details above the threshold of a particular scanner, you will do well to spend a little more money for a better scanner.

Productivity

If a flatbed scanner has enough dynamic range, the second question you should ask is about productivity. If you will be scanning large numbers of large-format transparencies, a flatbed scanner that allows you to scan only one image at a time may fall short of your productivity requirements. Many users are discovering that the best solution to this problem is simply to buy additional scanners. One operator can often work with multiple scanners very effectively, achieving much higher levels of productivity and suffering lower levels of frustration and stress induced by waiting.

For medium- and large-format transparencies that will be enlarged beyond the limits imposed by most flatbed scanners, and when there is a recurring need to record extreme shadow detail, drum scanning is the obvious choice. However, the least expensive drum scanners are no better than the 12-bit flatbed scanners, because they employ the same kind of CCD-based detection devices. Desktop drum scanners that employ the same kind of high-sensitivity photomultiplier tubes (PMTs) as traditional high-end drum scanners yield comparable levels of quality and productivity.

The special case of 35mm

The standard 35mm image frame measures approximately 1 by 1.5 inches (24 by 36mm). You would need to enlarge the frame by at least a factor of 8 to fill a standard magazine page. For commercial reproduction at 133 lines per inch, you should scan the original at approximately 1,600 dpi. This is far beyond the resolution of most flatbed scanners. A 600 dpi scanner will limit you to enlargements of less than 300 percent.

It is impractical, therefore, to use a flatbed scanner for 35mm scanning. At the other extreme, high-resolution drum scanning allows scanning of 35mm images right down to the grain. But drum scanners remain expensive and should be reserved for applications in which extreme magnifications are required. The vast majority of applications using 35mm originals are best handled using one of the special 35mm slide scanners made by Kodak, Nikon, Polaroid, and others. These scanners range in price from under $2,000 to more than $10,000. The three criteria of spatial resolution (maximum dpi), tonal resolution (including dynamic range), and productivity are equally relevant to the selection of a 35mm slide scanner.

Choosing the appropriate technology

Choosing the appropriate color input technology for your application is a matter of asking the right questions. Three questions are critical. First, will the technology accommodate your expected inputs? Second, will the technology be able to extract enough information from your inputs? Third, will the technology meet your productivity requirements? The first two issues are relatively easy to resolve with direct questions related to optical resolution, dynamic range, number of bits per sample, and so on. The issue of productivity is more difficult. You cannot always get straight answers about the actual throughput of a system, as throughput is nearly always a function of scan resolution and image size. To accurately assess the productivity of a scanning system, make sure that you account for *all* of the processing steps involved in preparing print-ready files—not just the scanning step.

Maximum enlargement factor

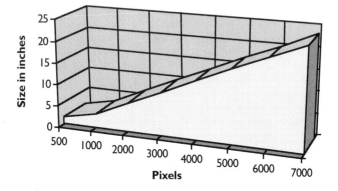

The maximum enlargement of a digital image for publication printing depends on the pixel dimensions of the image. According to this graph, a 3,000 by 3,000 pixel image can be enlarged to approximately 10 by 10 inches. As viewing distance increases, the enlargement factor also increases.

Digital photography

Digital photography is clearly a revolution in the making, and it is certain that most commercial work will be digital by the end of the decade. But there is currently a huge gulf between low-resolution entry-level cameras and systems with significantly higher resolutions.

At the low end are cameras manufactured by Apple, Kodak, Casio, Sharp, and others that are priced in the $400 to $1,000 range and offer resolutions up to about 800 by 600 pixels. These cameras are ideal for capturing images for display on a computer monitor, and for print applications in which the image size is kept small. A general rule of thumb is that for *commercial-quality* print applications you need approximately 225 to 300 pixels in a digital image for every inch of print. Thus, a digital camera that captures 800 by 600 pixels can be used for publication print sizes up to about 3.5 by 2.6 inches.

Above this first level of digital snapshot cameras, there are two main categories of digital camera: hand-held cameras for action photography and studio cameras for still photography. The most successful paradigm for hand-held cameras has been the classic 35mm film camera modified with the addition of a digital back. Kodak pioneered this concept by adding a digital back to a high-end Nikon 35mm camera. Kodak now sells a number of models built around Nikon and Canon professional systems, with pixel resolutions ranging from 1,000 by 1,500 at the low end to 2,000 by 3,000 pixels at the high end.

Studio cameras with resolutions ranging from 2,000 pixels square up to close to 10,000 pixels are sold by a number of manufacturers, including Leaf, Dicomed, and others. At the high end of this spectrum are cameras capable of matching or exceeding the spatial and color resolution of large-format film photography.

PhotoCD

PhotoCD allows you to have your 35mm film images scanned for a few dollars each, and you need not own the equipment yourself. Standard 35mm PhotoCD scans have a maximum resolution of 2,048 by 3,072 pixels, which allows for enlargements up to about 800 percent for most publication work.

Each PhotoCD image is stored at several resolutions on the disc in a file structure called an *image pac*. Images can be extracted from the image pac at the appropriate resolution for the final use. This multiple-resolution feature enables an application to access the lower resolution images rapidly, without having to first wade through all the high-resolution data.

What distinguishes PhotoCD from other scanning technologies is the way PhotoCD images are encoded. Rather than storing images as RGB files produced directly by the scanner, PhotoCD transforms the scanned images into a device-independent color space called *Photo YCC* before storing them on the disc. Photo YCC images transcend the physical characteristics of both the scanning and reproduction processes. They can be regarded as digital originals that can be interpreted and rendered in a

variety of ways that were not anticipated when they were scanned. A good many stock photographs can now be purchased in the PhotoCD format.

PhotoCD represents a new paradigm of color scanning. Rather than scan images for a specific color output process, PhotoCD decouples scanning completely from output. The PhotoCD scanning process does not have to know anything about how the resulting digital images will be printed or displayed. In fact, there is no way of informing the scanning process of these things. By decoupling the scanning process from output, PhotoCD scans become information assets whose value extends far beyond the limits of a particular application. In the rapidly evolving techno-jargon of the publishing industry, PhotoCD images are said to be *repurposable*. With PhotoCD, you scan first and ask questions later.

The default PhotoCD scanning method for color transparencies is called *lock-beam*. In lock-beam, the scanner converts the color values in a transparency directly into pixels without any interpretation or adjustment of their color values. Lock-beam scanning produces PhotoCD images that digitally capture the appearance of the film originals. When used in conjunction with appropriate color management software, lock-beam scanning delivers color-accurate reproductions of original transparencies within the gamut limitations of the chosen output process.

When scanning color negative films, the PhotoCD system normally employs an automatic tone and color correction function called *scene balance*. Scene balance automatically adjusts exposure and white balance during the scanning process to remove unwanted color casts recorded on the film. The technology was developed originally to automate the color-correction function in photofinishing operations. Scene balance is most appropriate for use in conjunction with photographic applications in which there is no possibility of controlling lighting conditions, such as photojournalism.

Color imaging becomes the norm

The rapid development of technologies for inexpensive acquisition of high-quality color image data is creating a huge demand for color printing capabilities to match. Most of the printers now being sold on the consumer market are color devices. The office market is moving rapidly in the same direction. In the next few years, it is likely that color printing will become as standard as it has in the photofinishing industry, leaving black-and-white printing for special applications where a "classic look" is desired and the customer is willing to pay a considerable premium for it.

Chapter 3

DOCUMENT FORMATS FOR DIGITAL PRINTING

The digital printing processes described in Section 2 all have one thing in common. The data stream that drives them at the lowest level must precisely describe the images to be rendered pixel by pixel. At this level, the digital representation of a document is entirely device-dependent and resolution-fixed.

A file containing the precise data sequence to drive a specific print engine can be considered a digital document structure, although it is not a very versatile one. In the absence of the specific engine for which the data was prepared, the file has little utility. The world is full of digital files that were originally created for output on devices that are no longer in use. These files are the digital equivalent of the analog 8-track cassette sound recordings of the 1970s.

As information flows from the beginning to the end of the print publishing process, it becomes increasingly bound to the specific requirements of the target output device. In some cases the information begins its life in a database or set of files that have no reference at all to the output method that will eventually be employed. A typical relational database file, for example, does not contain information about how the contents of the file will eventually be formatted in a printed report. The database file is independent of both format considerations and output device requirements.

In some cases, as in the production of this book, the information is more closely bound to the final output formats from the beginning of the production process. (This book was input directly from the computer keyboard into the final page templates using the QuarkXPress page layout program.) When you create a document with a word processor or page layout program, you are most likely thinking of how the document will appear when printed.

In this chapter we will explore the various document structures that feed into the digital printing process. We begin with structures that are far removed from the specifics of the output devices that will eventually be used to print them, and work our way closer and closer to the primitive stream of binary digits that is required to make the print engine do its thing.

IMAGE FILE FORMATS

There are many existing file formats for pixel-based images. Only a handful are in widespread enough use to be considered de facto standards. For digital print applications, three formats are commonly used: TIFF, EPS and JPEG. Other formats, such as PhotoCD, PICT, GIF, BMP, WMF, and so on, are normally converted to TIFF, EPS, or JPEG before they are used in a print application.

TIFF image files
TIFF is an acronym for *Tagged Image File Format*, and was originally developed by Microsoft as a standardized way of organizing pixel-based image data. TIFF is an extremely versatile format, allowing for anywhere from a single bit per pixel up to a total of 32 bits representing cyan, magenta, yellow, and black color separations. A TIFF file contains a header indicating the number of bits in each pixel and the pixel dimensions of the image.

TIFF files can contain compressed or uncompressed pixel data. The compression method (LZW) is nonlossy (information is not lost in the process) and yields about a 2:1 compression ratio on average, cutting the size of the original file in half.

EPS image files
EPS is an acronym for *Encapsulated PostScript*. This file format is more versatile than TIFF because it can be used to encode pixel-based images as well as text and vector-based graphics. If the EPS format is used for pixel-based images only (as, for example, an output option from a program like Adobe Photoshop), screening information and

tone reproduction transfer curves can be embedded in the file. TIFF does not allow the inclusion of this kind of information within the image file.

EPS pixel-based images can be made up of one, three, or four color components per pixel, and as many as twelve bits per component. Thus it is possible for an EPS image to have as many as 48 bits per pixel (12 bits times 4 colors). All of the image data can be in one file, or divided into four separate color planes and stored in separate files along with a fifth header file containing a thumbnail for positioning the image on a page. In this case the file format is actually a set of five files called a DCS (desktop color separation) set. In printing applications for which separated color information is required, the DCS format will process faster than unseparated formats like TIFF.

JPEG image files

JPEG (which stands for *Joint Photographic Experts Group*) has become a standardized file format for storing compressed pixel-based images. JPEG can be used to compress grayscale, RGB, or CMYK color images. JPEG allows for variable compression ratios. Experimentation has shown that in general it is possible to compress an image to approximately one-tenth its original size using the JPEG format before you see any significant differences in the image when it is printed or viewed on a monitor. Some images can be compressed even more without visible deterioration.

An excessive amount of JPEG compression results in visible artifacts in the reproduction. The image will appear to break up into tiny squares corresponding to 8 by

8 pixel image cells. These JPEG artifacts can sometimes be detected in news photographs that have been greatly compressed prior to being transmitted electronically and then printed at high enlargement ratios.

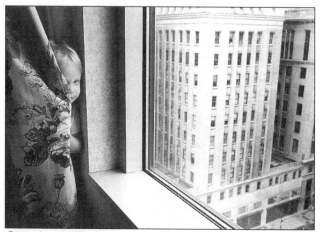

Original image file scanned and saved in uncompressed TIFF format.

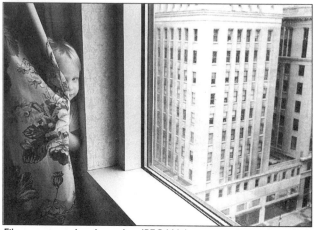

File compressed and saved as JPEG. With compression ratio as high as 10:1, there is no visible difference between the compressed and uncompressed files.

TEXT FILES

The simplest kind of digital document is a text file. All of the data elements in a standard text file are one byte long, and the meaning of each byte is fixed. In American English text files, the meaning of each byte can be determined by reference to the ASCII code (American Standard Code for Information Interchange). The following table gives the decimal ASCII codes for some selected characters:

Character	Code
A	65
B	66
C	67
a	97
b	98
c	99
1	49
2	50
3	51
#	35
$	36
space	32

Because each byte in an ASCII file encodes a single character, the following sequence of bytes: 72 69 76 76 79 44 32 87 79 82 76 68 33, is the text string, *HELLO, WORLD!*

The interpretation of ASCII files is an automatic function of most computers, making it possible for messages to be easily exchanged. Other alphabetic languages are represented with codes similar to ASCII. In the cases of non-alphabetic languages like Chinese and Japanese, more than a single byte is required to represent each character. These languages are therefore encoded using two bytes per character. This allows more than 65,000 characters to be represented.

Adding markup to a text file
In the simplest text file, each byte is part of the encoded message. However, it is possible to add information to an

ASCII file that is not part of the message itself, but is used to add structure to the message. For example, the message

The quick brown fox jumps over the lazy dog

can be modified by addition of tags that convey information about how the text should be rendered. In the following example, the tags are delimited by the open and close angle bracket characters (ASCII characters 60 and 62):

<New Century Schoolbook> <9 point> The quick brown fox jumps over the lazy dog

This is still pure ASCII, but the characters inside the angle brackets are not part of the message. They are intended to indicate the typeface and point size that should be used to render the text. Of course, this scheme must be agreed to by both the message encoder and the message decoder before it can work.

The information that can be embedded in a text file in this manner is generally known as *markup*. Markup can be used to indicate how a file should appear when rendered, as in the preceding example. Another example of markup of this type is Microsoft's *Rich Text Format* or *RTF*. The following is a small sample of RTF:

{\rtf1 \mac \deff8 \deflang1033 {\fonttbl {\f8 \fnil \fcharset77 \fprq2 Times;} { \f26 \fnil \fcharset77 \fprq2 GillSans;}} { \f26 \fs18 **The following is a small sample of RTF.** *}*

In this example, the RTF markup is in italic and the text is in bold. RTF provides a standardized method of marking up a text with formatting information that can be used to render the text. It is very similar in functionality to the classic typesetting languages of the past. It requires a processor that is able to decode the markup and take the appropriate action.

Generalized markup

Markup can also be used to indicate the logical structure of the information in a text file. SGML is an acronym for *Standard Generalized Markup Language*. SGML can be used to create a tagged markup language for any type of document imaginable, from simple documents such as news releases and memos to complex documents such as technical manuals and reference books. A markup language is described by an SGML *Document Type Definition* or *DTD*. This defines all of the different elements that can be found in a document, as well as how the different elements must be arranged in relation to each other.

The creation of an elegant, flexible DTD is a real art. It requires a careful analysis of a particular class of documents and a generalization of their structure that is sufficiently powerful to allow any document of that type to be logically described with the resulting markup language. In reality, SGML is a *metalanguage* for describing markup languages. The DTD defines the grammar of a particular markup language.

The most appropriate applications of SGML are for complex documents that will be used in a variety of ways, and where the value of the information is long-lasting. Two examples of document types that are particularly well-suited to the use of SGML are legal books and technical manuals. In contrast, short-lived layout-intensive documents such as magazines and catalogs do not lend themselves very well to use of SGML.

Several software applications currently are available for the creation and processing of SGML documents. These include SoftQuad's *Author/Editor*, Adobe's *FrameBuilder*, and Interleaf's *Interleaf Publisher*.

HTML: An SGML application

SGML was used to create the document architecture that is the basis for the *World Wide Web (WWW)*. At the heart of the WWW is a language called *HTML*, which stands for *HyperText Markup Language*. HTML provides a relatively small set of tags and simple rules for using them that can be employed to create a document that will then function

```
<!ELEMENT      Memo      (Header, Body)>
<!ELEMENT      Header    (To, From, Date, Subject)>
<!ELEMENT      To        (#CDATA)>
<!ELEMENT      From      (#CDATA)>
<!ELEMENT      Date      (#CDATA)>
<!ELEMENT      Subject   (#CDATA)>
<!ELEMENT      Body      (Paragraph+)>
```

This is a simplified SGML document type definition (DTD) for a memo. The memo has two main parts: the *header* and the *body*. The header has four parts: *To, From, Date,* and *Subject.* The *Body* consists of one or more *paragraphs* (indicated by the + sign).

```
<Memo><Header><To>Readers of this book</To>
<From>Frank Cost</From><Date>September 1</Date>
<Subject>How SGML Works</Subject></Header>
<Body><Paragraph>SGML is an acronym for Standard
Generalized Markup Language. SGML can be used to create a
tagged markup language for any type of document imaginable,
from simple documents such as news releases and memos to
complex documents such as technical manuals and reference
books.</Paragraph>
<Paragraph>The creation of an elegant, flexible DTD is a real
art. It requires a careful analysis of a particular class of docu-
ments, and a generalization of their structure that is sufficiently
powerful to allow any document of that type to be logically
described with the resulting markup language.
</Paragraph></Body></Memo>
```

This is a memo document marked up with the language defined above. Note that the tags (delimited by the open and close angle brackets) are taken directly from the DTD above. The tags clearly label each logical piece of the document. A computer program could easily find the name of the person to whom this memo was sent by simply referring to the DTD and then looking for the <To> tag. SGML can be used to describe the structure of any kind of document imaginable, and is an accepted international standard.

as a *page* on the WWW. The syntax of HTML is defined by an SGML DTD.

HTML allows the creation of documents that contain text, graphics, and references to external files. But what gives HTML its real power is the capability of including links to other locations on the WWW. Within a given HTML document, any number of links to other documents on the WWW can be included. This is why the term *web* is so appropriate. Imagine a collection of millions of documents, each linked to any of the others that the author believes may be of potential interest to the reader. By following these links, a reader can jump from document to document in pursuit of information. The number of possible trips from the same starting point is very large, if not quite infinite.

HTML is not intended to be seen by humans who are going about their daily business on the WWW. To illustrate this point, here is a sample of HTML taken from the Adobe Systems web page that directs you to a selection of free downloadable software:

<HTML><HEAD><TITLE>Free Software from Adobe </ TITLE></ HEAD><BODY><H1>Free Software from Adobe</ H1><HR> <P><DL> . . . etc.

The HTML contains tags that identify each piece of the file. Readers who are familiar with SGML will recognize the tags, which are delineated by the open and close angle brackets. An HTML document always begins with the tag <HTML> and ends with the tag </HTML>.

Fortunately, HTML was designed to be rendered by software programs called *browsers* that read the HTML and then present a user-friendly view of the page on a computer monitor. There are several different browsers in current use. These can be roughly divided between text-based browsers and graphical browsers. One such graphical browser is called *NetScape*. If you buy access to the WWW from a commercial access provider, there is a good chance that you will be using NetScape as your window into the WWW.

There is a lot of confusion about the relationship between the World Wide Web and the *Internet*. Some think they are just different names for the same thing. But the Internet had been in existence for many years before the advent of the WWW. In the academic, scientific, and technical communities, the Internet has been used to exchange information via electronic mail and a file transfer protocol (FTP) that allows connected users to log into and obtain data from computers anywhere in the world that are connected to the Internet.

Before the WWW, the Internet remained the province of a secret society of users, mostly in academic institutions and companies that either manufactured or made heavy use of computer technology. Learning to use the Internet was difficult. Mere mortals could not do it very well. The interface was entirely command-driven. The WWW has changed all of this, making it possible for nontechnical people to gain access to information using the medium of the Internet.

HTML is a specific document structure that was designed from the start for use on the WWW. Because web pages are intended to be viewed on a computer monitor with the aid of a browser, HTML has been kept purposely simple and generic so that web pages would be small, portable, and easy to interpret on a variety of platforms using a variety of browsers. The first generation of the language was criticized for its lack of typographic richness and inability to specify the subtle design aspects of a document in the same way that a page layout or even a word processing application could.

Several competing strategies for embedding fonts and typography in web documents have been proposed. These include Bitstream's *TrueDoc*, Agfa's *TrueType* font compression, Microsoft's *TrueType-for-the-Web*, and extension to Adobe's new version of *Acrobat* called *Amber*. All four of these technologies provide similar functionality, allowing compressed font subsets to be embedded in an HTML document. The fonts must be compressed because of the need for fast transmission over the Internet. The subsets include only the characters that are used in a particular document.

Other mechanisms are available for adding enough typographic and design richness to documents that can be distributed on the WWW to satisfy the requirements for printed output. Any digital file can be included in a web page and made generally available for downloading to any machine connected to the web. So, if you want to make a layout-intensive document available to people who visit your web page, you can include a link to the document that will allow them to download the file to their own machine. Appropriate application software is needed to decode the downloaded file. For example, Microsoft *Word* or a special *Word viewer* program is required to open, view, and print Word documents.

PAGE DESCRIPTION LANGUAGES

In the early 1980s two scientists from Xerox Corporation, John Warnock and Charles Geschke, decided to set out on their own and develop an unusual and paradigm-shattering commercial product. While in the employ of Xerox during the 1970s, they had helped develop a computer language called Interpress, which was the basis for complex graphical page description on a pioneering computer workstation called the Alto. The Alto was the first computer to use a mouse/icon interface, which was later made famous by the Macintosh computer. The Alto never became a commercial success for Xerox, but the spirit of the Alto was resurrected in the Macintosh with the help of other former Xeroxers who had been instrumental in the Alto's development and went to work for Apple.

Warnock and Geschke started a company called Adobe Systems. They understood that a computer that allows you to work with WYSIWYG images of pages on the monitor is only useful if you have some way to print the images you see. In the late 1990s we are perhaps on the verge of dispensing with hard copy in some areas of publishing where it is safe to assume that people have access to the equipment necessary to display electronic documents. But in the early 1980s, pretty pictures on a computer monitor were not very portable. Printing was an essential ingredient of

any future microcomputer-based publishing system.

PostScript

The revolutionary product developed by Adobe Systems was a computer language called *PostScript*™ and a processor that could interpret PostScript page descriptions and generate a data stream to drive a digital printing device such as a laser printer or film writer. The language alone would have been little more than a curiosity without the processor.

The first publishing application to generate PostScript page descriptions was Pagemaker, developed by Aldus, a software company named after the 16th-century Venetian book printer, Aldus Manutius. (Aldus became part of Adobe in a friendly takeover in 1993.) The first PostScript printer was the Apple Laserwriter 300 dpi monochrome laser printer. These products, along with the Macintosh computer, launched the desktop publishing revolution.

PostScript only began to have a profound impact on the industry with the introduction of the first high-resolution PostScript film writer. This was the *Linotype L-300,* which worked in conjunction with an Adobe PostScript raster image processor at the front end. PostScript page descriptions could be sent directly from a Macintosh computer to the RIP for output on the L-300 to produce graphic arts films at a maximum resolution of 2,540 dpi. This was sufficient for high-resolution rendering of text, line art, and halftones.

The first generation of PostScript technology was not designed for color printing, and was especially deficient when used for reproducing process color images. The algorithms that were used to convert contone images into screened halftones for print applications were primitive—adequate for grayscale reproductions but not for color. This did not stop early application developers from enabling their software to use PostScript to produce color separation films. The quality of the separations was poor, and PostScript technology was relegated to low-end applications where any color was considered a step up.

Level 2 PostScript

In 1990, Adobe published the second version of the PostScript language, which they called Level 2. This added a number of new capabilities and made it possible for PostScript technology to satisfy the requirements for high-end color work. Level 2 PostScript also provides other capabilities to support high-end applications. For example, it is possible to download a color rendering dictionary to a PostScript RIP to convert images to the output color space on the fly. This makes it possible to embed color management functionality in the RIP.

PostScript graphics

The PostScript language can be used to describe a rich assortment of graphics, including pixel-based images, vector-based images, and typography. The page description model is relatively simple. Each page is a rectangle, which can be of any size. In the default coordinate system, the lower left corner of the page is the origin and the basic unit of measure is 1/72 of an inch. Thus, a standard 8.5 by 11 inch page is 792 units tall and 612 units wide. The PostScript coordinate system can be scaled and rotated

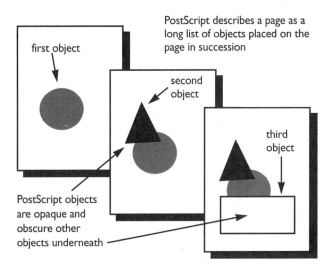

PostScript describes a page as a long list of objects placed on the page in succession

first object

second object

third object

PostScript objects are opaque and obscure other objects underneath

and the origin can be moved to any point on or off the page.

A PostScript page description is a long display list of objects to be rendered in order on the page. All PostScript objects are opaque. Earlier objects described on the page will be overprinted by later objects that overlap.

PostScript vector-based graphics are described by paths describing outlines and fills. Some basic operators include:

- *moveto* and *rmoveto* move the current point to a specified position on the page
- *lineto* and *rlineto* draw a straight line from the current position to the new position on the page
- *curveto* draws a curve between two points
- *arc* draws a circular arc

These operators can be combined to describe complex shapes that are either closed or open. The width and value of the outline can then be described. On a monochrome page, the gray value of the ink used to render objects can be established using the *setgray* command.

- 0.0 *setgray* sets the current ink value to solid black
- 1.0 *setgray* sets the current ink value to solid white
- 0.5 *setgray* sets the current ink value to 50 percent

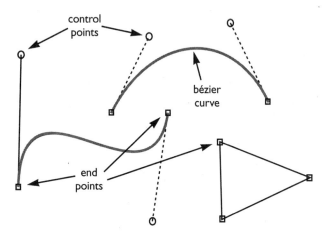

control points

bézier curve

end points

On color pages, operators similar to setgray allow the color of the ink to be set to specific RGB or CMYK values. These are setRGBcolor and setCMYKcolor. The width of the line that PostScript uses to draw the outlines of objects is established with the setlinewidth command.

- 1 *setlinewidth* selects a 1-unit wide line
- 0 *setlinewidth* selects the thinnest line that the target printer can render

The *fill* command is used to fill the current path with the current gray or color value. Thus, PostScript can describe the outlines of objects, the color of the pen used to draw the outlines, and the color of the fill. There is no set limit to the number of objects that can be described on a single page, and it is not uncommon for a page to contain hundreds or even thousands of individual objects.

PostScript pixel-based images

PostScript describes pixel-based images by first describing the rectangular boundaries of the images and then filling the rectangles with image data. If the image is intended to be rendered on a binary output device such as a laser printer or lithographic press, the screen frequency, screen angles, and dot shape can also be specified. Images can also be clipped to any shape desired on the page.

PostScript typography

PostScript treats type in a way similar to other graphics. The concept is simple. To set type on the page, an application must first establish the font and point size. This is done very simply using the *findfont, scalefont,* and *setfont* commands. This set of commands establishes 24-point Helvetica as the current font:

/ *Helvetica findfont*
24 scalefont
setfont

The type is then set on the page by moving to the desired location and laying down the letters. Because type is treated in the same way as other graphics, it can be scaled and rotated. This enables a wide variety of graphic effects incorporating type. The power of PostScript is its ability to

describe nearly any complex design combining text and graphics with great precision.

Encapsulated PostScript (EPS)

Any object or collection of objects that can be described with the PostScript language can also be placed into a container called an Encapsulated PostScript or EPS file. An EPS file encloses all of the objects it describes within a rectangular bounding box. The objects described in the EPS file can be included in higher level page description files. For example, EPS files from Adobe Illustrator can be embedded in Pagemaker or QuarkXPress documents.

PostScript's device dependencies

It is often said that PostScript is *output device independent*. Hundreds of printers, film writers, platesetters, and proofing devices can render PostScript documents directly. Encapsulated PostScript files are usually generic enough to be easily rendered on any PostScript output device. Some information in an EPS file may not be meaningful to a given RIP (e.g., RGB colors cannot be rendered on a monochrome printer), but EPS files are generally intended to be highly portable.

PostScript print files, in contrast, often include information that makes sense only in the context of specific output devices. This information is extracted from a *PostScript Printer Description* (PPD) file and added to the

In a typical PostScript workflow, the page layout program generates a PostScript print file including information from the PPD

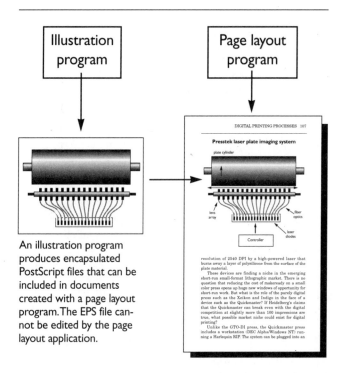

An illustration program produces encapsulated PostScript files that can be included in documents created with a page layout program. The EPS file cannot be edited by the page layout application.

PostScript file sent to the output device. The PPD can include such information as page size, print area, duplexing, stapling, color rendering information, print resolution and media type. A PostScript print file that includes information extracted from a PPD is therefore not easily transportable to other devices.

Unpredictability of PostScript processing

PostScript's Achilles heel has been its lack of structure. There is no way for a processor to know what is in a PostScript file until the file is processed from beginning to end. There is practically no limit to the number of objects that can be on a single PostScript page. It is also very difficult or impossible to detect where one page ends and the next one begins in a long PostScript document. This makes it impossible to predict how much time will be required to

process any given page or to process pages independently of one another. One page comprising few objects will process in a minute, and the next page comprising many objects will take much longer. This unpredictable nature of PostScript has been addressed by throwing as much fire-power at the problem as state-of-the-art computer technology will allow.

The time required to process PostScript pages has been dramatically reduced since the first PostScript RIPs of the mid-1980s, but the basic lack of structure and unpredictability remain. For this reason, it is not desirable to try to feed PostScript pages directly to the front end of a digital printer if the goal is to keep the printer running at its maximum throughput. The PostScript pages should be preprocessed into machine-specific format and stored in a buffer before being downloaded to the press. To avoid a bottleneck anywhere in the workflow, the average through-put of RIPped PostScript pages can be balanced against the speed of a printer by parallel RIP architectures where more than one RIP serves a single printer. However, if the printer becomes the bottleneck, one RIP may be configured to serve multiple printers.

Adobe Acrobat PDF

The Adobe Acrobat PDF file format is becoming a standard for layout-driven documents that are intended to be transmitted electronically and viewed or printed at a remote site. Adobe currently makes Acrobat readers for all of the major platforms, including MS Windows, Macintosh, Silicon Graphics, and Sun Sparc. These readers range in size from about one to three megabytes, depending on the platform. Adobe encourages anyone publishing Acrobat documents on disk or CD-ROM to include the Acrobat reader along with the documents. Adobe does not charge any licensing fee for this.

The advantage of the Acrobat Portable Document Format is that all of the design aspects of a document are preserved intact. Acrobat is essentially an electronic analog of paper, with a few additional features such as the ability to add electronic notations and perform simple searches for words and phrases.

Creation of an Acrobat document is done using a program called a *Distiller*. This is essentially a PostScript RIP that converts PostScript pages into PDF pages. Documents can be distilled using two different workflows. PDF documents can be written directly from an application such as Word or QuarkXPress using a PDF writer in place of a print driver. Alternatively, PDF can be generated by writing a PostScript print file from the page layout or word processing application, then distilling the PostScript file into PDF using the Acrobat Distiller directly. Either way, you end up with an electronic version of the document that can be viewed or printed using the Acrobat reader.

The Acrobat Distiller allows color and grayscale images to be compressed in the JPEG format, and monochrome images to be compressed using run length, CCITT fax for-

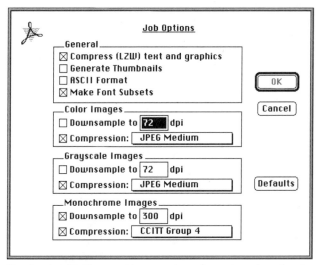

The Acrobat Distiller provides a number of ways to reduce the size of the PDF file by compression of fonts and images. If the document is intended for print, the color and grayscale images should be downsampled to no less than 1.5 times the screen ruling of the target printing process and compressed using JPEG low or medium settings for the best output quality. Monochrome images should be downsampled to the dpi of the printer and compressed using run length or CCITT Group 3 or 4 which is similar to fax compression.

mats. With compression, the typical PDF file is a small fraction of the size of the original application file or PostScript print file. This makes PDF especially well suited as a format for storing documents that are intended to be distributed electronically.

Although PDF is capable of describing pages with the same design complexity as PostScript, the first few generations of PDF did not support all of the graphic features available in PostScript, such as screening information, patterns, the ability to reference external graphic files, and color separation functions. Future releases of Acrobat will incorporate support for the prepress, personalization, and finishing operations that are essential in a production printing environment.

Adobe has also developed a production printing architecture called *Supra,* which converts PostScript and PDF documents into structured PostScript or PDF files that can be stored in a large disk array and then downloaded to a RIP or parallel RIPs prior to printing. It is a good bet that PDF will become the standard page description format for all documents that are distributed electronically and intended to be printed digitally, because it combines two essential features: document design specificity and document portability.

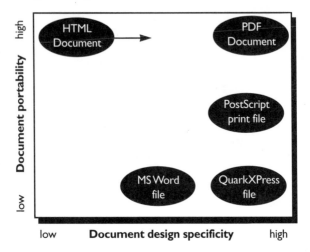

Section Two

Printing Processes

Chapter 4

ANALOG PRINTING PROCESSES

Printing processes that employ physical masters fall into four broad categories. These are: *relief processes*—processes that transfer ink from raised image elements by the same principle as a rubber stamp; *intaglio processes*—processes that transfer ink from cells or grooves engraved into a smooth (usually metal) surface; *planographic processes*—processes that transfer ink only from areas of a smooth surface that are ink receptive; *screen processes*—processes that employ a porous stencil to control the flow of ink to the substrate.

All mechanical printing processes are variations of these four themes. This chapter briefly explores each of these categories, comparing their speed, cost, image quality, and versatility. In most modern digital printing processes, the image content is digital up to the point where either films or plates are made. In some cases, plates are made by computer-controlled lasers directly on press. These processes are digital in every aspect except the final step of putting ink on paper. To keep things straight from now on, this book refers to all processes that employ a physical image carrier as analog printing processes.

One way to distinguish analog from digital processes is that analog processes require the image be computed and written only once to form the film or plate. This results in a physical image carrier that can be used over and over again. Digital processes, however, require that every pixel in the image be written each time the image is printed. The amount of data required to write an image must therefore be multiplied by the number of images printed in a given time period to establish a required "data transfer rate" for a digital printing system. We will discover that the data transfer rate of a digital printing system must be extremely high before the system can match the speeds of analog printing processes employing physical image carriers.

Printing processes can be thought of as *spatially variable coating processes*. What does this mean? Unlike standard coating processes that are only capable of transferring uniform layers of material to a substrate, printing processes can precisely control where on the substrate the coating will be applied.

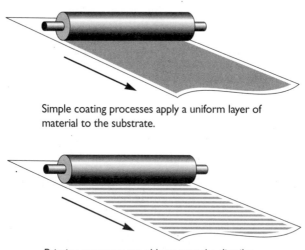

Simple coating processes apply a uniform layer of material to the substrate.

Printing processes are able to vary the distribution and placement of material on the substrate.

Some processes can also control the thickness of coating at each point on the substrate. The more precision, the higher the resolution of the process.

The materials that printing processes apply to substrates have the function of modifying the way light is either reflected by or transmitted through the substrate. Inks contain finely ground pigments that absorb light in specific ways. Varnishes and other clear coatings do not contain pigments, but are applied to alter the characteristics of the substrate surface. In some cases, clear coatings impart physical qualities such as abrasion resistance or waterfastness. Sometimes clear coatings are applied for

purely visual effects. All analog printing processes apply these materials in liquid form, and then rely on some mechanism for drying or solidifying the material once it is on the substrate.

Most analog printing processes are capable of applying a uniform thickness of ink or clear coating to selected areas of the substrate. In other words, the coating thickness cannot be varied from point to point. Such processes are sometimes termed *binary* because they either apply ink or do not apply ink to each point on the substrate.

If a binary printing process is used to apply light-absorbing ink to a light-reflecting substrate (e.g., black ink to white paper), the areas covered by ink will have high density and the bare substrate will have much lower

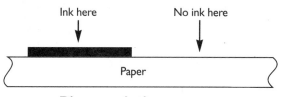

Binary printing process

density. Binary processes are only able to produce these two density extremes, and must resort to halftoning to trick the viewer into perceiving intermediate gray tones. (See Chapter 7).

Only intaglio processes are capable of varying the actual thickness or concentration of ink or colorant applied to the substrate. Gravure printing, for example, transfers ink from tiny cells etched into the polished surface of a massive metal cylinder. The depth of each cell determines the amount of ink that is transferred to the substrate at that point. The deeper the cell, the thicker the film of ink transferred and the higher the density of the resulting print.

Relief printing: The oldest process
Relief printing must have been discovered a very long time ago. We have found scraps of relief-imprinted paper

and fabric dating back a few thousand years. It is a safe assumption that earlier examples would exist were it not for the ravages of time.

In the absence of a concrete archeological record, we are free to speculate and dream about the origins of this most ancient of processes. Perhaps the relief principle was the discovery of a wayward caveman who, having just tracked dirt into the front entrance of his home, was forced to get down on his hands and knees and wipe up his muddy footprints. Thus, the discovery of printing may coincide with the first time a man actually did some work around the house, making it a truly momentous event.

Whatever the truth about its origins, relief printing has been practiced ever since, and remains important to this day. If we survey the current scene, there are essentially two broad categories of relief printing, one using hard relief plates and high-viscosity paste ink called *letterpress* and another using soft relief plates and low-viscosity ink called *flexography*.

As time passes, the clear distinction between these two is becoming clouded. Hybrid relief processes that

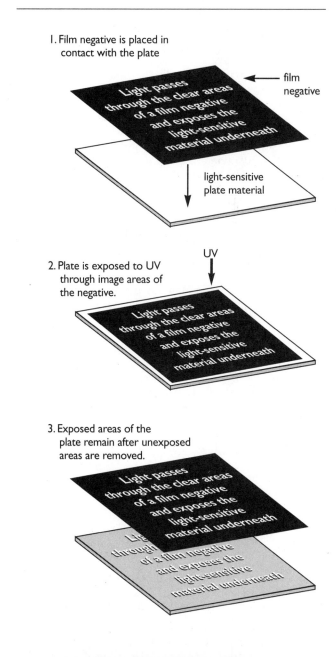

1. Film negative is placed in contact with the plate

film negative

light-sensitive plate material

2. Plate is exposed to UV through image areas of the negative.

UV

3. Exposed areas of the plate remain after unexposed areas are removed.

employ letterpress-like plates and flexography-like inking systems have been designed for a variety of applications. Relief processes have also been adapted to highly specialized applications. For example, two-piece aluminum beverage cans are decorated at speeds in excess of 1,600 cans per minute on special offset letterpresses.

Nearly all modern relief printing plates consist of a metal, plastic, or paper substrate coated with a layer of light-sensitive polymer (photopolymer) that is imaged by exposure to ultraviolet (UV) radiation through a film negative. The film is a light stencil. Image areas on the film negative are transparent, allowing the ultraviolet radiation to pass through. Nonimage areas are extremely dense, blocking the passage of radiation. The photopolymer coating on the plate can be either a liquid or a solid, and prior to exposure is called a *monomer*. When the monomer is exposed to ultraviolet radiation, it undergoes a chemical reaction that links the molecules and changes its physical properties. Monomers that start out liquid become solid polymers. Monomers that start out solid undergo a solubility change. The unexposed monomers are then removed. Liquid monomers are usually removed by blowing with an array of air jets. Solid monomers are removed by washing.

The resulting relief plate has a raised image surface that will take ink from a set of rollers and transfer it to a substrate. The relief must be high enough to prevent ink from adhering to and transferring from the nonimage areas. The amount of relief on letterpress and flexographic plates is in the range of 15 to 50 mils (0.4 to 2.0 mm). In even the shallowest relief plates, the thickness of the layer of monomer that must be polymerized to yield the necessary relief requires exposure to a tremendous amount of ultraviolet energy.

Relief computer-to-plate
Because of their high energy requirements, current photopolymer relief plates must be imaged by contact exposure through a film negative. This precludes the use of a digitally controlled imaging mechanism such as a scanning laser or LED array to form the relief image directly

in the polymer layer. It is possible, however, to use a high-energy laser to create a light mask on the surface of a polymer layer, and then to use this integral mask in place of a film negative. Such systems have been demonstrated and may soon become commercially available. The plate medium is similar to conventional photopoly-

Direct laser exposure of photopolymer relief plate

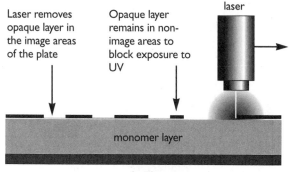

Laser removes opaque layer in the image areas of the plate

Opaque layer remains in non-image areas to block exposure to UV

laser

monomer layer

plate base

mer materials with a thin layer of ultraviolet-opaque dye coated on top. The dye is removed by exposure to the laser, creating areas in the mask that will allow ultraviolet to pass through. After laser exposure, the plate is placed into a normal plate exposure unit and exposed in the same manner as a conventional photopolymer relief plate. The process resembles conventional photopolymer platemaking from this step forward. The unexposed non-image areas are washed out in a solvent bath and the plate is dried and mounted on the press.

It is also possible to make a computer-generated flexographic plate by starting with a rubber-coated roller, and using an extremely powerful laser to blast away a layer of rubber in the nonimage areas. This process is used to make semi-permanent rubber rollers for printing continuous patterns on wallpaper and other specialty products.

Letterpress: Once king, now derelict

If we were to travel back in time 50 years or more, we would discover that letterpress was once synonymous with printing itself, accounting for almost everything that was printed. Now it is difficult to find examples of letterpress printing because it has largely been displaced by other processes. Some newspapers are still printed by letterpress, but nearly all new press installations in the newspaper industry are web offset presses. The image quality obtainable with lithography is generally preferred to that of letterpress. With the exception of some specialized instances, like the aforementioned aluminum-can decorating process, the golden age of letterpress has passed. The markets it once served are now dominated by lithography and gravure.

Flexography: From rags to riches

On our time travels to the world of 50 years ago, we would also want to pay a visit to a flexographic printer or two. We would find that the process was then called *aniline printing* because the inks contained noxious aniline dyes. Flexographic plates were made of molded rubber glued onto metal cylinders and were used to transfer crude images to cardboard for industrial marking applications. You can get a taste of this original form of flexography by examining images printed directly on corrugated shipping boxes.

Flexographic printers were once considered the bottom feeders of the industry, doing the dirty work that no self-respecting graphic artisan would touch. However, in the past 20 years, flexographic technology and capability has improved vastly. The industry has largely converted to water-based inks, making the process more ecologically sound.

Modern photopolymer plate materials and presses enable flexography to reproduce images on a variety of substrates, including some that are impossible to print by any other means. The process is especially well suited for nonporous substrates such as polyethylene, polypropylene, polyesters, and foil laminates. One example of a well-protected niche: all the polyethylene bags for pack-

aging bakery goods and frozen foods are printed by flexography.

Flexographic printing presses are divided roughly into two categories—*narrow web*, up to about 22 inches wide, and *wide web*, anything wider. Narrow-web presses are used primarily for creating labels and similar products, whereas wide-web presses are used for packaging and publication applications. Narrow-web flexography is typically a higher-margin business than wide-web. (Pharmaceutical labels generally command better margins than bread bags.)

Flexographic image quality

The flexographic ink transfer mechanism is extremely simple. The highly fluid ink is drawn out of a reservior on a rubber-coated roll. It is then transferred to an ink-metering *anilox roll*. The anilox roll has a pattern of tiny cells etched into the surface to hold the ink. Excess ink is scraped from the anilox roll with a steel blade called a *doctor blade*. The ink remaining in the cells of the anilox roll is then transferred to the areas of the soft plate sur-

Flexography

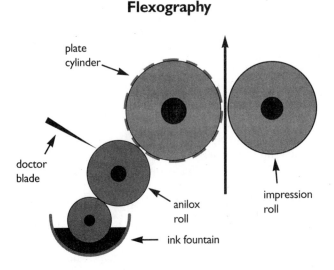

plate cylinder

doctor blade

anilox roll

impression roll

ink fountain

face that stand in relief. The inked areas of the plate make a *kiss impression* with the substrate, pressing it gently against a smooth metal impression roll to transfer the ink. The ink is then immediately dried in an oven or cured by exposure to ultraviolet radiation.

The slight pressure needed to transfer the ink from plate to substrate causes the ink to squeeze out around the edges of each image element. Halftone dots grow larger around the edges as a result. This causes plugging in the shadows. Highlight rendering is also a problem in flexographic printing. The smallest highlight dots on a plate may not transfer ink at all, making it difficult to reproduce subtle highlight details. A nightmare scenario is the task of reproducing a collection of high-key photographs using a flexographic press.

Flexographic image quality has improved greatly over the past few decades, largely as a result of advances in photopolymer plate technology. Still, the image quality does not match that of lithography, and it probably never will. Consequently, flexography has had limited application for publication printing, with one exception being a number of flexographic installations in the newspaper industry where image quality suffers more at the hands of the paper than the printing process itself. Flexography is also appropriate technology for the printing of text-only paperback books on low grades of paper.

Lithography: Queen of analog processes
If you enjoy learning about how things came to be the way they are, I highly recommend the book *The Invention of Lithography*, by Alois Senefelder. Here was an eccentric Bavarian inventor obsessed with finding an entirely new way of printing, thereby securing his place for all time in the chronicles of human invention. (Senefelder would doubtless be delighted at the appearance of his name in the pages of this book, printed in the last years of the 20th century by the very same process that he invented nearly 200 years before.)

This is not the place for the long story about Herr Senefelder's tribulations and triumphs, but I will say a few things about the nature of his invention that are still

relevant to most of the printing we do today. Before Senefelder, printing was done by one of three methods. In each case, the ink transfer mechanism relied on a geometric distinction between image and nonimage areas on the image carrier. In *relief printing*, the image is raised above the non-image, and ink is transferred only from these raised areas. In *intaglio printing*, ink is transferred from recessed cells or engraved lines. In *stencil printing*, ink is transferred through open areas of the stencil. Each of these three mechanical methods has been around for hundreds, if not thousands, of years.

Lithography is different from all of these other processes because the lithographic ink transfer mechanism is not strictly mechanical. A lithographic plate has a perfectly smooth surface. Image and nonimage areas are indistinguishable from one another by touch alone. In a darkened room, you would have a hard time telling the difference between a lithographic plate and an ordinary smooth sheet of aluminum or polyester.

So how does it work? Ink applied to the image areas of a lithographic plate must somehow be repelled by the nonimage areas on the same plane. This is possible if the nonimage areas of the plate are moistened with a thin layer of water. Oil-based ink will not adhere to the wet nonimage areas. If the image areas are sufficiently water-repellent, ink can be applied to the image while leaving the nonimage areas clean.

The ink layer is then transferred, or *offset,* to an intermediate roller called a *blanket cylinder*. From the blanket the ink is transferred to the substrate. Because the blanket cylinder has a soft rubberized covering, it is able to conform to a wide variety of paper surfaces, making lithography an extremely versatile printing process. If you can get it to run through a press, lithography can probably print an image on it. The use of an intermediate blanket cylinder upon which the image is offset before being transferred to the substrate is why lithography is often called *offset printing*.

The use of water to dampen the nonimage areas of a lithographic plate introduces a great deal of variability into the process. If the amount of water flowing to the

Offset lithography

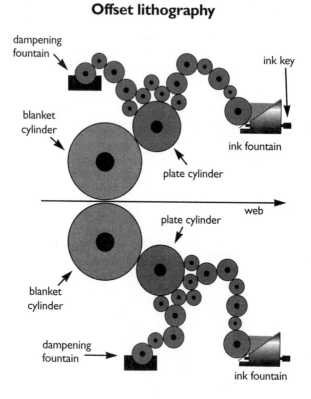

plate changes, the flow of ink to the blanket and substrate will also be affected. By controlling the ink-water balance on a lithographic press, the press operator is able to control the densities and colors that are printed.

Using lithography for short-run color
The major weakness of lithography for short-run color applications has been the large amount of paper that must run through a press before ink-water balance is achieved and the first good press sheet emerges. The time that passes between the start of the press and this first good sheet is called *makeready*.

strikes them. (The plate coatings for conventional contact exposure can be much slower than those intended for laser exposure, because each point on the plate surface is exposed to the light source simultaneously through negative or positive films.) The photopolymer is hardened by the laser in image areas. The unhardened nonimage areas are then removed in a conventional wet plate processor. Laser-exposed photopolymer lithographic plates closely resemble and function in the same way as contact-exposed plates.

Direct silver litho plates

Another type of lithographic plate compatible with CTP systems is the *direct silver* plate. Direct silver plates have a complex multilayer emulsion containing light-sensitive silver halides. The plates also incorporate a developer in the emulsion. Development of the exposed plate is simply a matter of activating the developer and then fixing the image by running the plate through a wet process. The effect of exposure is amplified by the *photomultiplication* effect of development. Thus, direct silver plates can be exposed to relatively low-power lasers. Most direct silver plates are polyester-based, but larger format plates may have aluminum bases for increased dimensional stability.

Laser-imaged plates for waterless lithography

a sheet of polyester is coated with a thin layer of ink-receptive material and then another thin layer of ink-repellent material such as polysilicone, an image can be formed by blasting away the top layer with a laser to reveal the ink-receptive layer underneath. This is the basis for the plate imaging mechanism in the Heidelberg GTO-DI and QuickMaster digital printing presses. This technology was pioneered by PressTek, which has also introduced stand-alone direct laser platemaking machines that can be controlled directly by a computer system. Presstek is developing wide-format CTP systems for larger press sizes, and cylindrical sleeves for gapless printing that will enable waterless offset printing to compete effectively with flexography in the wallpaper printing market. The addressability of these systems is in

One way to reduce the cost of makeready is to automate the functions by which ink-water balance is achieved on a conventional press. By feeding digital information about the image contents of a press sheet to the ink control system of the press, the press controls can be preset to optimize the ink flow for that particular sheet. This provides an initial *coarse adjustment* of the press. Fine adjustment must still be done by the press operator, but the total makeready time is significantly reduced.

A better way to reduce the cost of makeready is to eliminate the need for dampening altogether. For a conventional lithographic process, this would be disastrous. Without dampening, the nonimage areas of the plate would take ink from the inking rollers as easily as the image areas. Hence, the thin layer of water on a conventional plate must be replaced by some dry material that performs the same function. Current dry offset plates employ polysilicone compounds in the nonimage areas. Special inks designed to release completely from the polysilicone layer are used in place of conventional lithographic inks. The absence of water in the system removes an important cooling mechanism that must somehow be compensated for; usually, plumbing systems are added through which cool water can be pumped to remove excess heat from the press.

Sheetfed and web-offset lithography

Lithographic presses can be placed in two broad categories. Sheetfed presses print on individual sheets of paper and normally print on one side of the sheet as it passes through the press. The speed of a typical sheetfed press is expressed in terms of number of sheets per hour. Typical modern sheetfed presses are capable of printing at speeds of 12,000 to 15,000 sheets per hour. Unless the press is capable of *perfecting,* or printing on both sides of the substrate simultaneously, the sheets must be run through the press twice.

The range of sheetfed offset press sizes is vast, from the small single-color duplicator capable of handling only an 8.5 by 11 inch sheet size, up to massive six-, seven-, or eight-color presses capable of printing on sheets 60 or

more inches across. This makes lithography an extremely versatile process. A great variety of commercial products are produced on sheetfed offset presses. These include publications, catalogs, packaging materials, labels, and direct mail pieces. The process is able to print high-quality color images directly on a wide variety of substrates, including paper, board, plastics, and metals.

Web offset presses print simultaneously on both sides of a roll of paper as it passes through the press. Web presses are normally run at higher speeds than sheetfed presses, yielding as many as 50,000 impressions per hour. The range of paper types available for web printing is more limited than for sheetfed printing. Web printing is used primarily for the production of magazines, catalogs, newspaper inserts, and other similar products. Special narrow-web offset presses are used to print continuous business forms.

Laser exposure of a lithographic plate

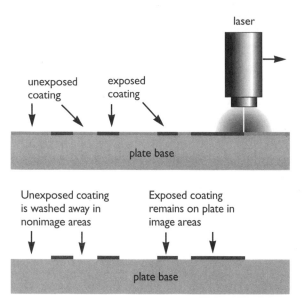

laser

unexposed coating

exposed coating

plate base

Unexposed coating is washed away in nonimage areas

Exposed coating remains on plate in image areas

plate base

Contact exposure of a lithographic plate

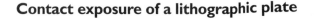
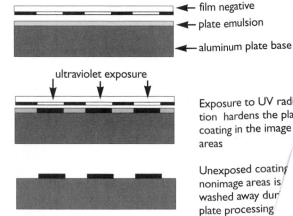

film negative
plate emulsion
aluminum plate base

ultraviolet exposure

Exposure to UV radiation hardens the plate coating in the image areas

Unexposed coating nonimage areas is washed away dur plate processing

Lithographic plates

The image areas on lithographic plates are on plane as the nonimage areas. There are two typ ventional lithographic plates designed for con sure through film masks. On *negative* lithogra the image is formed by exposure of the imag blue/ultraviolet source that hardens the im prevents it from washing away when processed. On *positive* plates, the nonima selves are exposed and the molecular bond break down and become soluble. On bo positive plates, wet processing removes ing in the nonimage areas, leaving a receptive material in the image areas. no more than a micron or two thick.

Laser exposure of lithographic pl

Special high-speed photopolymer lithographic coatings compatibl trolled laser imaging. The photop of reacting almost instantaneou

Laser-imaged waterless litho plate

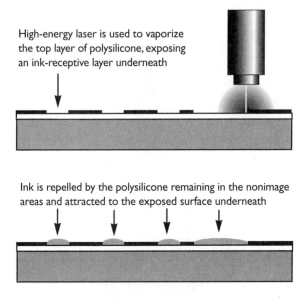

High-energy laser is used to vaporize
the top layer of polysilicone, exposing
an ink-receptive layer underneath

Ink is repelled by the polysilicone remaining in the nonimage
areas and attracted to the exposed surface underneath

the range of 2,500 dpi, which yields image quality similar
to conventional sheetfed offset lithographic printing.

Laser ablation lithographic platemaking

Conventional lithographic plates can also be made by a
process of laser ablation transfer. Presstek and Polaroid
were the first companies to build CTP systems that
employ this process. The idea is relatively simple. A high-
energy laser is used to transfer material from a donor
sheet to a conventional aluminum plate base. The trans-
ferred material becomes the image layer on the plate.
Polaroid has demonstrated a laser ablation platemaking
system that can also be used to produce contract-quality
color proofs. The ablation transfer mechanism works well
with pigments, making it possible to produce a digital
proof using the same colorants as the target printing
process. This is in contrast to the laser thermal transfer

Gravure process

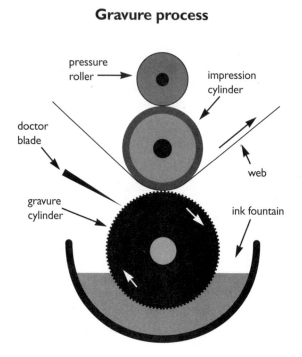

mechanism used in the Kodak Approval contract proofing system, which employs dye-based colorants that must be formulated to match the appearance of pigments under standard lighting conditions.

Gravure

The simplest, fastest, and longest-run analog process is called *gravure* or *rotogravure* printing. All modern gravure presses are web fed, and can be as large as 16 feet across. The largest presses are used for decorating specialty products such as vinyl floor coverings, and are normally run at speeds of a few hundred feet per minute. Publication gravure presses are typically about half as wide, but operate at much higher speeds—more than 2,000 feet per minute. A modern publication gravure

press printing full-color images on a 110-inch wide roll of paper at a speed of 2,500 feet per minute is an awesome sight to behold. It seems that the rotation of the earth must surely be affected by such a massive amount of steel spinning so rapidly. The noise level inside a gravure plant when several of these presses are running simultaneously is unbearable without proper ear protection.

The gravure ink transfer mechanism is very simple and direct. The gravure cylinder is engraved with a tiny pattern of cells. The cells vary in both depth and width. The deepest cells produce shadow tones and the shallowest cells produce highlights. The cell frequency on a typical gravure cylinder is in the range of 150 to 220 cells per inch, depending on the application.

The cylinder rotates partially submerged in a pan of fluid ink. The entire surface of the cylinder is bathed in the ink. The ink is then scraped from the nonimage areas by a finely honed steel *doctor blade* pressed firmly against the surface. The scraping action removes all of the ink from the nonimage surface, leaving ink in the engraved cells. This ink is then immediately transferred to the web under tremendous pressure exerted by a rubber-coated steel impression roller. The transferred ink is immediately dried after each impression. Gravure inks have a high solvent content that must be completely removed in the drying process. In the majority of applica-

Electromechanical gravure cylinder engraving

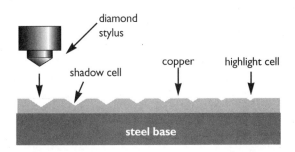

tions, organic solvents are used. However, water-based inks are employed in some applications and UV curing polymers are employed in others.

The image quality attainable with the gravure process is excellent, rivaling other photographic-quality processes such as offset lithography and dye diffusion printing. The editorial pages of *National Geographic* magazine, considered to be a prime benchmark of high-quality printing, are printed by gravure.

Computer-controlled gravure cylinder engraving

Of all the analog processes discussed in this chapter, gravure has the highest prepress costs. Most cylinders are imaged by computer-controlled electromechanical engraving machines. The cylinder engraving machines, made by the German company, Linotype-Hell, and the American company, Ohio Engraving, are massive pieces of equipment requiring equally massive capital investments. In the most advanced systems, the engraving process is fully automated, with imposed data streaming directly from digital prepress system to engraving machine. In fact, computer-to-plate imaging was common in the gravure industry long before the term was used in the context of other processes.

Gravure cylinder engraving is accomplished with a tiny diamond stylus that oscillates in and out to engrave a pattern of cells into the rotating cylinder. The cylinder has a steel core, with a thin layer of copper plated on top into which the cells are engraved. The stylus moves laterally across the cylinder as it turns, like a lathe bit, leaving a helical trail of cells behind. By using as many as eight engraving heads in parallel, a typical publication-sized gravure cylinder can be completely imaged in less than 10 minutes.

Once the cylinder has been engraved, it is plated with a thin layer of chromium to impart hardness. The cylinder can then produce millions of impressions before the surface begins to wear excessively. The high cost of cylinder preparation, and the durability of the cylinder, make gravure an appropriate technology for print run lengths in the millions. For the same reasons, gravure is not able

Screen printing process

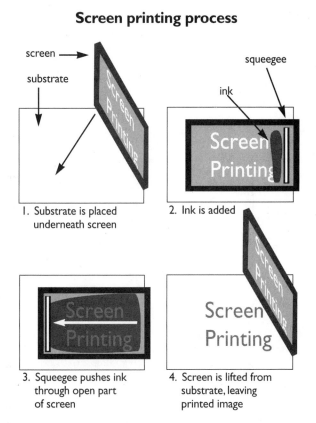

screen

substrate

1. Substrate is placed underneath screen

squeegee

ink

2. Ink is added

3. Squeegee pushes ink through open part of screen

4. Screen is lifted from substrate, leaving printed image

to compete in short-run markets. There have been several attempts over the past few decades to develop new cylinder-engraving technology to reduce costs and enable gravure to compete more effectively with web offset lithography for shorter runs. These have included laser-engraved plastic cylinder sleeves and photographically imaged photopolymer cylinder coatings. Thus far, none of these technologies has become viable.

Still, gravure remains the preferred process for production of printed products when the number of impressions is in the millions. This includes mass-circulation

publications such as *Reader's Digest, Cosmopolitan, TV Guide,* and the *National Enquirer,* as well as packaging for mass-market consumer products and specialty materials such as floor coverings and decorative panels.

Screen printing
Screen printing employs tightly stretched fabric screens through which thick, high-viscosity ink can be pushed by the action of a rubber squeegee. A stencil applied to the screen blocks the passage of ink in the nonimage areas. The screen is held firmly against a smooth surface and the ink is pushed through the open image areas. Because the screen can be wrapped partially around three-dimensional objects, screen printing has widespread application for imprinting graphics directly onto manufactured products. All other processes, such as lithography, flexography, and gravure, are restricted to printing on flat sheets. The wide variety of potential substrates (from paper to plastics to metals and everything in between) demands a sophisticated approach to ink formulation and ink-substrate compatibility testing.

Screen printing is employed in a number of specialized manufacturing applications. It can be used to apply conductive circuit patterns to the components in touch control panels, or to add decorative elements to manufactured goods. It can even be used to control the flow of an adhesive to specific areas of a surface to be glued.

One application of screen printing that is now threatened by digital printing processes is large-format signage. For many years, screen printing had been the staple for producing signs, from simple single-color posters to full-color banners printed on plastic or fabric substrates. The rapid development of wide-format electrographic and ink jet printers has displaced screen printing in many of these markets. Firms that previously specialized in screen-printed signs are now investing in digital devices that eliminate the need for expensive prepress equipment and materials, and dramatically reduce the turnaround.

Chapter 5

DIGITAL PRINTING PROCESSES

All of the analog printing processes described in Chapter 4 use a physical image carrier or plate to transfer ink to paper. Some lithographic image carriers and most gravure image carriers are now imaged digitally in computer-to-plate (CTP) systems. The trend is clearly in the direction of computer imaging of all plates, with the consequent elimination of intermediate processing steps involving reflection copy or film. Even relief plates, which are currently imaged by exposure to massive amounts of ultraviolet radiation through film negatives, will eventually be imaged in CTP systems.

Once the plate is made, however, the image reproduction process is a purely analog affair. Ink is transported from reservoir to plate, and then from plate to substrate, by mechanical means. Modern printing presses may incorporate a number of digital subsystems to monitor and control color register, paper tension, ink density, and other important variables. However, the image information that the press transfers to the substrate does not have to exist in digital form. Analog printing presses often employ computers to help them do their job more efficiently, but they do not need computers to tell them *what* to print.

Thus, we do not consider modern lithographic or gravure processes *digital,* even though the images they reproduce almost certainly were in digital form at some point earlier in the process. But what about processes that use physical printing plates that are imaged by computer-controlled systems right on press? Should we call these devices digital presses?

One way to resolve this issue is to refer to any printing device that inputs a digital data stream and outputs printed pages as a *digital printer*, and then further distinguish between printers that first build a physical master from which multiple copies are printed and those that do not. The primary advantage of a physical master is

that once it exists, there is no further need to retain the digital master or to repeat the processing required to write the image. The primary advantage of masterless digital processes such as *ink jet printing* or *electrophotography* is that no cost is incurred in the creation of a physical master. This enables digital processes to be used for extremely short runs and for the printed image to be varied from impression to impression.

With the integration of computer-to-plate (CTP) systems on the front end, large multicolor printing presses can be viewed as digital printing devices that convert an

This gray box can be viewed as a digital printer that inputs a data stream and outputs printed pages.

input data stream into a set of physical masters, which are then used to reproduce the images.

Later in this chapter we will learn about printing presses that use physical masters made on built-in digital platemaking systems. But first we will survey the range of printing technologies employing digital masters. Digital printers on the market today fall into four broad categories based on the underlying image-rendering mechanism employed: silver halide, thermal, ink jet, and electrostatic. Within each category are a number of variations on the basic theme. The following section surveys the field and makes important distinctions among the various technologies available.

SILVER HALIDE PROCESSES

Silver halide imaging has been around for more than 150 years. The first commercial photographic process, revealed to the world by the French inventor, Daguerre, in 1839, employed a thin layer of light-sensitive silver iodide coated on a polished silver plate to capture a latent image projected upon the plate surface through a camera lens. In this process the latent image is rendered visible and somewhat permanent by exposure to mercury vapor. The mercury amalgamates with the exposed silver to form the highlight areas of the image. The thin mercury layer scatters the light falling on it more than the mirror-smooth silver in the shadow areas. When illuminated at the correct angle, the highlights and shadows are correctly rendered and the image springs to life. (It is perhaps ironic to note that this earliest photographic process has never been exceeded in its ability to record fine detail. Inspection of a daguerrotype plate under high magnification reveals an amazing amount of information in the image that is completely invisible when viewed with the naked eye.)

Since Daguerre's time there have been many advances in the science and technology of photographic imaging, but silver halide materials still dominate. The simple reason for this is that no other materials have been discovered that are capable of recording images as efficiently as silver halides. (Electronic cameras employing charge-coupled devices rival the efficiency of silver halides, but produce analog or digital images that must be processed by complex machines before they can be viewed.)

Photographic paper has long served as a print medium enabling multiple copies of images to be produced from a single original. Automated photo printing systems can produce thousands of duplicate prints in an hour.

Because photographic film and paper are light-sensitive, images can also be written onto them line by line with a scanning beam of light. This is the basic idea behind all conventional imagesetters, film plotters, and a few machines classified as digital color printers.

Digital printers using silver-halide media

Two types of devices employing silver halide substrates are worthy of mention. Both produce photographic quality images that must be wet-processed before they can be used. One is a direct process and one involves a chemical transfer of the image from a donor to a receiver.

The direct process is employed in a wide range of film recorders on the market. At the high end of this market are devices manufactured by LVT, Inc. The process is fairly simple. Photographic film or paper wrapped around a spinning drum is imaged directly by exposing it to narrow beams of light through tiny electronic light valves that modulate the intensity of the light. The net effect is to build a latent continuous-tone photographic image on the substrate line by line. The latent image is then developed and fixed in the normal manner of silver halide-based photographic materials. The LVT system can be used to image color transparency film or paper at resolutions ranging from 150 to more than 3,000 dpi. The resulting prints are nearly indistinguishable from transparencies or prints produced in a camera or enlarger.

The indirect method is employed in color printers manufactured by Fugix. These devices digitally expose a silver halide-based donor material that contains a layer of developer beneath the silver halide layers. The exposed donor is then moistened with water and pressed into contact with a receiver. The color image is rapidly transferred to a receiver sheet where it is fixed. The donor and receiver are then peeled apart, and the donor is discarded. The process is reminiscent of the original Polaroid transfer photographic process. The resulting image is of photographic quality. However, because these processes employ complex substrates, the material costs are much higher than other digital processes that are compatible with inexpensive, plain-paper substrates.

THERMAL PRINTING PROCESSES

Thermal transfer printing, in the form of hot stamping, has been used for many years to apply decorative binary

images to a variety of products. The process is a simple extension of relief printing, where, instead of transferring a layer of ink, the relief surface is used to transfer a colored layer of wax or thermoplastic material from a ribbon to a substrate. The stamp is heated to a temperature high enough to melt the colorant layer and cause it to transfer to the substrate when pressure is applied. This process is still used extensively to apply decorative images to a variety of substrates; the foil stamping on a fancy book cover is the most common example. One important feature of hot metal stamping is the variety of substrates with which it can be used. Practically anything that is flat and slightly compressible is compatible with the process.

Hot stamping is similar to all other analog printing processes because the image is fixed. As such, the process is well suited for producing multiple copies of the same image. But imagine that you could change the image on the metal stamp for each successive impression. Then you would have something similar to a digital thermal printing process. The key to all of these processes is a mechanism called a *thermal array*.

Mechanics of digital thermal printing

A thermal array is a device comprising a row of tiny heating elements that are individually controllable by a computer. When the array is pressed into contact with a heat-sensitive material, which is transported slowly past the array, an image can be formed by controlled firing of the heating elements. The resolution of a thermal imaging system is fixed along the axis of the array, but variable perpendicular to it because the speed of media transport can be adjusted while the rate at which the thermal elements are fired remains constant.

Most thermal printing processes have the same addressability in both horizontal and vertical dimensions, although improved resolution can be obtained by increasing the vertical (perpendicular to the array) addressability. The maximum addressability of current thermal arrays hovers around 300 dpi, which is extremely low for binary printing and quite high for contone printing. Consequently, binary thermal processes produce crude

low-resolution prints and contone thermal processes produce photographic-quality prints.

Direct thermal printing

Direct thermal printing easily qualifies as the simplest of the digital printing mechanisms in current use. The process uses a special paper that is coated with a dye-based material that turns black when heated. The imaging mechanism employs an array of thermal elements that can be switched on and off independently as the thermal paper moves past to form binary images at resolutions up to about 300 dpi. Direct thermal printing is most commonly employed today in low-end fax machines and some label/barcode printers for industrial and commercial use. Because the process relies on a thermally-induced chemical change in the substrate, most direct thermal processes are limited to monochrome printing. However, there are thermal substrates with two separate thermal chemistries for producing two-color prints (usually black and red) in a special printer capable of imaging them. Thermal papers capable of full-color image rendering have been demonstrated in the laboratory, but none have yet appeared on the market.

The expensive coated paper, poor ergonomics, and relatively low resolution of direct thermal printing have prevented it from making significant inroads into general office or commercial markets. For applications where the quality of the substrate and print is a secondary issue, and simplicity of the printer hardware is primary, direct thermal printing is likely to remain in use for some years to come. This will be largely in the form of embedded systems for printing receipts, labels, barcodes, and related applications. The fax market is moving away from thermal printing to ink jet and laser printing, where the advantages of plain paper are overwhelming.

Direct thermal imaging of graphic arts films

The direct thermal mechanism is also employed as an imaging method for low-resolution dry process graphic arts films. The first commercial dry thermal film product was introduced a few years ago by CalComp. The materi-

al, called *Ecofilm,* can be imaged in a large direct thermal array printer. Another dry thermal film system, called *PressMate,* is manufactured by Lasermaster. Both Ecofilm and the Pressmate system yield films that are suitable for offset duplicator-quality printing.

Thermal transfer processes

Direct thermal printing requires the use of a special substrate that changes color when exposed to heat. Another approach is to use a thermal array to transfer colorant from a ribbon to a substrate. It is convenient to think of thermal transfer processes as digital versions of iron-on techniques used to transfer images from a donor sheet to a receiver. The donor is in the form of a continuous ribbon with a layer of transferable colorant coated on one side. By applying heat to the back of the ribbon while pressing it firmly against the receiver, the colorant can be made to transfer from the donor to the receiver. Thermal transfer processes range from low-resolution single-color processes used for demand label printing to high-resolution color

Thermal transfer processes

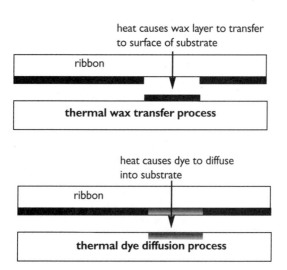

heat causes wax layer to transfer to surface of substrate

ribbon

thermal wax transfer process

heat causes dye to diffuse into substrate

ribbon

thermal dye diffusion process

processes capable of producing photographic-quality reproductions.

Thermal transfer printing processes form an image on the receiver by transferring a two-dimensional pattern of tiny image elements. The simplest and most common use of thermal printing is for the demand printing of bar-coded labels. Nearly all of the single-color thermal printing devices currently in use are for highly specialized applications involving relatively small output formats.

For output sizes of 8.5 by 11 inches and larger, thermal array printers exist that are capable of full-color rendering employing either three (CMY) or four (CMYK) primary colorants. Some printers are capable of transferring a single thickness of colorant from the ribbon at any one point in the image, forming a binary imge. These are generally referred to as thermal wax transfer printers. Printers capable of transferring varying concentrations of colorants from point to point in the image are called dye sublimation or dye diffusion printers. A few printers currently available, such as those made by Fargo, work in both binary wax transfer and variable dye sublimation modes, depending on the type of ribbon installed.

This brings us to two general weaknesses of thermal transfer processes. First, because the hard surface of the thermal array must press the ribbon into intimate contact with the receiver, the receiver must have a smooth, uniform surface. This precludes the use of plain paper. Second, the use of heat to transfer the colorant from the ribbon to the substrate imposes speed limitations on the processes. Thermal printing processes are slow and not likely to get much faster in the future, physics being what it is.

Thermal wax transfer printing

The simplest thermal printing process employs a binary printing mechanism to transfer a layer of wax-based colorant from a thin polycarbonate ribbon to a special substrate. The resolution of current thermal arrays is approximately 300 dpi, but the highest resolution printers are capable of switching the heating elements at a higher frequency to achieve approximately 600 dpi reso-

Thermal wax transfer process

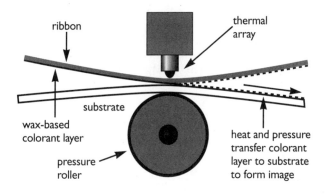

ribbon

thermal array

wax-based colorant layer

substrate

pressure roller

heat and pressure transfer colorant layer to substrate to form image

lution in the dimension perpendicular to the array.

Thermal wax transfer printers are the simplest of the thermal array devices, requiring simpler hardware to control the firing of the thermal elements. Most current printers employ arrays with approximately 300 elements per linear inch. An array capable of imaging an 8 inch wide band contains approximately 2,400 elements.

The thermal wax transfer ribbon has a relatively simple structure. The base of the ribbon is a thin layer of polycarbonate and the transfer layer is a coating of wax-based colorant. This colorant has a relatively low melting point. When heat and pressure are applied, the colorant layer releases from the ribbon and transfers to the receiver. The transfer is complete, leaving little residual colorant on the ribbon.

Variable-dot thermal transfer

A modification of the thermal transfer process has been developed by Fujicopian that yields remarkably better image quality from the same basic mechanism. By controlling the amount of heat applied to the elements in the array over a range from low to high, the amount of colorant transferred at each point in the image can be var-

ied. Thermal wax transfer printers using the Fujicopian mechanism are capable of varying the density of each pixel to produce up to 16 shades of gray from shadow to highlight. These printers, manufactured by NEC and Casio, have more complex control hardware than simple binary thermal wax transfer devices because the heat applied to transfer each pixel must be variable over a range of 16 values. The resulting image quality is dramatically finer, however.

Thermal dye diffusion process

The thermal dye diffusion (often called *dye sublimation* or *dye sub*) print mechanism looks on the surface almost identical to wax transfer printing, except that this process is a continuous-tone process rather than binary. A number of devices on the market, made by Kodak, 3M, Tektronix, and others, employ this print mechanism. All of the current commercial devices have similar resolutions of around 300 dpi. Because these printers are capable of varying the density of the colorant at each point, though, the tonal resolution of the system is much greater than that of wax transfer printing. Dye diffusion printers are capable of producing extremely high-quality

Thermal dye diffusion process

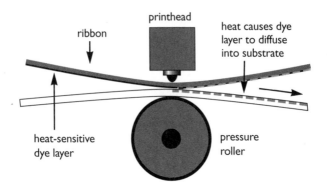

printhead

ribbon

heat causes dye layer to diffuse into substrate

heat-sensitive dye layer

pressure roller

output approaching that of photographic prints.

The least expensive dye diffusion printers employ ribbons with the three primary colors of cyan, magenta, and yellow. The dyes are formulated in such a way that the overprint of all three primaries produces an acceptable black. Dye diffusion printers intended for use as proofing devices for graphic arts applications add a black ribbon panel to produce a true black using a single layer instead of overprinting the three primaries. The addition of the black ribbon makes it possible for the printer to achieve a color gamut that completely encloses the gamut of most color printing processes. The black ribbon can also be used to render all of the black line art on a page, including type.

Current dye diffusion printers are capable of varying the density of each printed dot over a continuous range from dark to light. The nominal tonal resolution of these printers is 256 gray levels per color per dot. Thus, color images intended for rendering on a dye sub printer should possess a tonal resolution of eight bits per pixel per color channel.

Although dye diffusion printers appear on the surface to be nearly identical to wax transfer printers, and have output resolutions in the same general range (300 dpi being the standard), the fact that the dye diffusion printer can render 8 bits of data per dot produces extremely high-resolution prints. The dye diffusion printer can pack approximately 256 times more image information into a unit area of print. This yields photographic-quality images.

Both thermal wax transfer printing and dye diffusion printing are extremely slow, requiring several minutes to produce a single color print. The cost of the substrate and ribbon for a single page-sized print has decreased considerably over the past few years, but still averages around $2.00. Tabloid-size output material costs may be as much as $7.00 per sheet. This normally restricts the use of thermal transfer printing processes to applications where a small number of prints (one to five) is needed.

Laser thermal transfer process

A scanning laser beam can also be used to cause the transfer of colorant from ribbon to receiver. This process is used in high-end digital color proofing systems made by Kodak, Optronics, and Polaroid. Whereas thermal array processes image an entire row of pixels simultaneously, as the ribbon and receiver are pressed against the array, laser thermal transfer processes transfer the colorant point by point in a scanning configuration.

The ribbon and receiver are held in intimate contact, and either wrapped around the outside or inside of a cylindrical drum. In external-drum configurations (as in the Kodak Approval color proofers), the laser moves laterally as the drum spins past it to image the receiver in a helical pattern. In internal-drum configurations, the laser is deflected against the inside of the drum in a helical pattern. In either case, the laser heats up the colorant layer and causes it to transfer.

The transfer mechanism is termed *sublimation* when it involves dyes, and *ablation* when pigments are

Laser thermal transfer

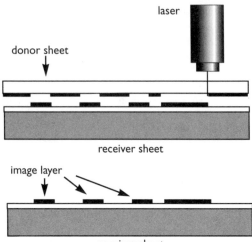

involved. In either case, the laser causes the colorant layer to vaporize and transfer across a minute air gap to attach to the surface of the receiver. In some processes the image is transferred again to a secondary surface.

Whereas thermal arrays currently have a maximum addressability of 300 dpi across the array, laser thermal systems can achieve addressabilities approaching 3,000 dpi. However, laser thermal transfer systems are binary processes and are only capable of printing halftone images.

INK JET PROCESSES

Ink jet processes produce density on a substrate by controlled deposition of tiny droplets of ink to form an image. There are two broad categories of ink jet printing: continuous and drop-on-demand.

Continuous ink jet printing

The physical principle at the foundation of continuous ink jet printing has been known for nearly a hundred years. A thin stream of liquid ejected from a container through a tiny orifice can be broken up into a steady stream of uniform droplets if subjected to vibration at a high frequency. The source of vibration in modern continuous ink jet printheads are piezoelectric crystals that produce hundreds of thousands of individual droplets each second. If the flight of the ejected droplets can somehow be controlled, images can be formed by steering the droplet stream to specific locations on a surface.

The earliest examples of continuous ink jet printing used a single nozzle to eject droplets, which were then magnetically deflected to write crude dot matrix images on a moving surface. (The picture that comes to mind is from an old cartoon where a tommy-gun-toting gangster writes a threatening message with bullet holes on the side of a passing police car.) Single-nozzle ink jet printheads can be used to mark on a variety of substrates, porous and nonporous, flat and three-dimensional. This form of printing is used primarily for high-speed industri-

Continuous ink jet printhead

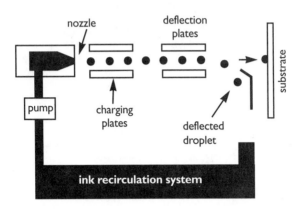

al marking. If you pick up any consumer product such as a bottle of soda or a loaf of bread, you are certain to find examples of ink jet printing of this type.

There are limitations to the complexity or size of printed images that can be produced using a single-nozzle ink jet device. Simple low-resolution text is easy enough. However, printing large, complex images is out of the question.

Continuous-array ink jet

What if you had a number of nozzles lined up in a row, each ejecting a continuous stream of droplets, and each droplet could be controlled independently of the others? Then you would have a *continuous-array ink jet print-head*. The leading manufacturer of continuous-array ink jet printing systems, Scitex Digital Printing, describes one such mechanism as a "two piece electronic shower-head" with a single row of orifices (240 per inch) etched into a metal plate and an electronic charging mechanism to control the fluid curtain of jets. As the jets emerge from the orifices, the continuous streams of liquid are broken into a train of individual droplets by a piezoelectric resonator operating at a frequency in the range of 50,000 to 100,000 hertz. The frequency of the resonator determines

the exact rate of droplet formation. (At 100,000 hertz, each orifice produces 100,000 droplets per second.) The droplets are uniform in size and spacing. The jets pass in front of an array of tiny charging electrodes. This array contains one electrode for each jet. When voltage is applied to a charging electrode, the corresponding jet is charged and then deflected into a *catcher*. The deflected droplets are recirculated into the ink reservoir. Undeflected droplets fly onto the moving substrate to form the image.

The largest current arrays are approximately 4.25 inches in length, with 240 nozzles per inch for a total of more than 1,000 nozzles. For applications where greater print width is needed, the output from two parallel print-heads can be stitched together to cover nearly the entire width of a standard 8.5 by 11 inch sheet. The rate of droplet ejection in these systems is extremely high, allow-

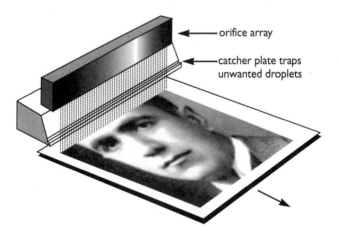

As the substrate moves beneath a continuous-array ink jet print-head, individual droplets are either allowed to travel to the substrate or deflected into a catcher, where they are recirculated. The droplet generation rate of the widest arrays can be as high as 100 million droplets per second. This allows the substrate to move at speeds approaching 500 feet per minute at the highest print resolutions currently available.

ing the process to operate at speeds in excess of 500 feet per minute. Thus, high-speed continuous-array ink jet printheads can be fitted to a wide variety of sheetfed or web printing presses, collators, mail bases, folders, and other inline and offline equipment.

Current continuous-array ink jet printers are capable of printing at a resolution of 240 binary dots per inch. The quality of the output is therefore slightly lower than the lowest resolution laser printers on the market. Image quality is also compromised somewhat because the ink tends to splatter against the paper. The need for the ink return path plumbing and high-pressure pumps limits the closeness of the spacing of parallel orifices. It is therefore unlikely that future systems will go much beyond 300 dpi spatial resolution. However, it has been demonstrated that a variable number of individual droplets emerging from a single orifice can be directed to a single location on the substrate, allowing for modulation of the dot size and a dramatic increase in the quality of printed images.

Applications of continuous-array ink jet printing

Continuous ink jet processes have been used successfully for adding variable fields of textual and simple graphical data to moving webs or sheets that have already passed through a conventional lithographic or gravure printing press. The simplest form of continuous ink jet printing is used to print mailing labels directly onto magazines and catalogs. Continuous ink jet printing uses low-viscosity inks that have specific dielectric properties compatible with the imaging system. This severely restricts the variety of materials that can be used. Resin-based binders and pigment-based colorants are not compatible with these systems.

Scitex Digital Printing builds web fed digital presses based on the linear array continuous ink jet engines that the company developed. SDP has taken its core technology, which has been used for low-resolution single-color printing targeted at direct mail and labeling applications, and extended it into the realm of color printing. Current technology is capable of full-color printing at a resolution

of 240 dpi with 8 gray levels per dot. Scitex's vision is to create high-speed, high-resolution, wide-format continuous-array color ink jet presses for a variety of applications where variable imaging is required.

Continuous area-modulated ink jet

One variation of continuous ink jet printing is the *area-modulated* process used by Iris ink jet printers, also made by Scitex. These are able to direct varying clusters of droplets at each point in the image to produce a continuous-tone effect that appears much like gravure printing. The Iris printers apply ink to a substrate wrapped around the surface of a rotating drum. By comparison to continuous-array ink jet processes, Iris printers are very slow. The time required to produce one image is several minutes. The resolution is 300 dpi with 32 gray levels per dot. Iris printers produce photographic-quality color images in sizes up to 30 by 40 inches. The inks are dye-based and are often laminated with a UV protective layer to prevent them from fading.

Drop-on-demand ink jet processes

Liquid drop-on-demand ink jet printing is a process whereby ink droplets are expelled from tiny orifices and directed immediately to the substrate, but only where needed to form the image. Several different mechanisms exist. The most common form uses heat to vaporize a small amount of water-based ink in a chamber to form a gas bubble. This, in turn, causes a droplet of ink to be expelled from an opening in the chamber. The chamber must then be refilled before the next droplet can be expelled. This severely limits the maximum speed of the process. Another variation on this theme uses a piezoelectric plate that can be slightly deformed by passing a current through it, thereby reducing the volume of an ink reservoir and causing the ejection of a single droplet of ink. This ink-ejection mechanism can be used in conjunction with melted wax-based inks that are ejected from the printhead onto the substrate, where they freeze. These devices are called *melted wax* or *phase change ink jet printers*. The piezoelectric mechanism can also be used

Piezoelectric ink jet process

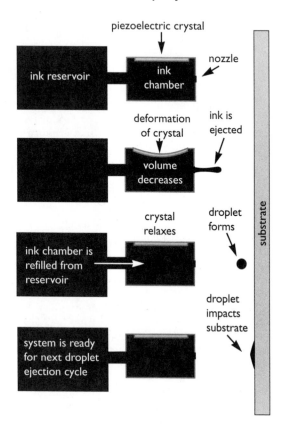

with low-viscosity solvent-based inks that dry after landing on the substrate.

Drop-on-demand processes are capable of slightly higher spatial resolutions than continuous-array ink jet printing, but they are much slower. One of the simplest commercial implementations of drop-on-demand technology is in office ink jet printers, in which the entire printhead and ink reservoir is disposed of when the ink supply is depleted. Variations on this theme have been used to construct larger format printers for poster-sized full-color

Ink jet printer variables

Substrate type is a critical variable for piezoelectric and thermal drop-on-demand ink jet printers using water-based inks. The rendering algorithms must be tuned to the specific paper type. This Epson printer requires different special papers for rendering at different output dpi settings. Phase-change ink jet printers are not as dependent on the substrate because the wax-based ink freezes on the substrate surface rather than penetrating the fibers.

output. The resulting image quality is acceptable for color printing applications where the printed output is viewed from a distance of several feet or more.

Most drop-on-demand printheads have multiple orifices arranged in an array to increase the throughput of the system. Thermal drop-on-demand ink jet printheads can incorporate many multiple orifices because the thermal ejection mechanism is very compact and many can be packed into a small area. Piezoelectric ink jet printheads are more complex and do not allow for as much parallelism. Thermal engines therefore have a slight edge in speed. Compared to continuous-array ink jet processes, however, all drop-on-demand processes are slow.

Phase-change ink jet printers
Phase-change ink jet printers (sometimes called *solid ink jet printers*) employ wax-based pigmented inks that are kept in a molten state within a reservoir. These printers are sometimes called "wax crayon" printers because the

Thermal ink jet process

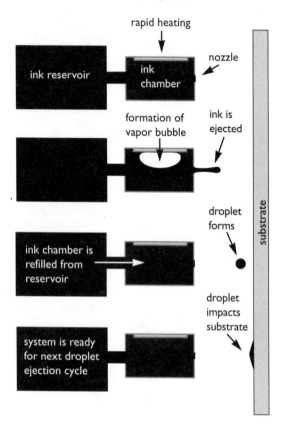

inks start out as solid wax pellets that make very effective writing implements in their own right.

The molten ink is ejected from the printhead when a signal is fed to a piezoelectric element, causing the volume of the ink chamber to be reduced slightly. Some printheads eject droplets when a background current applied to the piezoelectric element is turned off suddenly. Other printheads are designed to eject droplets when current is applied and to replenish the ink chamber when the current is switched off. Either way, the ejection of

droplets can be controlled precisely to form a binary image on the substrate.

All current phase-change ink jet printers are four-color devices. Manufacturers include Tektronix, Brother, Dataproducts, and Polaroid. The highest resolution printers currently available are capable of 600 dpi binary addressability. Because the wax-based ink freezes on contact with the substrate, there is practically no opportunity for the ink to penetrate below the surface. Consequently, most of the pigment is held out on the surface. This produces extremely sharp, saturated images on a wide variety of substrates. In fact, this process is compatible with the widest range of substrates of any digital printing process.

Unlike other ink jet processes, the wax-based ink does not contain any solvent. The full volume of material ejected from the nozzle freezes on the surface of the substrate, producing a relatively thick image layer. The layer is actually so thick that you can easily feel the dot structure if you run your fingers over it. The surface is easily scuffed and does not hold up well to rough handling. On the positive side, the colorants are pigmented and therefore extremely lightfast. This makes them ideal for applications where they will be displayed in brightly lit environments over long periods, but will not be handled, or where they will be used for proofing purposes.

The phase-change ink jet printing mechanism ejects single droplets of ink through an orifice by rapidly constricting the volume of a tiny ink chamber. Once a droplet has been ejected, the chamber must be refilled before another droplet can follow. This places limits on the rate of droplet generation similar to other drop-on-demand ink jet processes.

Thermal ink jet printers

Thermal drop-on-demand ink jet printing is the de facto standard for low-cost desktop color printing. Color printers capable of near-photographic-quality printing are now available for less than $400. These printers incorporate disposable printheads that integrate the ink supply into the head. Only one of the major manufacturers, Epson,

employs alternative piezoelectric technology in its desk-top ink jet printers. All the other desktop ink jet printers on the market are thermal devices. Major manufacturers include Hewlett Packard and Canon.

Thermal drop-on-demand ink jet inks are complex water-based solutions that combine a number of characteristics that are critical to their performance. They must have an extremely low viscosity and surface tension so that they can be easily ejected from a tiny orifice. They must also be formulated to vaporize quickly when raised to their boiling point.

The basic mechanism is very simple in concept. A tiny chamber with a heating plate on one side and an orifice on the other side is filled with ink. The heating plate is then rapidly heated to a temperature well above the boiling point of the ink. The ink in direct contact with the plate vaporizes and forms a bubble, which displaces enough of the volume of the chamber to eject a droplet from the orifice. Once the droplet has been ejected, the heating plate cools and the chamber is refilled from the ink reservoir by capillary action. The cooling and refilling are accomplished in a tiny fraction of a second, but the rate of droplet generation cannot exceed the physical capabilities of the system to dissipate heat and refill the ink chambers.

In all current devices, full-page printing is accomplished by moving the printhead back and forth on a rail while scrolling the paper incrementally after each pass of the head. The simplicity of design and relatively few moving parts result in extremely high reliability and almost no need for maintenance other than a dusting now and then. The first generation of printers were prone to orifice clogging, but these problems have been solved with newer ink formulations and self-cleaning routines that keep the orifices clear.

Current printers have an addressability of 300 dpi at the low end and 600 dpi at the high end. In a typical thermal ink jet printhead, a number of orifices are arranged in one or more arrays. The number of orifices, combined with the droplet generation rate and resolution, determine the speed of the system. Current systems have any-

Electron-beam printing

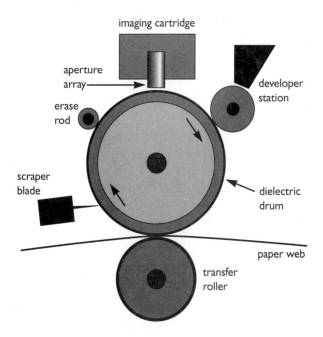

where from 50 to 100 orifices capable of printing up to a quarter-inch wide swath each pass.

ELECTROSTATIC PROCESSES

Electrostatic processes involve the selective charging of a dielectric surface by exposure to an electron beam or discharging of a photoconductive surface by exposure to light. In either case, the exposure produces a latent image on the surface that will either attract or repel charged toner particles. The toner can be transported to the surface by dry carrier beads or suspended in a liquid vehicle.

Electron-beam printing

Electron-beam printing is accomplished by directing an array of electron beams at a spinning drum with a dielectric surface that is capable of temporarily holding a negative charge. The electron beams are switched on and off to write a latent image on the dielectric surface as it spins. During the development step, this latent image attracts charged toner particles, which are then transferred to paper under high pressure. The marking resolution of this process is very low (240 and 300 dpi in commercial devices) and the toner transfer process tends to calender the paper surface, imparting an undesirable sheen that most people find objectionable.

The latest generation of electron-beam printers, made by Delphax, use heat rather than pressure to fuse the toner, thereby eliminating the calendering effect of pressure fusing. The resolution of the process remains low, but the speed can be extremely fast. Delphax manufactures electrographic printers with maximum speeds ranging from 75 to 850 pages per minute in a price range from $75,000 at the low end to approximately $1.2 million at the high end. Although Delphax holds the patents to the process, it has licensed the technology to Olympus Image Systems. Olympus makes less expensive, smaller, and

Electrophotographic process

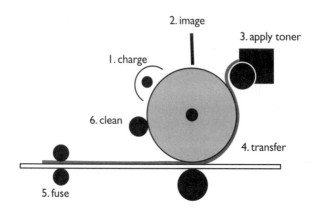

slower electron-beam printers with speeds ranging from 24 to 45 pages per minute and prices ranging from $6,000 to $25,000.

Current electron-beam printers are all monochrome devices, but Delphax is developing new devices with color capabilities which it claims will come to market in the 1997–1998 time frame. The primary markets for electron-beam printing will most likely be those where high speed is more important than image quality.

Electrographic printing

Electrographic printers employ digitally controlled print-heads that apply static charges directly to coated dielectric paper. The special paper retains the charge and the image develops as the paper passes through liquid toner. The liquid toner is solvent-based. These printers are sometimes called *electrostatic printers* or *electrostatic plotters*. Wide-format color electrographic printers are currently manufactured by Raster Graphics, Xerox, and Océ-Bruning. They produce relatively low-resolution color prints in widths up to about 53 inches. The color quality and lightfastness of these prints is excellent, making them ideal for outdoor signs intended to be viewed from a distance. The chief competition to electrographic printing in the large-format market are drop-on-demand ink jet devices that are far less expensive and yield higher resolution images.

Electrophotographic printing

One type of electrophotographic printing employs a charged photoconductive surface that is selectively discharged by a scanning laser light beam modulated by a computer or by controlled switching of a matrix of light-emitting diodes (LEDs). The generic term *laser printer* is sometimes used to describe either mechanism. Once the surface has been selectively discharged, oppositely charged colorant or toner is brought into contact with the surface and is attracted to the areas retaining the charge. Areas discharged by exposure do not attract the toner. The toner layer can then be fixed on the surface or transferred to a secondary surface and fixed. This type of

printer is called a *write white* system because the nonimage areas are written by the exposure source.

In some systems, the toner carries the same charge as the charged photoconductor and is attracted only to those areas that are discharged by exposure to light. This type of system is called a *write black*, because the image areas are written by the exposure source.

In liquid toner electrophotography, the toner is suspended in an insulating liquid. The imaged photoconductive surface is flooded with the liquid toner suspension. Charged particles of toner are attracted to the oppositely charged image areas on the photoconductor. The toner is then transferred to a secondary surface or fused directly onto the photoconductive surface. In dry toner electrophotography, the toner is applied in powdered form to the charged photoconductive surface. The resolution of both liquid and dry toner systems has improved dramatically over the past several years because of advances in toner manufacture.

The first generation of laser printers was capable of marking the substrate at 300 binary dots per inch. At this addressability, type and line art appear slightly ragged, and reproduction of continuous-tone images is problematic. To produce a smooth halftone scale from highlight to shadow, the halftone screen must be extremely coarse (i.e., the halftone dots must be very large). The current "standard" addressability is 600 dpi, which is capable of rendering type and line artwork with sufficient resolution to satisfy most graphics applications. At 600 dpi, halftone rendering of contone images is still problematic. If the halftone screen ruling is higher than about 85 lines per inch, grayscale rendering becomes difficult. At a typical commercial screen ruling of 150 lines per inch, a 600 dpi printer is only able to produce approximately 16 discrete halftone values from shadow to highlight—not enough for smooth grayscale rendering.

The highest resolution printers now available are capable of marking the substrate at 1,200 dpi. These printers, with engines made by Canon and Lexmark, are capable of rendering type and line art with resolution approaching that of commercial lithographic printing.

Color electrophotographic printers

The electrophotographic printing mechanism is complex when compared with simpler processes like ink jet and thermal printing. Accomplishing full-color printing means multiplying the complexity of a monochrome system by at least a factor of four. Manufacturers of low-end printers include Apple, Hewlett Packard, QMS, Tektronix, and Xerox. Image quality at this end of the spectrum is adequate for simple business graphics but not for photographic reproduction.

In the midrange, color copiers/printers such as the Canon CLC line and Xerox Majestik series offer faster throughput and higher image quality. The Canon CLC 800, for example, can print 28 single-sided 8.5 by 11 inch sheets per minute. The color image quality of these devices is near-photographic.

Digital color presses

Two digital color printing presses employing electrophotographic engines have recently been introduced to the graphic arts market. One uses dry toner electrophotography to print color images onto a web of paper, and the other uses liquid toner electrophotography to print onto sheets.

Xeikon electrophotographic press

Dry toner electrophotographic technology is used in the Xeikon color printing engine. The Agfa Chromapress and the IBM 3270 color printers are based on the same engine. (In this discussion we will refer to this press as the Xeikon, but our analysis is equally relevant to the others.)

The Xeikon engine uses fixed LED arrays to image the photoconductive drums. The intensity of the exposure from the LEDs can be changed to vary the density of the toner applied to each point in the image. The marking resolution is 600 dpi, but with the variable density capability, the resulting image quality is extremely high.

The main liability of dry toner technology is that the surface of the print has a dull appearance, lacking the gloss of the Indigo print. The matte surface of the print is

Xeikon electrophotographic press

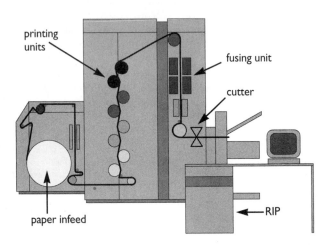

most noticeable when printed on glossy substrates. Therefore, most Xeikon printing is done on uncoated paper. A common misunderstanding about the Xeikon engine is that it is restricted to uncoated paper. In fact, the press can print on almost any kind of paper, and users have generally avoided coated papers only for aesthetic reasons. Much progress has also been made since the introduction of the machine in achieving glossy effects on a wide variety of substrates, including papers, plastics, and foil laminates. This can be accomplished by altering the fusing temperature and duration, or by coating or laminating the printed sheets.

The Xeikon device prints on a web of paper that is driven through the machine by two rollers, one before the paper is printed and one after all four colors have been applied to both sides. A most ingenious aspect of the Xeikon engine is the way the imaging cylinders turn against the paper as it moves through the press. Each of the imaging cylinders is free-wheeling, and is driven by the paper, which is attracted to the static charge on the cylinder surface. The paper is literally pulled through the press, turning the imaging cylinders as it moves past.

It has long been known that color electrophotographic processes suffer from a great deal of color variability due to changes in ambient temperature and humidity. On most color copiers, color balance can be manipulated at the console to compensate for the natural and wide variability of the process. The Xeikon press takes a more systematic approach by controlling the temperature and humidity inside the closed cabinet to stabilize the process. This works quite well. The Xeikon press delivers reasonably consistent color quality from sheet to sheet and run to run.

Indigo E-Print electrophotographic press

The liquid toner device is called the Indigo E-Print. The Indigo press employs a scanning laser to image a photoconductive surface at a resolution of 800 dpi. This process is strictly a binary process, however. It is not capable of varying the density of the dots, as is the Xeikon press. The Indigo press prints at about half the speed of the Xeikon press when measured by the number of letter-sized duplexed sheets produced per minute.

Indigo E-Print electrophotographic press

The E-Print uses a common impression cylinder to secure the paper. A single-image cylinder is charged and then imaged with a scanning laser. The first color ink is applied to this imaged cylinder and transferred to the blanket. During the next revolution of the press, the cylinder is imaged again and the next color ink is applied from the same ink application unit. A switching mechanism allows all inks to be applied by the same injection system. After all inks are applied to the image cylinder and transferred to the blanket, one after the other, the ink layers are applied to the paper completely in one revolution (leaving no residual ink on the cylinder).

This is the key technical development that allows the E-Print to change the image content of each subsequent press sheet and makes it possible to do up to six-color printing from a single image-blanket cylinder combination. The press is also capable of turning the sheet over in a work-and-tumble fashion to print the reverse side.

The E-Print takes a maximum sheet size of 11 by 17 inches, and prints at a rate of aproximately 1,000 single-sided four-color sheets per hour. This yields 2,000 letter-size, single-sided, four-color sheets when they are printed two-up on an 11 by 17 inch sheet. The Xeikon DCP-1 is about twice as productive as the Indigo E-Print when printing full-color duplexed work, being capable of producing approximately 1,000 duplexed A3 sheets (or 2,000 duplexed A4 sheets) per hour.

Conventional processes using digital masters

We always have a problem with terminology when technology runs in new directions. The term *digital printing* can be used to describe everything from desktop ink jet printers costing a few hundred dollars to digital color presses costing hundreds of thousands. The term is also used to describe the Heidelberg GTO-DI and the new Quickmaster DI presses. These devices are fundamentally different from the other digital devices, though, because they are waterless offset lithographic presses that employ digitally imaged printing plates made directly on the press. On both presses, the plates are imaged at a maximum resolution of 2,540 dpi by a high-powered

Presstek laser plate-imaging system

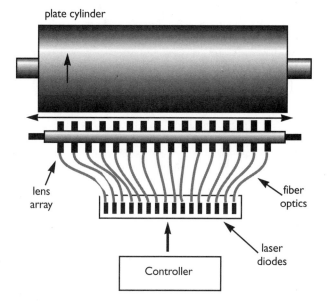

plate cylinder

lens array

fiber optics

laser diodes

Controller

laser that burns away a layer of polysilicone from the surface of the plate material.

These devices are finding a niche in the emerging short-run small-format lithographic market. There is no question that reducing the cost of makeready on a small color press opens up huge new windows of opportunity for short-run work. But what is the role of the purely digital press, such as the Xeikon or Indigo, in the face of a device such as the Quickmaster? If Heidelberg's claims that the Quickmaster can break even with the digital competition at slightly more than 100 impressions are true, what possible market niche could exist for digital printing?

Unlike the GTO-DI press, the Quickmaster press includes a workstation (DEC Alpha/Windows NT) running a Harlequin RIP. The system can be plugged into an Ethernet network, and will take work directly from Macs or PCs. Heidelberg optimized the screening on this press

to produce the best possible grayscale and color rendering. The entire system was designed from the ground up, and will print any size sheets from 3.5 by 5.5 inches minimum to 13.375 by 18.125 maximum. This sheet size is slightly smaller than that of the GTO-DI.

Heidelberg claims that the Quickmaster will start to produce good sheets after only 25 sheets. This compares to 50 sheets for the original GTO-DI, because that press did not have temperature-controlled rollers. The Quickmaster can print on any paper stock from onionskin paper to 12-point board, as well as various plastics and cloth substrates.

Whereas true digital presses, such as the Xeikons and Indigos, are appropriate for press runs up to about 500 impressions, the Quickmaster is intended to work in a range between 100 and several thousand impressions.

Keeping the presses rolling

Digital printing presses are no different from conventional analog presses in one important regard. They are making money only when they are running and good sheets are being printed. Short press runs demand faster changeovers than long runs to maintain the same percentage of uptime. At the extreme short-run end of the spectrum, the need for fast changeovers becomes critical. If an average job requires only a few minutes of press time, the time allocated to changeovers must be reduced to near zero.

The ideal front-end system for a digital press should be able to switch from one job to another, or vary the content of each impression within a job on the fly, without slowing down the press. The digital presses currently on the market can all be configured with front ends that are powerful and flexible enough to keep them running with any combination of variable input imaginable. Chapter 9 explains how these systems work.

Section Three
Rendering Digital Documents

Chapter 6

Rendering Digital Type and Line Art

Type presents a number of challenges that are easy to overlook or ignore during the early stages of production, but that return with a vengence to rob us of profit and peace of mind when the job is being printed. Since the introduction of desktop typography in the mid-1980s, many millions of dollars have been spent correcting type-related mistakes that could easily have been avoided with a little bit of foresight. There is perhaps no worse feeling than discovering a type-related error in a printed job that could have been corrected with a few clicks of the mouse button when the electronic files were being prepared.

At first glance, type appears to be so simple. Most of it is black-and-white line art. Type management software gives a good approximation on the computer monitor of how the printed results will appear. Hard-copy proofing of type can be done with an inexpensive laser printer. So what can possibly go wrong? This very attitude is guaranteed to lead you to typographic trouble. The apparent simplicity breeds complacency that leads to stupid mistakes, and often to feelings of extreme self-loathing.

There are two general categories of problems related to type:

1. *Type management problems.* These problems are related to discrete errors that are independent of the particular printing process used for output.

2. *Type rendering problems.* These problems result from poor understanding of the capabilities of a particular printing process.

Type management

The cause of nearly all type management errors is the fact that type fonts remain external to the documents in which they are employed. If a document uses a font that is not available on the computer system employed to view or print it, a *font substitution* of some kind will be made.

In some cases the substitution is easily detected, as when Courier or Times is substituted for a missing text face and the text no longer fits or flows properly within the allotted space. In other cases the substitution is less obvious, and can easily escape detection during the production process. The extremely low resolution of the computer monitor often masks problems that only become apparent when printed at higher resolution. In this example, the subtle design features of the New Century Schoolbook typeface used for the body text of this book are almost completely lost when rendered at actual size on the computer monitor.

New Century Schoolbook

Enlargement of 12-point type rendered on
a 600 dpi laser printer

New Century Schoolbook

Enlargement of 12-point type rendered on
a 72 dpi computer monitor

There are currently two methods for the representation and manipulation of type. Adobe pioneered the modern era of vector-based typography with the introduction of PostScript in the mid-1980s. *PostScript Type 1* fonts have become the de facto standard on the Macintosh platform for high-end graphics. The alternative outline font technology is called *TrueType*. The technical differences between PostScript and TrueType are subtle and inconsequential in normal use. Both technologies are available on Windows and Macintosh-based systems, though fonts for one system cannot be used on the other.

The files for this book were prepared using the QuarkXPress page layout program. The typeface used for the text (what you're reading right now) is an Adobe Type 1 font called New Century Schoolbook. This typeface consists of four separate fonts: Roman, *Italic,* **Bold** and ***Bold Italic***. All four of these fonts reside in the fonts folder in

the system folder on the hard disk of the Apple Macintosh computer used to produce this book.

The Macintosh system uses bitmapped fonts to display type on a computer monitor at certain sizes, and outline fonts for display at other sizes. There are five bitmapped versions of this typeface on the Macintosh system used to construct this book. These are used for display at 10, 12, 14, 18, and 24 point sizes. There is only one bitmapped font at each of these five discrete sizes. When a bitmapped font is used for display of italic, bold, or bold italic, the bitmaps are altered by obliquing and/or fattening to simulate the appearance of italic or bold. In this example, the obliqued roman was formed by modifying one of the roman bitmapped fonts. The true italic below it was formed by reference to the italic outline font.

Obliqued Roman

True Italic

If the roman version of a typeface exists in the fonts folder or directory, the typeface will appear in the list of available fonts. Page layout and word processing applications allow you to select the typeface, and then establish the type style as normal, bold, italic, bold italic, and so on. If you choose *Italic,* and there is no italic font on the system, the application will use the obliqued bitmapped font to simulate the italic. On the monitor at actual size, these obliqued or fattened romans are difficult to distinguish from real italic and bold fonts because of the relatively low resolution of the monitor.

The software does not always inform you that these little sleights-of-hand have taken place. If the bold and italic fonts are still missing when the type is printed, they will again be faked by modification of the bitmaps. The result will be a crude simulation of a real italic or bold that may escape notice until the expense of correcting the error has grown to profit-destroying proportions.

One common font substitution problem that is particularly difficult to detect is when a font is included in an illustration that is then incorporated into a page layout. If the font in the illustration is not available on the system used to print the page, a substitution will be made without any notification. Errors of this kind are easily overlooked, especially when the substituted type is in the form of small labels within the illustration.

Preventing type management errors

The key to prevention of type management errors is to keep track of all fonts used in a document, including those embedded in illustrations, and to place all fonts into a special folder that accompanies the document at all times.

Type rendering

Adobe Type 1 fonts employ bézier curves to describe the outline of each character. Bézier curves are described by cubic equations (equations containing terms raised to the power of three) and can be combined to define the outline of individual characters. The more intricate the design of the typeface, the more curves are likely to be needed to describe the individual characters, and the larger the resulting font file.

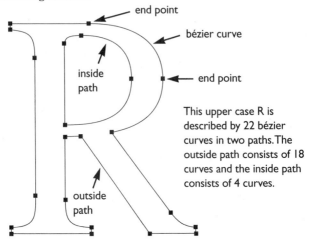

end point

bézier curve

end point

inside path

outside path

This upper case R is described by 22 bézier curves in two paths. The outside path consists of 18 curves and the inside path consists of 4 curves.

A PostScript or TrueType font is one complete collated set of characters in outline form, along with information called *hinting* that is used when the characters are rendered at small sizes on low-resolution printers. The characters in a font can be entirely different from corresponding characters in other fonts. For example, the phrase *Digital Printing* in the *Gill Sans* font uses the same sequence of character codes as the string ✦❋✳✳▼❀● ☆❑✳■▼✳■✳ in the *Zapf Dingbats* font.

Gill Sans

Zapf Dingbats

For type to be printed, the characters in a font must first be converted from outlines to bitmaps at the appropriate size and resolution. The resolution of the specific output device in dpi determines the resolution of the bitmaps. The higher the dpi resolution of the output device, the closer the bitmaps will approximate the shapes of the outlines.

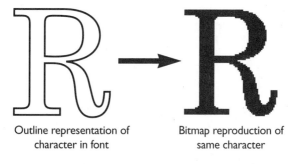

Outline representation of
character in font

Bitmap reproduction of
same character

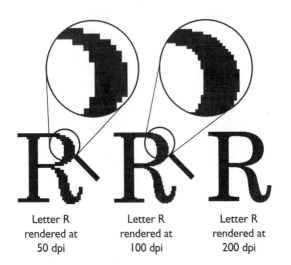

Letter R
rendered at
50 dpi

Letter R
rendered at
100 dpi

Letter R
rendered at
200 dpi

If the resolution of the printer is high enough, the edges of the rendered type will appear smooth, and the finest subtleties of the type design will be captured in the reproduction. At lower print resolutions, edges become "jaggy" and the rendered type departs significantly from the original design. At the lowest printing resolutions (characteristic of low-resolution laser and ink jet printers), literal conversion of character outlines to bitmaps would produce ugly and nearly illegible results. Thus, adjustments must be made to the bitmaps to improve their appearance. This is also essential when type is rasterized for display on a computer monitor. These adjust-

Rasterized outlines without hinting

Rasterized outlines with hinting

ments are controlled by the *hinting* information included in each font. Hinting has the effect of carefully pixel-editing the bitmaps for each character in the font to achieve the most visually pleasing results.

Without hinting adjustments, type rasterized for low-resolution printing would exhibit artifacts such as broken letters, irregular stem widths, uneven baselines, and inconsistent letter shapes. You can clearly see some of these effects in these enlargements of the samples of type shown on the previous page.

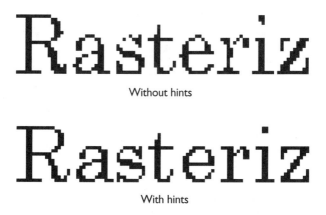

Without hints

With hints

By altering the way the letterforms are rasterized, hinting works to improve the appearance and increase the legibility of text type by compromising the faithfulness of the reproduction to the original outlines. When the same typefaces are output on higher resolution devices, such as film imagesetters or direct-to-plate systems, the bitmaps are modeled more precisely on the outlines. Thus there are subtle, but important, differences between the same typefaces rasterized for different print resolutions.

In addition to the distortions introduced by hinting at low print resolutions, print engines can also distort the appearance of the type in ways that do not accurately reflect the original design. For example, laser printers

add density around the fringe of all image elements because powdered toner migrates across charge boundaries. This has the effect of increasing the thickness of fine lines and the apparent weight of type.

Dye sublimation printers produce a result different from laser printers when rendering fine lines and type. The edges of all line elements appear soft and slightly out of focus. This is because the transition from image to non-image is not abrupt, but more gradual. The soft edges negatively affect the legibility of type. This has been the greatest weakness of dye sublimation printing as a color page proofing medium.

The combination of hinting adjustments and distortions introduced by the printing process can often mean that a document rendered on one printer will appear significantly different from the same document rendered on another.

Rendering digital line art

There are two distinctly different kinds of digital line art originals. Line art that originates in a drawing program, such as Adobe Illustrator, Corel Draw or Macromedia Freehand, is described in a vector format that must be converted into a bitmap format before being rendered.

Vector to raster conversion

Digital line art in outline or vector form must be converted to a bitmap before it can be rendered on a digital printer. The vector image is scaled to the proper size and then rasterized at the precise resolution of the printer for the best result.

Addressability versus resolution

When a bitmapped image is rendered on a real digital printing device, ink or toner has a tendency to spread at the edges of image elements. This may compromise the ability of the printing process to render all of the detail in the bitmap (i.e., the resolution of the printing process). The detail in the bitmap on the left may be lost if there is too much distortion in the rendering process, as shown on the right.

This is done by a process similar to the one used for type. The process is called *scan conversion* or *rasterization*. When vector art is rasterized, the RIP will produce a bitmap at the exact resolution of the target printer. The higher the resolution of the printer, the more faithful the bitmap will be to the original outlines.

The size of the bitmaps increases as a square of the linear resolution, so a 1,200 dpi bitmap is 4 times as large as a 600 dpi bitmap and 16 times as large as a 300 dpi bitmap. Most high-resolution film writers will accept bitmaps at several resolutions—usually even divisors of the maximum resolution. For example, a film writer with a top resolution of 3,600 dpi may also process bitmaps at 1,800, 1,200 and 900 dpi.

Rendering graduated fills

Drawing programs such as Illustrator, Freehand, and Corel Draw all provide a way of creating graduated fills or *vignettes* that change continuously in tone and/or color in a linear or radial fashion. PostScript does not provide a way to directly describe a graduated fill. However, draw-

ing applications describe graduated fills by combining filled objects that change in even increments from one value to another. This effect is called a *gradient* or a *blend*. A blend is created by generating a series of intermediate objects between two end points. When the blend is rendered (by a PostScript RIP, not a blender), each filled object is rendered completely in turn. The result is a gradual change from the fill value of the first object to the fill value of the second.

The design goal with blends is usually to achieve a smooth transition between the two extreme fill values. Sometimes transitions are not rendered smoothly. There are two reasons why this can happen. First, if the number of intermediate steps selected by the designer is not high enough, the tonal/color transition from step to step

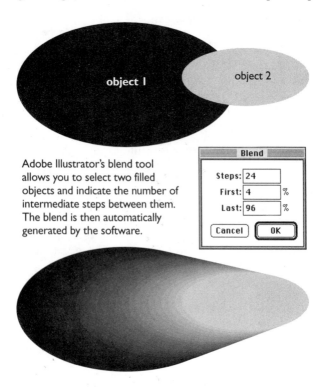

object 1

object 2

Adobe Illustrator's blend tool allows you to select two filled objects and indicate the number of intermediate steps between them. The blend is then automatically generated by the software.

Blend

Steps: 24
First: 4 %
Last: 96 %

Cancel OK

This blend is described by a stack of 86 ellipses from dark to light. The tonal increment between any two ellipses is approximately one percent

PostScript blend

A smooth blend from dark to light in the PostScript file may be rendered with visible steps on some printers. This is known as *contouring.* Generally contouring becomes more of a problem as the resolution of the printer decreases.

Rendered blend

will appear as discrete jumps. This can be remedied by choosing a higher number of intermediate steps. As a general rule, tonal transitions from step to step should not be greater than 1 percent (e.g., a blend from a 30 percent value to an 80 percent value should include no fewer than 49 intermediate steps).

The second cause of lack of smoothness in a blend is the inability of the printer itself to render smooth transitions. In this case, no matter how many intermediate steps there may be in a blend, the printed result will exhibit the same objectionable artifacts. On a binary printing device, 600 dpi is often sufficient addressability for pleasing rendering of type and binary line art. This same addressability is not sufficient for pleasing rendering of gradations and images containing smooth tonal or color transitions.

Contouring can often be minimized on halftone printers by decreasing the screen frequency of the printed halftones. This trades one problem for another, however, because as the screen frequency decreases, the halftone dot structure becomes more visible. The problem of contouring also occurs in the reproduction of images, as we will discover in Chapter 7.

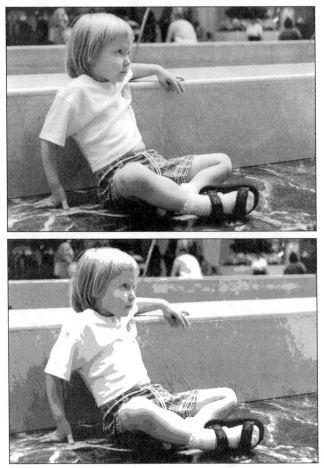

Contouring can be seen in the lower image. This is most likely to occur at high screen frequencies on low-resolution printers.

Chapter 7

RENDERING IMAGES

One of the saving graces in graphic imaging is the fact that we are shooting at a relatively stationary target. People can only see so much detail in a printed image at a normal reading distance. (It may even be true that the eyesight of the population has been in steady decline since eyeglasses were invented several centuries ago.) Cramming more detail into an image than people can see is an absurd waste of resources unless the image is intended to be viewed with the aid of a magnifier. When extremely fine screens are used to show off technical capabilities to potential customers, the viewer must be explicitly informed as to the extraordinary nature of the work, lest it go completely undetected. (Over the years I have received many promotional pieces from printers and press manufacturers that I would probably have recycled immediately had I not been informed that the piece exhibited some rare capability that could only be properly appreciated through a 10-power loupe.)

Digital halftoning
Binary digital printers produce a range of gray tones by employing digital halftoning methods. Much study has been devoted to digital halftoning in recent years. The prime focus has been on developing screening methods that produce high-quality visual results given the resolution limitations (a function of the dpi) of printing devices. Most current desktop laser printers, for example, can render binary images at a resolution of 600 dpi. (The highest resolution laser printers currently available are capable of 1,200 dpi resolution). At 600 dpi, it is difficult to produce a smooth halftone gray scale while keeping the screen frequency high enough to hide the halftone pattern from view.

We will soon see why this is true. The capability of digital printers to render images can be modeled and quantified so that meaningful comparisons can be made

among various devices. Before we can do this, however, we must first understand the fundamental principles of digital halftoning.

All binary printers are capable of making marks on a substrate at a specific frequency. These marks are sometimes called *spots* or *dots* or *pixels*. This book refers to them as *printer dots* and distinguishes them from *halftone dots*. This terminology is consistent with the term *dpi* (dots per inch) when used in reference to the addressability of a digital printer. (This book uses the word *pixel* to mean the smallest discrete element in a digital image, so a pixel is a number and not a little pile of ink or toner sitting on a piece of paper.) A 600 dpi laser printer, for example, is capable of placing printer dots every 1/600 of an inch in both the horizontal and vertical dimensions. The printer can either make a printer dot or not, and has no control over the size or density of individual printer dots. Because of this, that printer is really capable of printing only two discrete tones, black and white.

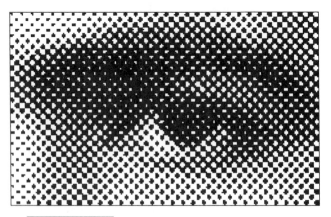

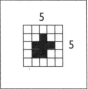

Enlargement of a detail of a 60 lpi halftone printed on a 300 dpi binary output device. Each halftone dot is formed in a 5 by 5 pixel cell. The total number of gray levels obtainable is (5 X 5) + 1 = 26.

To render a halftone image, a binary digital printer controls the spatial placement of printer dots on the substrate to control the density in the image point by point. There are many ways to do this. The most common way is to construct conventional halftone dots out of clusters of printer dots and distribute these printer dots at a fixed frequency across the surface. This is sometimes called *amplitude-modulated* halftoning. In the preceding illustration, each halftone dot is constructed in a 5 by 5 cell of printer dots. This yields a total of 26 discrete halftone values (including the white paper).

In the following example, the halftone cell has been expanded to 20 by 20 printer dots. The number of dots rendered in each halftone cell determines the percentage of the area covered and the number of positions in the cell

Halftone dot growth sequence

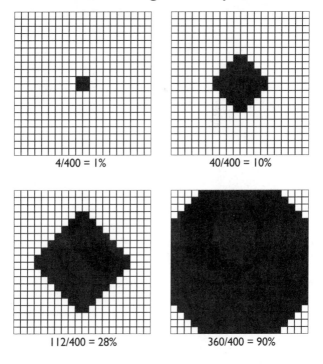

4/400 = 1%

40/400 = 10%

112/400 = 28%

360/400 = 90%

The smallest addressable spot determines the dpi of a printer. dpi = the number of these per inch

The spacing of rows of halftone dots (indicated by the white arrow) determines the lpi of the halftone.

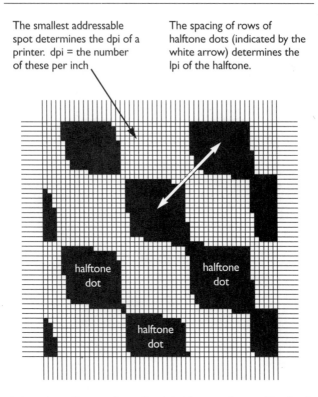

determines the number of printable gray tones. The basic formula for calculating the number of printable gray tones is: *number of gray tones = (lpi/dpi)2 + 1*.

According to this rule, at any given dpi the screen frequency of a conventional halftone and the number of printable gray values are inversely related. As the screen frequency increases, the number of printable gray values decreases. This relationship is illustrated in the chart on the next page. It is important to note that as the screen frequency increases, the ability of the printer to produce a smooth gradation from light to dark is also compromised. On a 600 dpi binary printer, a halftone screen frequency of 150 lines per inch yields only 17 printable gray tones. With resolution enhancement techniques this number can be increased slightly. However, below about 1,200

Tonal versus spatial addressability in conventional halftoning

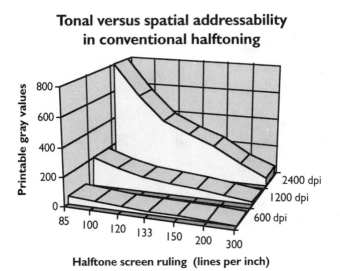

Halftone screen ruling (lines per inch)

dpi, a binary printer is not able to render a smooth gray scale and also keep the halftone dots small enough so they cannot be detected at a normal viewing distance.

Frequency-modulated screening

Frequency-modulated (FM) *screening* (sometimes called *stochastic screening*) is an alternative halftoning method that renders gray tones in a printed image by varying the spacing or frequency of tiny dots of uniform size and density. This is distinguished from conventional halftoning, which varies the size of uniformly spaced dots. FM screening can be compared with conventional halftoning, which is now sometimes called *amplitude-modulated* or *AM screening*. FM halftoning algorithms have existed for many years, but only recently have computers become powerful enough to enable their practical application.

Both analog and digital printing processes can employ FM screening. Many advantages have been attributed to these new screening methods. Color printing is normally accomplished by accurately overprinting four separate halftone images using cyan, magenta, yellow, and black inks. With AM halftoning, the regular rows of halftone

Halftone dot shapes

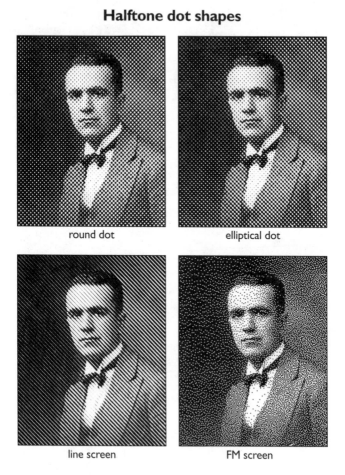

round dot

elliptical dot

line screen

FM screen

dots must be angled precisely in relationship to one another to minimize interference patterns called *moiré*. Because FM screens have no regularly spaced dot structures in them, there is no possibility of moiré. FM screening also eliminates the possibility that some regular pattern in the image itself (such as a picket fence or a hounds-tooth fabric) will interfere with the halftone

screen and cause a moiré problem. This is especially important in clothing catalogs, where many of the images contain fine periodic patterns.

Because FM screening solves the moiré problem, colors in addition to cyan, magenta, yellow, and black can be used to expand the process color gamut (the range of printable colors). This is most useful at the premium end of the commercial printing market, but also has applications in digital color proofing. One proposed method of expanding the process color gamut, called HiFi color, is a seven-color process using cyan, magenta, yellow, red, green, blue, and black inks. Another method expands the color gamut by printing two separate layers of cyan, magenta, and yellow ink to increase the density range of each of the subtractive primary colors. In theory, FM screening allows for as many layers of ink to be overprinted as necessary. This calls to mind the 19th-century chromo-lithographic printing process of the Currier and Ives type where as many as 30 or more layers of ink were used to reproduce color images.

FM screening also improves the smooth grayscale rendering capabilities of many digital printers. This is especially relevant for low- and medium-resolution binary processes such as ink jet. However, because FM halftone dots are much smaller than conventional halftone dots,

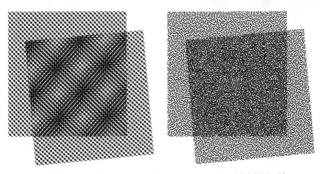

The problem of moiré in the overprinting of AM halftone screens (on the left) does not occur with FM screens (on the right). FM screening enables high-quality four-color printing on low- to medium-resolution digital printers.

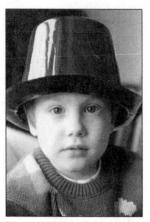 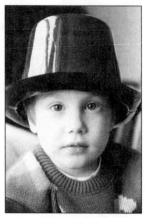

The same grayscale image is printed using a conventional halftone screen on the left and an FM screen on the right. The FM screened image is darker in the midtones because of the increased amount of dot gain.

FM screens print darker than conventional screens, especially in the midtones. When preparing images for reproduction using conventional halftoning, the digital images must be altered to compensate for distortions to the halftone dots that occur on the printing press. This distortion is called *dot gain* because of the tendency for halftone dots to gain size through the ink transfer process. This has the effect of darkening the image, shifting the midtones toward the shadow end of the tone scale. Digital images prepared for print applications must be compensated for the effect of dot gain. FM halftones require a greater degree of compensation than conventional screens. In digital printers that employ FM screening, this compensation is often automatic and transparent to the end user.

FM screening techniques have been employed successfully to obtain high detail definition and good grayscale rendering on relatively low-resolution digital printers. FM screening is now almost universally employed in drop-on-demand desktop ink jet printers for rendering grayscale and color images. However, when

FM screening of a grayscale contone image

contone original

FM screen

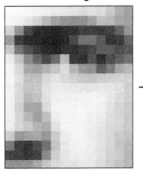

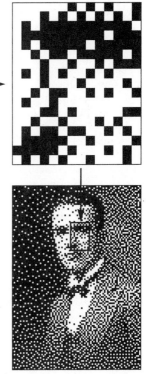

There are many different ways to render a contone digital image on a binary printer. In this example, the resolution of the contone original exactly matches the addressability of the binary printer. The decision as to whether a pixel is printed depends on whether the accumulated density in the original exceeds a fixed threshold value at that point. When the density threshold is exceeded, a dot is printed and the density remainder carries over.

employed by monochrome laser printers, FM screening tends to increase the likelihood of undesirable artifacts in the printed images. Most laser printers will introduce streaks that detract from the appearance of the print. This is especially problematic in images containing large flat areas of even density. Most laser printers therefore employ conventional amplitude-modulated screens.

FM screens sometimes appear grainy in areas of even color and density. The regular halftone dot patterns of conventional screens are easily filtered and ignored by

the visual system. Random dot patterns cannot be filtered in this way. The problem of grainy appearance is a potential detriment to overall image quality. To overcome this problem, hybrid screening technologies combining the advantages of both FM and AM halftoning in the same image are now employed in some high-end applications. In areas of even tone, especially in the highlights, conventional halftone patterns yield a smoother appearance than FM screens. But in areas of high detail, FM screens produce better results. Sophisticated screening software can analyze an image to determine where the appropriate screening geometry should be applied, mixing FM screening and conventional screening to the best overall effect.

Tonal range of digital printers
Thus far we have talked about the capabilities of digital printing processes to produce smooth transitions from highlight to shadow. Another important capability of a digital printer is the range of tones that can be produced. Every printer has a similar capability with regard to the highlight end of the scale. The extreme highlights are a function of the paper color rather than a result of anything the printer does to the paper. The shadows, though, are a different story. Each combination of printer, paper, and ink or toner will render shadow tones differently. Some printing processes are capable of producing extremely rich, dense shadows, whereas others will not be able to achieve such high densities.

You can get a good feel for these differences in conventional printing by comparing the density of shadows in a typical newspaper to those in a news magazine. The difference is more a result of the difference in paper than anything else. Newsprint is extremely porous. Ink is easily absorbed into the fibers. This has the effect of diminishing the density of the print, because of the large degree of light scattering that takes place at the surface. On smooth, coated paper, the ink holds out on the surface and there is far less scattering of light. The differences in shadow density from process to process are sometimes dramatic.

These same issues are important in the domain of digital printing. In electrophotographic printing, for example, processes employing dry toners (such as desktop laser printers) often produce a lower apparent maximum density (dmax) than processes employing liquid toners. This difference can be seen in the shadow rendering of the Xeikon dry toner system compared to the liquid toner systems of Indigo. Indigo prints have a glossy quality that increases the apparent density of the extreme shadows. Xeikon prints are less glossy and tend not to appear as dense in the shadows. With higher fusing temperatures and other modifications to the process, dry toner systems are now achieving gloss and density characteristics similar to liquid toner systems.

In desktop ink jet printing, the differences between prints made on plain, uncoated office papers and special coated ink jet papers can be dramatic. Plain paper allows the ink to wick down into the fibers. Because most ink jet inks are dye-based, the colorant also wicks down into the paper, where it is partially obscured by the fiber structure. This greatly diminishes the strength of the colors, reducing the maximum densities achievable. On coated paper, the dyes are held out on the surface and are prevented from wicking into the paper. The light-absorbing power of the dye molecules is therefore not compromised.

Necessary compromises
Because it is rarely possible to achieve the same dmax in a printed reproduction as in an original photograph, it is usually necessary to adjust the process to compress the range of densities found in the original, so that the reduced range of densities obtainable in the reproduction will not be too objectionable. We are always making these kinds of compromises in printing.

Imagine that you are going to reproduce a photograph that has a density range of 2.0 with a dmin of 0.0 (white photo paper) and a dmax of 2.0 (darkest shadow). Imagine that you are going to use a printer, ink, and paper combination that will only give you a maximum density range of 1.5. In other words, the darkest tone that can be produced by a solid film of ink on the paper is 1.5

Tone reproduction curve

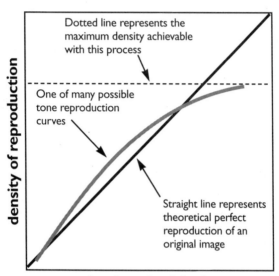

density of original

(measured with a densitometer zeroed on the white paper). No matter how you slice it, the range of tones in the reproduction is going to be shorter than that of the original, and the reproduction cannot be perfect.

The relationship between densities in the original and densities in the reproduction must therefore be adjusted so that the reproduction presents the best compromise. The simplest way to relate the densities in the original to the densities in the reproduction would be to reduce all of the densities by the same factor (a linear transformation). This would have the effect of flattening the contrast of the original to fit the reduced density range of the reproduction.

The figure above shows a typical tone reproduction relationship between original and reproduction. The 45-degree line represents a perfect reproduction where each density in the original is reproduced exactly. The curved

line shows the relationship between the densities in an original and densities in a reproduction where the dmax of the reproduction is less than that of the original. This curve shows how densities in an original image will be reproduced by a given printing process.

If every image required the same tone reproduction treatment, life would be too easy. By changing the shape of this curve, the tone reproduction can be altered to suit the particular type of original that you wish to reproduce. For example, if the original photograph is a high key image, with a lot of highlight areas and few shadow areas, the tone reproduction could be adjusted to enhance the detail in the highlights at the expense of the detail in the shadows. Imagine a photograph of a white elephant wandering through a landscape covered with snow. Most of the information in such a photograph is contained in the highlight areas. The elephant's skin is textured, but the darkest details on the skin are still quite light. The snow has texture, but all the tones are very light. There is no point in wasting detail on shadow areas that are not contained within the photograph.

On the other hand, some photographs contain a lot of shadow detail and not a lot of highlight. These are called low key images; a good example would be a picture of a black cat in a coal mine. In such an image, there is a lot of detail in the shadows and none in the highlight. The tone reproduction curve should be adjusted to enhance the detail in the shadows at the expense of detail in the highlights.

The tone reproduction curve shown earlier may suffice for a normal photograph (neither low key nor high key), but may not give optimum results for other types of originals. Tone reproduction must therefore take into account the qualities of the original photograph.

Effect of screen frequency on tone reproduction

We have already seen that the method of screening can have a profound effect on tone reproduction. The same image rendered by the same printer with AM and FM screens will exhibit dramatic differences in the tone reproduction. This is because FM halftone dots are a lot

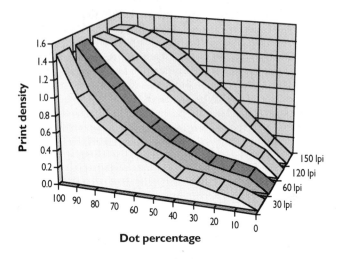

Dot percentage

smaller and more closely spaced than AM halftone dots, and tend to gain more density in the midtone areas.

This phenomenon explains why the screen frequency of a conventional halftone has an influence on tone repro-duction. In general, as the screen frequency increases, midtones are rendered darker. The graph above shows the relationship between halftone dot percentage and density at four different AM halftone screen frequencies on the same laser printer. Note that as the screen fre-quency increases from 30 to 150 lpi, the curve changes shape dramatically. Note also that for all four curves, the maximum density is the same.

This illustrates a critical point about the preparation of black-and-white images for reproduction. The capabili-ties of the printing process to render density and the halftone screen frequency both have a profound effect on the appearance of the printed images. In the next illus-tration, the same digital grayscale image is reproduced four times at four different screen frequencies. The litho-graphic process used to print this book exhibits the same behavior as any digital printing process. At higher screen frequencies, the midtones print darker than at lower screen frequencies. An image that is reproduced with the

The effect of halftone screen frequency on tone reproduction

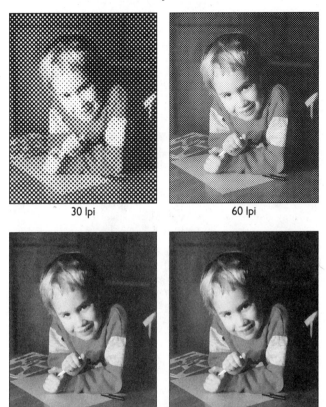

30 lpi

60 lpi

120 lpi

150 lpi

desired tone reproduction at one screen frequency will appear different at other screen frequencies. Thus, it is important that grayscale images be prepared with a specific output process, using specific screening parameters, in mind.

There are two ways to adjust a digital image so the reproduction will possess the desired tonal characteristics

when rendered on a given printer at a given screen frequency. One way is to adjust the pixel values in the image by using a tool such as the Photoshop curves or levels filters. These tools change the absolute values of the pixels in the image.

Another way is to construct a Photoshop transfer function and include the function with the image by saving it as an EPS file. The transfer function is then used by the PostScript RIP that screens the image for printing to adjust the dot values to compensate for the anticipated density gain in the reproduction process.

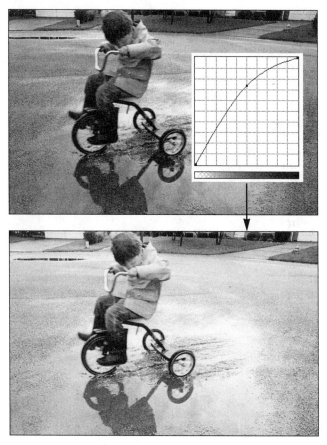

Chapter 8

COLOR MANAGEMENT

When you realize how many billions of dollars are spent every year in the print communications industry in pursuit of acceptable color reproductions, you begin to understand why so many intelligent people have been working for so long trying to make it easier to do.

When we are dealing with a single target printing process such as sheetfed offset lithography, it is possible to gain an intuitive understanding of how the process renders color by repeatedly exercising the system. Traditional color experts acquire mental color lookup tables after years of experience that allow them to adjust the inputs to a printing process to achieve the desired results. This experience includes knowledge about the specific combinations of halftone dot percentages required for a wide range of *memory colors* such as blue sky, green grass, and flesh tones. The best color professionals in the business also have intimate knowledge of their customers' color preferences and adjust the reproduction process to give them what they want.

What is color management?

The term *color management* encompasses a range of technologies related to the correct interpretation and rendering of color information. In the broadest sense of the term, people have been doing color management since the first multicolor printing was accomplished more than a century ago. In those days color management consisted of controlling the preparation of images on a series of lithographic stones so that the printed results would match the expectations of an artist.

Color management software characterizes digital color input devices, color monitors, and color printing processes (both conventional and digital), so that colors in an original image will be displayed and printed accurately. This enables us to prepare color images for print using

a completely visual approach. To accomplish this, color management technology must objectively (numerically) define color so that it can be rendered accurately. Most color management systems employ a *reference color space,* which is *device-independent.* Most reference color spaces are based on CIE color standards.

Defining color objectively

Color can be measured with an instrument called a *spectrophotometer* or *spectro-densitometer.* This instrument can be used to analyze the light-absorbing properties of an object and generate a curve that represents the reflectance of the object at discrete wavelengths within an established range. This range is usually from somewhere around 400 nm (nanometers) to somewhere around 700 nm, corresponding roughly to the visible range of the spectrum.

The spectral reflectance curve tells us everything we need to know about the objective color of an object. However, it does not tell us what color we will see. This is because what we see depends not only on the color of the object but also on the color of the light with which the object is illuminated. For example, if an object is white, and it is illuminated with a red light, it will look red. This

Spectral reflectance curves

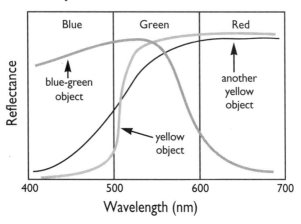

makes perfect sense. Even though the white object reflects all wavelengths of light roughly the same, the illuminant is red, and therefore the only light we see reflected back from the white object is red light.

It is very difficult and cumbersome to work with spectral reflectance curves. It is easy to tell whether two curves are the same, but it is very difficult to tell how significant the difference in perceived color will be between two different curves.

The color that we perceive also depends on the psychophysical characteristics of the eye and brain. The average characteristics of the eye and brain have been established by the International Standards Organization (ISO), a part of the International Commission on Lighting (CIE) for what is called the *standard observer*. This defines the way the eye is stimulated by three colored light sources (a red source, a green source, and a blue source) such that matches are made between the mixture of the three light sources and single pure spectrum colors. At each wavelength, the three sources are adjusted in intensity so that a match is seen between the mixture of light and the pure spectrum light. The three intensity values are called the *tristimulus* values for that spectrum color using those three illuminants. The tristimulus values are called X, Y, and Z and correspond approximately to the redness, greenness, and blueness of a color as seen by the eye.

Because tristimulus values have three dimensions, they can be plotted on a three-dimensional Cartesian coordinate system. The total range of perceivable colors defines a color space called a *color gamut*. Each perceived color occupies a point in that space.

The XYZ color space is not uniform, however, and the distance between any two colors in the space does not tell us how different they will appear from one another. This is of crucial importance. When we are looking at a reproduction of an original image, or comparing two copies of the same image, we are most concerned about how closely the colors match.

Uniform color spaces

Much work has been devoted to the development of more uniform color spaces. Today, the most widely used color space is called CIELAB. This defines three variables, L*, a*, and b* (pronounced *L-star, A-star,* and *B-star*), that correspond to three characteristics of perceived color based on the opponent theory of color perception. The three variables have the following meaning:

> *L* = lightness, ranging approximately from 0 to 100. 0 = dark and 100 = light*
>
> *a* = red / green axis, ranging approximately from -100 to 100. Positive values are reddish and negative values are greenish.*
>
> *b* = yellow / blue axis, Ranging approximately from -100 to 100. Positive values are yellowish and negative values are blueish.*

Because CIELAB color space is somewhat uniform, a single number can be calculated that represents the difference between two colors as perceived by a human being. This difference is termed ΔE (pronounced *Delta-E*) and is calculated by taking the square root of the sum of the squares of the three differences (ΔL^*, Δa^*, and Δb^*) between two colors.

Here is an example. Suppose that you measure two objects and find that their CIELAB coordinates are:

object #1: L = 90.5, a* = 10.0, b* = 72.0*
object #2: L = 92.0, a* = 12.9, b* = 75.0*

The differences for L*, a*, and b* are 1.5, 2.9, and 3.0 respectively. If we calculate the ΔE between these two colors, the result is:

$$\Delta E = \sqrt{(2.25 + 8.41 + 9.0)} = 4.4$$

In CIELAB color space, each ΔE unit is roughly a *just-noticeable difference* between two colors. So the two colors

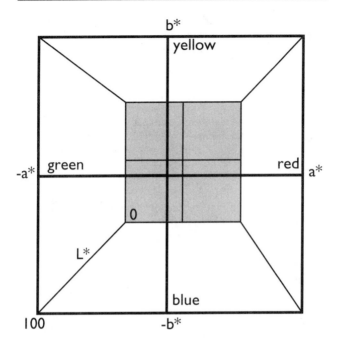

in the example are 4.4 just-noticeable-differences away from each other. For any combination of object, illuminant, and observer, CIELAB coordinates give us some way of telling how differently two colors are likely to appear to a human observer.

CIELAB is therefore the obvious choice for an objective device-independent color specification system that can be used as a reference color space for the purposes of color management.

Use of CIELAB in color management
Color mangement systems must be able to objectively characterize the behavior of color input and output devices. They use a CIELAB-based reference color space to relate the behavior of real color input and output devices to an objective standard. Color input devices include scanners and digital cameras. Color output devices

include computer monitors and printers. It is important to realize that there are no standards governing the way color input devices record color, nor how color output devices render color.

Characterizing color input devices

Let's first take a look at how a color management system characterizes the behavior of an input device. This can only be done with the use of a physical standard color target that can be measured using a calibrated color measurement device. A standardized target set in current use is the IT8 set. The three major film companies (Kodak, Fugi, and Agfa) all manufacture IT8 sets, which include photographic print and transparency (35mm and 4 by 5 inch films) versions of the target. The targets contain 264 colored patches representing a sampling throughout CIELAB color space, and a 23-step scale of neutral grays along the bottom. The IT8 target is illustrated below (unfortunately not in color).

There are minor differences between the targets from manufacturer to manufacturer, as well as among targets made by the same manufacturer. However, these differ-

The IT8 color target

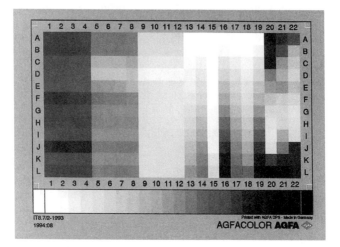

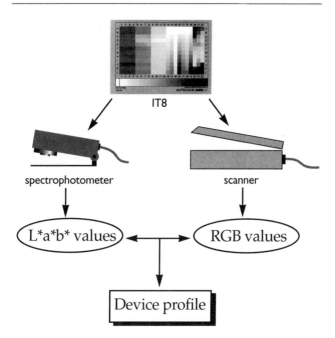

ences are factored out and do not compromise the accuracy of the color management systems that make use of them. The illustration above shows how the IT8 target is employed to generate a profile for an input device. The color patches on the target are first measured with a calibrated spectrophotometer. This results in a table of CIELAB values for the target.

When the same target is presented to the scanner, the RGB values that the scanner produces for each patch on the target are compared with the CIELAB values. The color management software is then able to construct a profile for the scanner. The *profile* is a lookup table (LUT) that can be used from that point forward to relate RGB files produced by the scanner back to the CIELAB reference color space. The RGB file and the profile together are used by the color management system to assign objective meaning to images coming from the scanner. This profile can only be applied to images scanned on that device.

To make an input profile for a new scanner with the Agfa FotoTune color management software, 1) scan the IT8 target; 2) create a TIFF file of the scanned image; and 3) Run the *New Input Profile* software module, where you select the TIFF and then click on the analyse button. The entire process takes less than five minutes.

Furthermore, the profile applies only to images scanned using the same settings on the scanner.

This brings us to an important weakness of the color management paradigm. The assumption with any input profile is that it reflects the way the device records color from original images. However, scanners and digital cameras come equipped with software that allows adjustments to the scanning process to handle a wide variety of originals. To obtain the highest quality data from a scanner, it is necessary and desirable to use these controls. The upshot is that the scanner does not necessarily record color the same way from one original image to the next. This works against the idea of establishing a single profile for an input device that will work in all cases.

The best way to address this problem is to identify the major scanning setups that are typically used and to establish a separate device profile for each setup. For example, you may routinely use three different gamma settings on the scanner for low key, normal key and high key images. It is therefore desirable to create three separate device profiles for the scanner and to use the appropriate device profile for each image scanned.

These two images required different scanning setups. The low key image on the left was scanned to emphasize detail in the shadows. The high key image was scanned to emphasize the highlights.

Digital cameras

You can characterize a digital camera system in the same way you characterize a scanner. The big difference between the two is that digital cameras normally do not contain their own light sources. Thus, for color management to be compatible with digital photography, the light sources and their geometry must not be altered from the configuration used when the device is characterized. In digital photo applications where lighting can be kept constant, color management works quite well.

It is worth mentioning at this point that all color management systems characterize input devices by scanning a photographic target and then analyzing the digital result. For example, Kodak color management software uses an Ektacolor print of the IT8 target to characterize reflection scanners and Ektachrome transparencies to characterize film scanners. If a reflection scanner is used to scan an original image that does not employ the Ektacolor dye set (an original water-color painting, for example), the color management system treats the digital values returned by the scanner as though the original were an Ektacolor print anyway. This introduces the

potential for an occasional surprise in the color reproduction process. A particular red, for example, may reproduce with a pronounced hue shift toward cyan or yellow. This is unusual, however. In most cases, these systems will interpret the values returned by a properly characterized input device with a high degree of accuracy.

Agfa color management software uses IT8 targets produced on Agfa reflection and transparent photographic media. At first glance these targets appear to be identical to the Kodak targets. However, the Agfa targets use slightly different dye sets than the Kodak media, and the two sets are not interchangeable. Producing an Agfa input profile with a Kodak target will compromise the accuracy of the Agfa system, and vice versa.

Characterizing output devices

Color management software must also make use of lookup tables that characterize the monitors and printing processes that will be used to view and print the images. This is done by relating the color rendering properties of the output processes back to the same reference color space used to characterize the input device. With all devices in the imaging chain properly characterized, it should be possible to render a color value produced by any color input device on any color output device, and expect the output to closely match the original. Color management cannot perform miracles, however, as we shall soon see.

Characterizing the monitor

Color monitors convert digital RGB values into analog signals that control the intensity of red, green, and blue phosphors. For every RGB combination, the mixture of red, green, and blue light emanating from each pixel on the screen produces a sensation of color. Most color monitors allow the user to control the intensity and contrast of the display by turning knobs that are conveniently placed on the front of the cabinet. Although only a few standard phosphor sets are in common use today (Sony and Hitachi), every monitor does the digital-to-analog conversion differently.

The same color image displayed on two different monitors is therefore guaranteed to appear differently. Color management software makes it possible to characterize a monitor so that the way it displays color is objectively related back to the reference color space. In other words, color management software can learn what colors a monitor actually displays when it is fed specific RGB values, and then use this information to display colors objectively, as well as to interpret colors that a user sees on the monitor objectively. A properly characterized monitor will allow colors in an original image scanned on a scanner that has been previously characterized by the CMS to be displayed accurately.

It can also be used to capture the color preferences of a human user. The color management system can objectively identify the colors you see on the monitor. If you are happy with what you see, the CMS knows how to keep you happy in reference color space terms. If you are not happy, you can change what you see with software controls that change the RGB values until you become happy. Because the CMS can relate any RGB combination

Monitor characterization begins with identifying the monitor type and setting the gamma, white point, and phosphor set. The ambient light parameter should reflect conditions in the normal working environment. Ideally, there should be very little ambient light. However, it is not practical in most cases to expect people to work in the dark.

displayed on the monitor back to the reference color space, it always has an objective definition of what you are seeing. This ability to objectively characterize the display of color on a computer monitor is very powerful. Without the ability to do this, there is no hope of using the monitor as an accurate color communication tool.

Monitor characterization is accomplished with a colorimeter that is specially designed to measure the colors displayed on a monitor. These devices record the intensity of red, green, and blue light emitted by the monitor when selected RGB combinations are displayed. The process is completely automated in most cases, requiring the user only to place the colorimeter on the face of the monitor (these devices come equipped with large suction cups to enable them to cling to the glass) and then run the characterization routine.

The appearance of images on the monitor is of central importance. If the monitor is not characterized so that the software knows the relationship between digital RGB values fed to it and the resulting colors that will be displayed, then attempts to make color changes based on visual judgments will have unpredictable results. The monitor characterization software should make it possible for the color management software to display extremely accurate digital representations of original images scanned on a characterized input device. This is possible because most originals do not contain colors that fall outside the color gamut of the typical monitor. The monitor gamut completely encloses the gamut of most original prints or transparencies.

Comparing photographic originals to reproductions rendered on a color monitor is not a simple task. A print must be illuminated by some light source in a viewing booth. The intensity of the light must be matched closely with the luminance of the monitor. If the original is a transparency, the intensity of the light box must be matched to that of the monitor.

With a good match between monitor and original, color can be edited more precisely. The original serves as a reference point that remains fixed. Without such a reference, it is easy to overedit an image, introducing color

distortions that are far greater than what was intended. This is because the human visual system rapidly adapts to variations in color balance to establish a psychological white point. If you are looking at a photograph of a person wearing a T-shirt, you will normally see the T-shirt as white no matter what color the actual pixels on the display are. Only by reference to some external standard will you be able to detect color casts and properly gauge their magnitude.

A properly characterized monitor also enables the CMS to display accurate soft proofs. The CMS must reference a profile of the printing process to be able to do this. The most comprehensive CMS solutions include all of the necessary software and peripherals needed to characterize input devices and monitors, as well as a way to characterize the behavior of the output device.

Characterizing color printing processes

Every color printing process has its own peculiar way of rendering color. Nearly all of them use cyan, magenta, yellow, and black colorants. However, there is no standard definition for any of these colorants. Among the hundreds of digital color printing devices currently on the market, many different colorant sets are in use.

The ideal function of each process colorant is discussed at length in Chapter 1. Here we need to develop an understanding of how real colorants behave. Let's focus first on magenta inks. The ideal magenta colorant would absorb all of the green portion of the visible spectrum and transmit all of the red and blue portions. This is shown graphically on the top of the next page. Unfortunately, Mother Nature has not come forth with chemical compounds that behave in this manner. Along with the ideal magenta, the illustration includes the spectral reflectance curves of three real magenta inks on the same graph. Note how far from the ideal each of these inks is, especially in the blue region of the spectrum. The truth is that real magenta colorants absorb a great deal of blue light, as well as a good amount of red light. The net result is that real magenta colorants appear to be contaminated, as though some black ink were mixed with

Magenta colorants

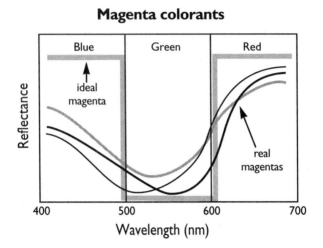

them. Some magentas are better than others, appearing cleaner or more saturated. However, magentas in general are a dirty bunch. It is important to emphasize that different magenta colorants are dirty in their own peculiar ways.

The other process colorants have similar characteristics. Many chemical compounds are used to formulate cyan and yellow colorants. Real yellows are the closest to an ideal of the three. However, literally hundreds of different cyans and yellows are in current use, each of them different.

In a color printing system, the spectral characteristics of the three primaries and the unique characteristics of the black colorant will determine the range or gamut of colors that can be produced. These are not the only variables, however. The characteristics of the paper and the way the colorants are transported to and secured on the surface also have a profound effect on the gamut of the process.

Binary color printing processes use halftoning to control the amount of colorant that is applied to each point in a printed image. The combination of colorant, vehicle, paper, and halftoning method all contribute to the color rendering characteristics of a process. All of these vari-

Cyan colorants

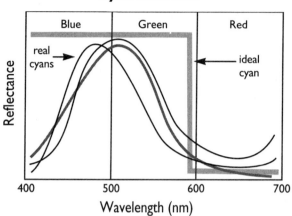

ables must be taken into account before a color management system can properly characterize the process. You may be tempted at this point to throw up your hands in despair at the complexity of the problem. How can we have any hope of getting a handle on all these variables? The answer, in a nutshell, is that if we treat all of the variables as part of a system, we can ignore all of the

Yellow colorants

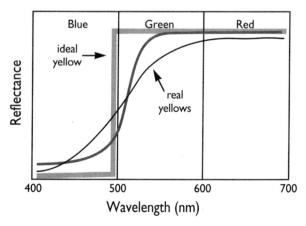

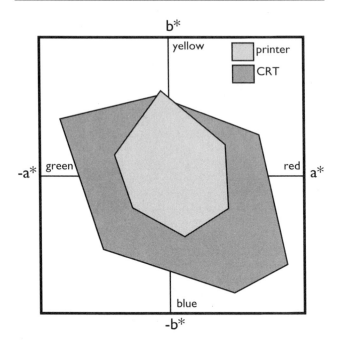

The gamut of a typical color monitor is much larger than that of most color printing processes. Colors in the large gray hexagon that fall outside of the light gray hexagon can be displayed on the monitor, but cannot be printed. In this comparison, the printing process is able to render slightly more saturated yellows than the monitor.

independent variables that contribute to its behavior, and characterize the system as a whole. Color management software has to determine only two things about a color printing system. First, what is the gamut of the system in terms of the reference color space? Second, how can the system be made to produce all of the individual colors that fall within the gamut? In other words, what colors does the system print, and how can it be made to print them?

Output profiles

Making an output profile is the mirror image of making an input profile. The objective in this case is to print a test form with a number of color patches on it, measure the printed colors with a spectrophotometer to see where they fall in reference color space, and then build a profile for the output device. Because most users of color management software are not expected to have access to sophisticated color measurement devices, many first-generation color management packages do not allow users to make their own output profiles. The profiles are created by the software manufacturer for existing color printing processes, and either bundled with the color management system software or sold independently.

A number of software products are now available that allow CMS users to create their own custom output device profiles. These employ digital color targets that the user prints and then measures with a spectrophotometer. The user saves these measurements in a file that is processed by the CMS to generate a color profile for the device.

These products have become more viable as the prices of hand-held spectrophotometers have come down. In the

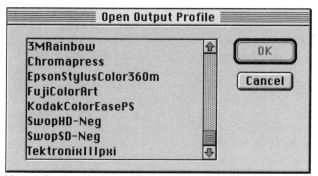

Most color management software packages include a number of output device profiles. These profiles represent the behavior of test machines operated by the software maker and may not accurately reflect the actual behavior of your device. For this reason, it is desirable to create your own output profiles, if possible.

early 1990s most hand-held spectrophotometers were priced at well over $10,000. Now, accurate instruments can be obtained in the $1,000 range. This makes it possible for nearly anyone working with color professionally to own a color measurement device.

By objectively characterizing the behavior of color input and output devices, color management allows us to work with color images in an entirely visual way without having to understand anything about the theory of color reproduction. However, it is important to understand that color management cannot solve some of the classic and eternal problems in color reproduction that have always been there to compromise our happiness.

What is possible? What is not?

You have to be able to distinguish between fact and fantasy if you are to develop a mature attitude toward color management. For example, you may be tempted to believe that color management can guarantee that all of the colors in an original image will be faithfully reproduced by a printing process, overlooking the simple fact that the range or gamut of colors available from any one color printer has clear boundaries beyond which you simply cannot go. If a printing process is incapable of rendering a particular color, no amount of color management will coax it to do so.

We have always lived with the color-rendering limitations of printing processes. Seasoned color professionals are able to work within these limitations. This is a highly refined craft. However, it is not without its risks. Reading the minds of art directors or designers is difficult even when they tell you exactly what they want and their desires actually do fall within the capabilities of the reproduction process.

Color management seeks to replace human color expertise with visual tools that are easy to use and that do not require a technical understanding of color reproduction to be used effectively. Ideally, the user of this software should not have to know subtractive color theory, or even the names of the subtractive primaries. The user should also not be burdened with the knowledge that the

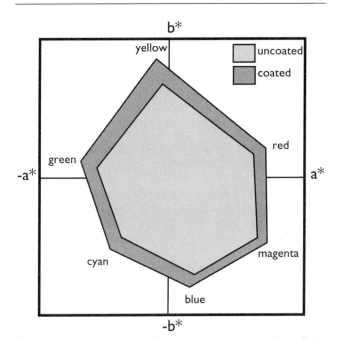

These gamut plots represent the color-rendering capabilities of the same ink jet printer on two different paper stocks. Coated paper yields the larger gamut because the dye-based colorants in the inks are held out on the surface more efficiently. Uncoated paper absorbs the ink more rapidly, and the dyes wick down into the paper fibers. This reduces the saturation of the printed colors.

color gamut of color monitors is inherently different, and generally much larger, than that of most printing processes. In fact, the user should probably not even be aware that color management is happening. In other words, the process should be transparent.

CMS workflows
Current CMS software is accessed as plug-ins to applications such as Adobe Photoshop or QuarkXPress. With the CMS products manufactured by Kodak, Agfa, Candela, and others, the software can be used to convert RGB files to CMYK for a specific target output process.

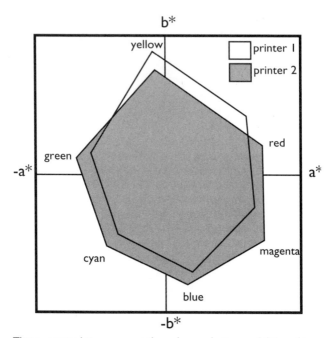

These gamut plots represent the color-rendering capabilities of two different ink jet printers on the same coated paper stock. These printers use different colorant sets and screening algorithms. In the red, blue, and green regions of color space, printer 2 produces more saturated colors. Printer 1 achieves better saturation in the yellow.

Alternatively, scanned images can be saved as RGB files and dropped into picture boxes in a page layout program. The CMS will then convert the RGB data to CMYK for the target printing process on the fly. This latter workflow enables documents containing color images to remain independent of the output device. If images are converted to CMYK and then incorporated into color documents, those documents are hard-wired to a single printing process and cannot be rendered properly on other printers.

Color management software can also be used to generate PostScript *color rendering dictionaries* (CRDs) that

can be downloaded to a PostScript RIP. A CRD converts CIELAB color specifications into CMYK values for a specific color output device. Images or spot color values in the reference color space can be converted directly by the CRD. This places the color transformation from device-independent to device-specific color space as close to the end of the process as possible.

Colorimetric or photographic rendering?

This brings us to a critical point. Because color printing processes generally have much smaller gamuts than original photographs or color images displayed on a monitor, many colors that we want to see printed cannot be printed. So we have to compromise.

There are two ways that a CMS can try to satisfy an original color specification that falls outside the gamut of the output process. The first way is to use the closest color inside the gamut. (Recall that the proximity of colors in CIELAB space can be expressed in ΔEs). This is an

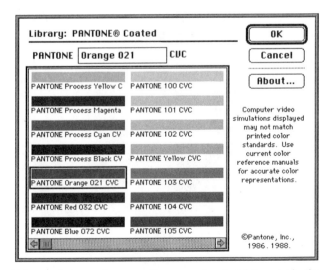

When a designer chooses a Pantone color that falls outside the gamut of the printing process, the CMS should output CMYK values that will yield the closest possible match to the specification.

appropriate compromise for spot color specifications, such as when a designer chooses a specific *Pantone* color from a swatch book. This method of color rendering is called *colorimetric rendering,* because it seeks to match the original colorimetric specification as closely as the gamut limitations of the printing process will allow.

Color images must be treated quite differently than spot color specifications. If the CMS attempts to transform all out-of-gamut colors in a photographic original, such that the printing process renders the closest possible match, the subtle relationships among colors in the original can be lost. Imagine that you start with a photograph of a red apple, and that all of the reds in the apple fall outside the gamut of the printing process. Colorimetric rendering would find the closest printable match to each

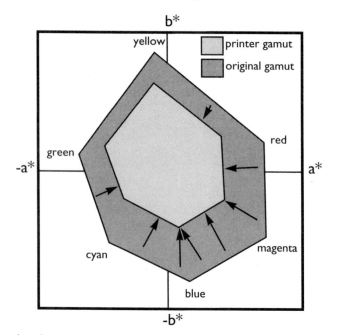

In colorimetric rendering, colors in the original that fall outside the gamut of the printing process are reproduced with the closest available color inside the printer gamut.

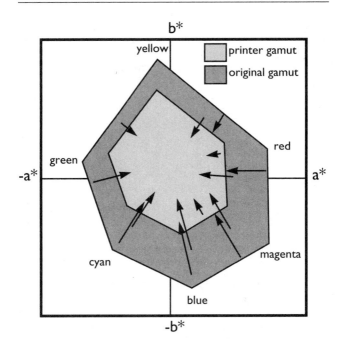

Photographic color rendering preserves the relative differences among colors in the original. This is accomplished by remapping each point in the larger color space to a corresponding point in the smaller space such that the relative distances among the points remain proportional. Note that colors in the original that fall inside the gamut of the reproduction process must also be changed. In colorimetric rendering, colors inside the gamut of the reproduction process are not altered.

of the shades of red in the apple. This would have the effect of flattening the detail in the original, producing a cartoon-like, flat color reproduction.

Proofing
Soft proofing is accomplished by using profiles for the input device, output device, and monitor to display an accurate view of how the image will ultimately appear in print. Much research has been conducted over the years on the relationship between color displayed on a monitor

and printed color, and how closely they can be made to match. From experience, we know that if every device in the chain is properly characterized, and the ambient lighting conditions are strictly controlled, soft proofing can be extremely accurate. Color accuracy is not the only issue determining the usefulness of a proofing method, however. Soft proofs lack the portability and permanence required for some applications. Soft proofs also cannot be evaluated under different lighting conditions, nor can they be held in your hand or hung on the wall.

Hard proofing

In many cases, there is no substitute for a hard color proof. It is not always possible to evaluate the effectiveness of images that will ultimately be printed by looking at a soft proof on a color monitor. The need for hard proofing will therefore always be with us.

Accurate hard proofing makes use of the input, final output, and proof printer device profiles. If you are using a dye sublimation or ink jet printer for hard proofs, these printers must possess color gamuts that completely enclose the gamut of the final target printing process. In fact, any proofing device must be able to render the entire gamut of colors of the target printing process.

Real-world color management

Most stand-alone CMS solutions are aimed at commercial markets where attention to accurate color reproduction has been the rule, and preparation of images for print has always been labor-intensive. In these markets, the idea that color expertise can be replaced by software is sometimes greeted with hostility. In some cases the hostility is warranted, because the very best software sometimes produces results that just do not look very good. There is a fundamental difference between a color monitor and a sheet of printed paper. What works on the monitor may not work on paper, even when the two are in close agreement.

The future of color management

Current technology works reasonably well within the confines of the few applications where it has been integrated as plug-in-level software, despite generally awful user interfaces and workflows that seem diametrically opposed to the way people intuitively desire to work with color images.

Color management properly belongs at the system level, where all applications that manipulate the same color data files are in agreement as to how those files will be transformed for display and print. System software should enable a user to easily access a device profile for a color printer and automatically adjust the display of all graphic elements to accurately reflect how they will appear when printed. The user should also be able to edit color in RGB space while viewing a soft proof for any selected output device. By choosing another output profile, the display should instantly change to reflect how everything will appear when printed on that device.

Conversion to device-specific CMYK color space should occur at the last moment before rendering—not a moment sooner. In fact, there is really no reason why humans even need to know what CMYK means. It should be as obscure as the innermost workings of your computer or your telephone. We will know that color management has become a mature technology when the subject itself has disappeared forever from the pages of books about printing. Perhaps the next edition of this book will jump from Chapter 7 to Chapter 9 without so much as mentioning it. Let's hope so!

Section Four

Digital Printing Applications

Chapter 9

VARIABLE PRINTING

The capability of varying the content of printed images from one impression to the next existed long before the digital age. The need to add variable content to printed units can be satisfied by strictly mechanical methods. The classic mechanism for doing this is a *numbering machine* — a small device that contains several circular numbering wheels. The wheels are more properly described as ten-sided polygons with a raised relief digit on each face. The number of wheels determines how high the machine can number (e.g., a six-wheel machine can count from 000000 to 999,999). If the odometer in your car could print, it would be a numbering machine. These machines were originally made for use on letterpress equipment. Each successive impression advances the mechanism to the next number.

Numbering machines are still used in a number of applications where successive numbering of printed products is required. Business forms and checks are primary examples. Current numbering machines are more likely to be computer-controlled than mechanically tripped. This allows the machines to be programmed with more flexibility, allowing for nonsequential numbering applications. Current machines are also likely to be used in conjunction with offset lithography, where they cannot be integrated into the lithographic ink transfer mechanism. Lithographic printing presses that allow on-line variable numbering are mechanically complex and custom-designed for specific product applications. Check-printing presses, for example, are specially designed devices that cannot easily be used to produce other types of products.

It is possible to extend the concept of a numbering machine into the realm of words by making each wheel larger and including alphabetic characters along with the ten digits. Some high-speed computer printers have used this type of mechanism, but the complexity of these machines borders on the absurd. Analog printing from

physical masters is ideal for applications where nothing changes from one impression to the next. Mechanical devices such as numbering machines enable analog processes to add variable information to the individual pieces of a job, but the nature of the variable information is extremely limited.

Digital variable labeling

Variable printing is where digital technologies really begin to shine. Digital print engines convert data streams into printed images. If you change the data stream, the printed images change. The most ubiquitous application for variable printing is high-speed marking of manufactured goods. Most consumer products sold today are marked with coded information that can be used to identify when and where the product was manufactured. Direct mail pieces are individually addressed and personalized using digital technology. High-speed ink jet processes have emerged as the dominant digital printing technology for these types of applications. Both continuous and drop-on-demand piezoelectric ink jet printers are used. The continuous devices are far more expensive than the drop-on-demand devices, but can generally achieve much higher speeds. Typical line speeds today are in excess of 1,000 feet per minute for the highest resolution continuous-array ink jet printers.

Monochrome continuous-array ink jet printers can be used to add variable image content to preprinted forms. This is common practice in the direct mail industry where the fixed information is preprinted using multicolor lithography, and variable information is then added to personalize each piece. The variable information is pulled out of a database and formatted for print output on the fly. In most direct mail applications, the variable information content is text only, and the digital stream required to drive the print engine can be pieced together rapidly from preexisting bitmaps. The processing required to prepare the data stream for each image is therefore quite simple and can easily keep up with the fastest print engines in current use.

Variable graphics

Variable text is the least demanding of variable print applications because the variable content added is constructed out of a limited set of bitmapped graphics, which can be stored in their final digital form and streamed directly to the print engine controller in their native format. Graphics can also be treated in similar fashion. If the graphics are stored in a database in the same format that will be streamed to the print engine controller, they can be inserted directly into the data stream and fed directly to the printer.

In high-speed operations where ink jets are used to add variable content to sheets printed by other processes, it is imperative that the system be able to detect the exact geometric position of the preprinted images on individual sheets and control the output from the printheads to achieve proper register. This is usually accomplished by adding timing marks to the edges of the preprinted forms. The marks are detected optically and used to synchronize the ejection of droplets to imprint the variable images in the correct locations on the page.

Current continuous-array ink jet printers made by Scitex Digital Printing used for adding variable text and graphics to preprinted forms, now operate at speeds exceeding 1,000 feet per minute. When run in parallel, these printers can be used to print as many as 5,000 letter-sized pages per minute.

Preprinted forms for desktop applications

The addition of variable information to conventionally printed sheets can also be accomplished on a much smaller scale using desktop ink jet or laser printers. This capability has spawned a large and growing market for preprinted paper products that can be personalized in desktop printers. These products include checks, labels, business forms, stationery, and predesigned brochures.

Integrated variable printing

Varying the image content of sheets that are printed on digital electrophotographic or ink jet presses is potentially more complex than adding the content to previously

printed forms. This is because the variable data must be embedded in the stream that is also used to print the fixed portions of the form. The simplest systems allow rectangular windows to be defined on the form into which variable content can be poured. There may be a limit to the percentage of the area of the form that can be varied in this manner. For example, a system may allow 25 percent of the printable area to be varied, while 75 percent remains fixed.

Designing variable-content publications

Software is now available to facilitate the creation of publications that contain variable content. The simplest solution to this problem is to create the fixed pages in a standard page layout application, such as QuarkXPress or Adobe FrameMaker, and create an encapsulated PostScript or PDF version of the document. The fixed pages are then imported into another application that allows the addition of variable fields.

Before the first digital presses were introduced, RIP technology had only been used to convert high-level page descriptions into device-specific data streams that would be used to create a physical master, or to drive low-speed digital printers directly. The first generation of PostScript RIPs were quite slow, and produced a bottleneck in the workflow. Subsequent generations of RIP technology have eliminated this bottleneck for applications in which the same image is reprinted many times.

When image content is varied from one impression to the next, the process by which the data is prepared and streamed to the print engine controller must be able to keep up with the press. If the press is capable of printing several thousand sheets per hour, and each sheet is unique, the RIPping must be done offline or by parallel processors to match the speed of the press.

Gutenberg was a mass marketer at heart

Digital printing presses capable of varying 100 percent of the image from one impression to the next are fundamentally different from any previous generation of printing technology. In the middle of the 15th century, Johannes

Merging fixed and variable content

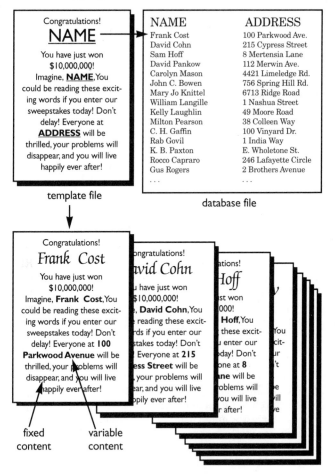

A template file contains the fixed part of a document as well as windows that reference external sources of data. In this example, the windows are filled with data extracted from a database of names and addresses. In this way each printed piece is personalized. The variable windows could also reference a database containing graphical elements such as EPS or TIFF files.

Gutenberg invented a mechanical system for reproducing pages of text. From a single master type form, he could make hundreds or thousands of copies, all exactly the same.

After the passing of more than five centuries, Gutenberg is alive and well. Most of the printed products that we encounter in our daily lives are produced on analog presses that are unable to vary the images they print from one impression to the next. The high cost of preparing the printing plates for these presses precludes their use for very short runs. Full-color sheetfed offset lithography is seldom used for runs of less than 5,000 impressions, and processes such as gravure and flexography are often used to produce millions of identical printed products. Variable information can be added to these products using a continuous ink jet printhead, but the product itself cannot change. In most cases, the variable information amounts to little more than a mailing address.

You can design a 200-page color catalog and have it printed on a web offset or gravure press for less than a dollar. The only catch is that you'll have to order a million copies of the catalog to get this unit price. However, if you have a large enough base of customers, the printed catalog is an inexpensive way of getting information into their hands. For some types of products, the mass-produced catalog remains the most effective form of advertising.

Targeted marketing

The capabilities of digital printing to vary the content of each printed piece have never been available before. This has unleashed a mad rush of speculation as to how these capabilities might be harnessed. In the first few years following the introduction of the Xeikon and Indigo digital presses, the only people who made any money with digital printing were consultants and writers, who can always turn any mad rush into a personal gold rush. Conferences were held, articles and books were written, and business plans were drawn up.

However, many of the earliest adopters of digital printing presses were sadly disappointed when they discovered that their customers were clueless as to how

System architecture
for variable page printing

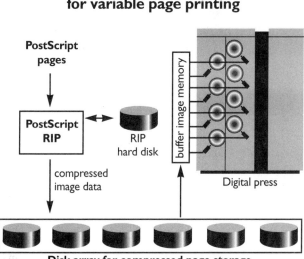

**PostScript
pages**

**PostScript
RIP**

RIP
hard disk

compressed
image data

buffer image memory

Digital press

Disk array for compressed page storage

these new capabilities might help them better reach their customers. There simply was no precedent.

But what if you could somehow determine the precise needs and wants of a potential customer, and then use digital printing to create a custom catalog or direct mail piece incorporating variable text and image content? The higher page cost of the digital process might be justifiable if the custom targeting capabilities produced better results. For example, if the cost to produce a direct mail piece digitally is five times the cost to produce it using an analog printing process, but the response rate on the digital piece is ten times better, digital printing is the more cost-effective technology.

To fully leverage the variable printing capabilities of digital processes, front-end systems must be able to integrate text and graphic elements drawn from various databases and merge them on the printed page. In the most sophisticated systems, a database containing information about existing customers' purchasing histories can be used in conjunction with another database of prod-

uct advertisements to configure custom-designed direct mail pieces that are targeted very precisely at individual customers. The success of these new approaches depends on the ability of software algorithms to successfully predict individual future purchasing decisions.

NAME	ADDRESS	LAST PURCHASE
Frank Cost	100 Parkwood Ave.	Model airplane
David Cohn	215 Cypress Street	Frisbee
Sam Hoff	8 Mertensia Lane	Backpack
David Pankow	112 Merwin Ave.	Old book
Carolyn Mason	4421 Limeledge Rd.	Disposable diapers
John C. Bowen	756 Spring Hill Rd.	Golf clubs
Mary Jo Knittel	6713 Ridge Road	N/A
William Langille	1 Nashua Street	Relaxation tapes
Kelly Laughlin	49 Moore Road	Stroller
Milton Pearson	38 Colleen Way	Big screen TV
C. H. Gaffin	100 Vinyard Dr.	Case of Carlo Rossi
Rab Govil	1 India Way	Armani suit
K. B. Paxton	E. Wholetone Way	Drum sticks
Rocco Capraro	246 Lafayette Circle	Salad shooter
Gus Rogers	2 Brothers Avenue	X-45
.

text database file

image database file

We have a special offer for

Frank Cost

We know you like airplanes! Imagine, **Frank Cost**, You could be so happy if you order now!

We have a special offer for

K. B. Paxton

We know you like music! Imagine, **K. B. Paxton**, You could be so happy if you order now!

Fixed form with merged variable text and graphic elements

Chapter 10

FINISHING

The printed sheets or rolls of materials that emerge from a digital printing device must normally be processed further to make a finished product. This can be as simple as collating and stapling the printed sheets before delivery. However, finishing operations can be extremely elaborate, requiring a good deal of time, expense, and special equipment.

The last shall be first
It has long been known that the design of printed products should always begin by considering what will happen at the end of the process, where everything will eventually come together. This book, for example, was printed in 16-page signatures on a web offset lithographic press. The signatures were folded, gathered, glued, covered and trimmed on three sides to produce the book you are now holding in your hands.

The capabilities of the printing press and the finishing methods to be employed were known long before the book was even written. The page design was chosen to take best advantage of the final product format. All halftone images were scanned and tone-corrected to accommodate the precise characteristics of the offset printing process.

The preparation of the electronic files for this book can be viewed as a two-stage process. The first stage was

independent of any specific concern about the particulars of the processes that would eventually be used to make the final product. Text was prepared using Microsoft Word, illustrations were drawn using Adobe Illustrator and images were scanned and retouched using Adobe Photoshop. All these elements were stored in separate files, and can be reused in a number of ways. Many of the illustrations and photographs that appear in this book, for example, may also appear in class presentation notes, journal articles, and technical reports in the future.

The second stage of production of electronic files for this book was the layout of pages using QuarkXPress. All of the elements prepared in stage 1 were merged in the QuarkXPress files. During this stage, the precise printing and finishing methods to be employed in the manufacture of the book were known and the QuarkXPress files were prepared accordingly. If, at the end of the page layout process, the publisher had decided to print the book on a different kind of press, or in a different format, the author would have collapsed in despair. All of the QuarkXPress files would have had to change to accommodate the new finishing plan.

Substrate types

Digital printing devices can be used to print on many different types of materials. These include papers, films, laminates, and fabrics (both woven and nonwoven). These materials can be fed into the printing device in either roll or cut-sheet form. If the material starts out in roll form, it can be rewound into a roll or cut into sheets after being printed. The Xeikon press, for example, is a roll-fed process that can produce cut sheets or rolls as output. Cut-sheet output is appropriate for publication work, and roll output is appropriate for labels and other applications where a roll of printed product is needed.

Some processes are able to print on a variety of substrates; others are restricted to special substrates. Phase-change ink jet printers, for example, are capable of printing on almost any material that will go through the press. (The author has seen examples of sandpaper printed on the grit side with a phase-change printer. The images

were beautiful.) Thermal dye diffusion printers, however, can only print onto special polyester sheets designed to receive the diffused dye from the donor ribbons. Between these two extremes are processes such as electrophotography and thermal ink jet that use water-based inks and produce different results on different substrates (e.g., plain versus coated papers). The chart below compares four processes using the criteria of substrate versatility and substrate dependence.

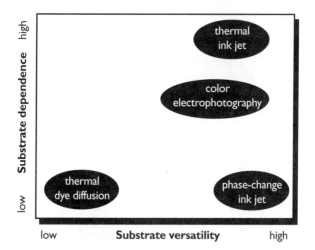

From this chart it is clear that phase-change ink jet and thermal ink jet processes can both print on a wide variety of substrates, but that thermal ink jet printing is much more dependent on the substrate. This explains why printer drivers for thermal ink jet printers ask you to supply detailed information about the type of paper you intend to use. They adjust the way tones and colors are rendered to accommodate the specific paper type.

Substrate sizes

Digital printers are currently available that can produce printed sheets anywhere from snapshot size up to billboard size. On the small end of the spectrum are thermal dye diffusion printers used to print photographic images

from digital files. On the other end of the spectrum are wide-format ink jet and electrographic printers that are used to create displays and signs for outdoor and public display. Generally, the larger the maximum size of the output sheet, the lower the absolute resolution of the printing process.

Many of the large-format ink jet devices are able to print on a continuous roll of material to produce extremely long images. One popular ink jet printer at the time of this writing is capable of printing a 54 inch wide image up to 160 feet long.

The first generation of sheetfed digital printing processes were restricted to small sheet sizes. This will undoubtedly change in the next few years, as presses are designed that can handle sheets in larger sizes. Some of most common sheet sizes used in the U.S. market are shown in the drawing on the next page.

Finishing operations

Many things can be done with printed sheets or rolls once they emerge from a printer. These can be grouped roughly into four categories:

1. Folding
2. Binding and trimming
3. Lamination and overcoating
4. Transfer processes

Folding

If you have ever studied *origami*, the Japanese art of paper folding, you know that a single square sheet of paper can be folded in thousands of different ways to produce as many different kinds of objects. Most automated folding machines are restricted to combinations of vertical and horizontal folds that produce rectangular signatures. Even so, the number of different fold combinations is staggering. A few of these are illustrated in the following pages, but many more are available.

The dimensions of the finished product are determined by the initial size of the sheet, the method and number of folds, the binding method chosen, and the amount of trimming allowed. The *perfect binding* method

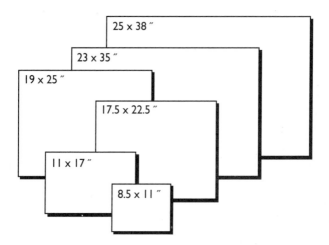

used to bind this book, for example, required that a small amount of material be trimmed from the spine before the gathered signatures were glued together. Once the signatures were glued and the cover was put on, the other three edges of the book were trimmed. Allowance must be made for this trim when the individual pages are assembled into an imposed press form.

Many digital printers produce single letter-sized sheets that are at their final size when they emerge from the printer. The Xerox Docutech is a good example of such a device. The Docutech duplex prints on either letter-size or 11 by 17 inch paper. The letter-size pages are gathered and bound without any trimming involved. The 11 by 17 inch sheets are normally folded to make 4-page letter-size signatures. These can then be nested to form books that will then be *saddle stitched*.

Color presses such as the Xeikon device can also produce letter-sized sheets that are gathered and bound without further trimming. A single book with a high page count can be printed in the correct sequence by downloading the preripped pages from a large disk array. In one configuration, using the Barco PrintStreamer front-end system, full-color books containing hundreds of pages can be printed in correct page sequence one at a time. The

Folds

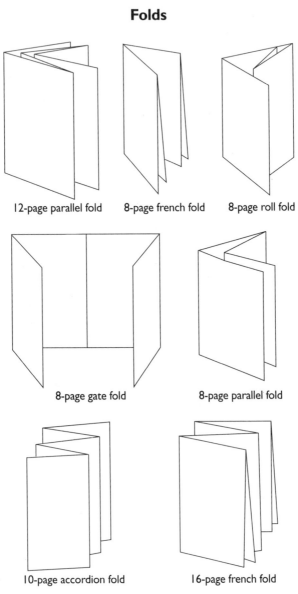

12-page parallel fold 8-page french fold 8-page roll fold

8-page gate fold 8-page parallel fold

10-page accordion fold 16-page french fold

gathered pages can then be bound inline or offline. The ability to print an entire book in sequential pages is especially desirable in demand printing operations in which products such as books and manuals are printed only after the order has been taken.

Binding and trimming

All publications larger than a single-sheet flyer must somehow be bound together into an integrated whole before they are ready for distribution. There are many binding methods in current use. Four major categories of binding are:

1. Sewn binding
2. Perfect binding
3. Mechanical binding
4. Saddle stitching

Sewn binding is the classic bookbinding method where folded signatures are sewn together and then trimmed and bound in a hard cover. This is still a popular method for binding hardcover books, and serves as the standard by which all other binding methods are judged.

An alternative to sewn binding is the *perfect binding* method used to bind this book. Instead of sewing the signatures together, the backs of the signatures are ground off and glue is applied along the spine to secure all the pages together. There are a number of variations on this theme, including new methods such as Otabind and RepKover, which produce a perfect bound book that lies perfectly flat on a table or desk.

Mechanical binding methods involve the use of metal spirals, plastic combs, or fasteners to secure pages together. Some of these are ideal for office applications because of the minimal equipment required. Spiral and comb binding methods also produce books that lie completely flat—an important feature in applications such as cookbooks, music books, and technical manuals. A new mechanical binding method, called Channel Bind, uses prefabricated hard cases with a metal insert in the spine. Loose pages are inserted into the case and a special device is used to crimp the metal insert to hold the pages securely. This results in a strong hardcover binding that

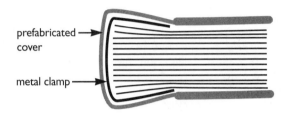

resembles a conventional case binding. Channel Bind cases come in a variety of thicknesses, but are restricted to books with letter-size pages. Because the pages are held together mechanically by a metal clamp, books bound by this method do not lie flat when opened. Channel Bind cases can be ordered with custom color printing incorporated. This enables a publisher to produce attractively designed books on demand.

The simplest binding method for publications with low page counts or printed on extremely thin paper is saddle stitching, a process that stitches through the spine with metal staples. In publications containing more than one signature, the signatures are nested and stitched before they are trimmed around the three remaining edges. This binding method is available for publications produced on digital presses such as the Xerox Docutech, Indigo E-Print, and Xeikon. When designing for saddle-stitched publications, it is important to compensate for *creep* of inside signatures away from the stitched spine, requiring more allowance for trim.

Lamination and overcoating

In many applications, a protective covering or coating can be applied to a printed sheet to enhance its durability. Lamination encases the printed sheet between two layers of clear plastic. Adhesive layers secure the plastic against both sides of the sheet. Laminators are available in sizes that will accommodate the entire range of digital print formats currently available, from the wallet-sized thermal prints produced by some ID card systems to signs produced on wide-format ink jet and electrographic printers.

Lamination is especially useful when printed sheets lack waterfastness and lightfastness on their own. Wide-format thermal ink jet printers are often used to produce signs that are intended for display in harsh environments. Point-of-purchase displays, for example, are exposed to constant high-intensity fluorescent illumination, and are expected to last for many weeks or months under such conditions. Signs intended for outdoor display must be able to withstand prolonged exposure to direct sunlight as well as to the elements. Most thermal ink jet inks contain dye-based colorants in a water-based vehicle and are easily damaged by exposure to ultraviolet radiation, humidity, and airborne oxidants. Lamination protects the printed surface from chemical and UV exposure.

Lamination is the most effective way to protect a printed sheet, but it is also the most expensive. Two other approaches are to overcoat the printed substrate with a protective material such as a varnish, acqueous acrylic, or UV-cured polymer, or to impart protective properties to the substrate itself. Moore Corporation, for example, has developed a method of coating labels printed on a Xeikon electrophotographic press with a polysilicone layer on top and an adhesive on the bottom. This process yields a roll of "linerless" labels that are nearly impervious to the elements and do not generate any waste as they are used.

Special substrates are now available that improve the waterfastness and lightfastness of thermal ink jet prints. These materials, marketed by Eastman Kodak, Kimberly Clark, and others, employ surface porosity and/or chemical additives to stabilize the dyes in the inks when they are applied to the substrate.

Transfer processes

A number of technologies are now available for transferring digitally printed images to surfaces that cannot be printed directly.

Images printed by a thermal dye diffusion printer can be transferred to the cylindrical surface of a ceramic coffee mug, for example. Heat and pressure are used to transfer the dyes from the printed sheet to the ceramic surface. A system consisting of a digital camera for image capture, a computer for adding other graphic elements such as text and line art, a small-format thermal dye diffusion printer, and a device for making the transfers to the ceramic mugs requires a relatively small capital investment.

Another transfer process employs special substrates marketed by Canon for desktop laser and ink jet printers. Images printed on these materials can be transferred to fabric by the application of heat and pressure with either a T-shirt transfer press or a hot iron.

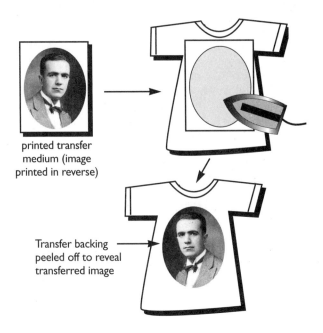

printed transfer
medium (image
printed in reverse)

Transfer backing
peeled off to reveal
transferred image

Chapter 11

CHOOSING THE RIGHT PROCESS

Choosing the appropriate printing technology for a given application is often an exercise in the fine art of compromise. Each process has strengths and weaknesses that must be weighed with respect to the requirements of the job at hand. In most cases the decision is fairly straightforward, because one or another digital process is clearly a better choice than any of the others. For example, color printing in the home market is now almost completely dominated by ink jet devices, because they are inexpensive, require little maintenance, and produce image quality that completely satisfies the needs of home users. In contrast, monochrome office printing applications on letterhead and envelopes are dominated by laser devices, because they provide the image quality, throughput, and low material costs demanded by that market.

This chapter examines a number of criteria for choosing printing processes for specific applications. As we will discover, digital printing processes must satisfy the needs of existing or emerging markets to remain or become viable. The formula for success in most cases has several dimensions.

There are six major criteria that will determine the suitability of a digital printing process for a given application. These are:

1. Print quality
2. Media size range
3. Media types
4. Physical properties of printed sheets
5. Run length/cost per unit
6. Throughput/turnaround time

Print quality

Print quality, independent of viewing distance, is a function of both the information-carrying capacity of the printing process per unit area and the quality of the

information itself. An analogy in the domain of music is instructive. The "quality" of a digital sound recording is both a function of the information-carrying capacity of the medium and of the musicianship of the recording artists. The highest fidelity recording of bad music is still bad. The same is true of image reproduction. If low-resolution data is rendered by a high-resolution process, the resulting print quality will be poor. Conversely, if high-resolution data is rendered by a low-resolution process, the resulting print quality will also be poor.

When we assess the print quality of any device, it is appropriate to concentrate on its information-carrying capacity and factor out the information quality variable. This is why standard digital images are used in comparison testing of printers.

Image quality is the most complex criterion because it involves subjective judgment. Completely acceptable image quality for one application may be unacceptable for another. Perhaps the most obvious example of this is the demand for brilliant color in the consumer market versus acceptance of monochrome printing in the office market. There is effectively no remaining demand for monochrome printers in the consumer market because color ink jet printers are now available at prices starting in the low hundreds of dollars.

Visual expectations

The question of image quality always comes back to a discussion of the resolving power of the visual system and the expectations of the observer, especially if the observer is the one who is expected to pay for the printing. It would appear that image reproduction processes have always had the tendency to move toward visual thresholds, whether they start above or below those thresholds. If there is not enough detail in a reproduction, there will be pressure on technology developers to increase the resolution of the process. At the same time, excess detail that cannot be seen from a normal viewing distance will usually be wrung out of a process over time to save time and money. Most of the photographic processes of the 19th century exceeded the resolution requirements for normal

Print quality and typical run lengths of printing processes

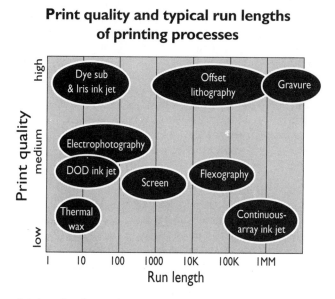

viewing. In the early part of this century, photographic pioneers like Steichen and Cameron began to purposely blur their photographs to produce a more artistic effect. Today, most photographs are made from 35mm negatives, and possess nowhere near the resolution of photographs made more than a century ago.

On the other side of the resolution threshold, film formats such as 110 cartridge and Kodak Disc film have all but disappeared from the market, because they produce images without sufficient resolution. Human visual expectations are the only significant standard for image quality. Image reproduction processes strive to satisfy these expectations.

Raising the print quality bar
The first generation of desktop laser and thermal ink jet printers had an addressability of 300 dpi. This produced visible aliasing, which was generally considered objectionable in all applications. Grayscale images reproduced

as halftones on a 300 dpi printer are crude. Type and line artwork appears jagged at the edges.

Nonetheless, the market embraced these devices for a number of applications where image quality was a secondary consideration after cost. Typesetting with your own Macintosh and laser printer was a lot less expensive than buying services from a traditional typesetting house over time. Shortly after the introduction of the first 300 dpi laser printers in the mid 1980s, a number of books, magazines, direct mail pieces, and other printed products that had been "typeset" on these printers began to appear on the market.

The reaction of the typesetting industry was one of intense disapproval and anger. How could anyone possibly be satisfied with the "garbage" that was streaming out of these newfangled laser printer devices? Some users were not, of course. And the industry generally acknowledged the quality deficiencies, despite the rapidly increasing number of users.

The next generation of laser printers jumped to 600 dpi addressability, and most featured some form of resolution enhancement technology that increased the smoothness of edges even beyond the theoretical limits at 600 dpi. This is now considered the standard addressability for laser printers as well as the black printers in most desktop color ink jet printers. (Epson was the first to market with a 720 dpi color ink jet printer capable of producing near-photographic-quality color reproductions.) At 600 dpi, especially with resolution enhancement, the quality of rendered type and line art is sufficient. Current high-end laser printers are capable of 1,200 dpi addressability. This additional addressability is wasted if all you are printing is text and simple line art. You cannot see the difference.

Grayscale images present a different challenge. At 600 dpi, a binary printer will have to trade some visible spatial resolution to achieve a smooth transition from the highlight to the shadow end of the scale. The best compromise between spatial and tonal resolution can be obtained with frequency-modulated screens. However, at 600 dpi, even the most sophisticated screening methods

will introduce spatial artifacts, such as graininess and contouring, that are visible and may be considered objectionable.

Increasing the addressability of a laser printer to 1,200 dpi improves the resolution of printed images. However, dry toner electrophotographic processes begin to misbehave as we try to squeeze more and more resolution out of them. The charged toner particles interact in ways that are not always predictable, and the resulting image quality may be compromised. This is usually in the form of streaking or mottling that is highly visible and highly objectionable. Color desktop laser printers suffer from many of the same problems as their monochrome comrades.

Ink jet printers are less problematic in this regard. The control over droplet size and placement, and the lack of interaction between the droplets, produces relatively smooth tones and transitions. The first generation of thermal ink jet devices were plagued by nozzle clogging problems caused by the crusting of dried ink around the nozzles. Clogged nozzles result in fine streaks in printed images that are highly objectionable. Current printers are largely free of these problems because of advances in printhead design and improvements in materials.

In color printing applications, the image-rendering capability of the typical $500 color ink jet printer is generally superior to color laser output from machines costing and weighing 10 times as much. Color ink jet printers are now dominant in the consumer market, and will undoubtedly come to dominate the office market for desktop color printing as well. However, high-end color electrophotographic copier/printers, such as those made by Xerox and Canon, will continue to be attractive for office network printing, where throughput and material costs are dominant concerns.

Media size range
Media size range is a discrete attribute of any printing process that will determine its suitability for a given application. We often see this capability expressed in terms of maximum printable area, which will nearly

always be less than the maximum sheet size. The smallest format printers are called *page printers*, and are typically designed around one or two standard sheet sizes (in North America these are 8.5 by 11 and 8.5 by 14 inches).

The next size up are printers capable of printing a two-page spread on one sheet. Sheet sizes here are 11 by 17 inches or slightly larger (e.g., 12 by 18 inches) to allow for a two-page spread with full bleed off all four edges. The slightly larger size is required in proofing applications, where the sheet will be trimmed to a final size of 11 by 17 inches with full bleed.

Beyond this size is the realm of large-format printers, where maximum width is often fixed and length is variable depending on the capabilities of the front-end computer system. In some cases the length is unlimited.

Large format usually implies greater viewing distance. Consequently, large-format printers typically possess lower absolute spatial resolution than page printers. However, one type of large-format color printer, the continuous area-modulated ink jet devices manufactured by the Iris division of Scitex, are capable of printing large sheets up to 30 by 40 inches at extremely high spatial resolutions approaching that of color photographic paper. Higher resolutions are also becoming available for wide-format drop-on-demand ink jet printers.

Media types

Some printers are compatible with a wide range of substrates. The term *plain paper* means more precisely *unspecified* paper. The ability to print effectively on unspecified paper is desirable. Laser printers and phase-change drop-on-demand ink jet printers are the most versatile in terms of paper type. This is because, in both cases, there is minimal interaction between the colorant and the substrate.

In the case of laser printers, the dry powder toner is electrostatically attracted to the substrate surface and fused there by rapid heating. The toner does not penetrate the paper fibers to any significant extent. Phase-change ink jet printers spit tiny molten droplets of wax-based ink at the substrate, where they freeze instanta-

neously upon contact. Again, the ink does not penetrate the substrate significantly. In both cases, therefore, differences in the surface qualities of substrates do not have a significant impact upon image quality. Hence, these processes are said to be compatible with plain paper.

Ink jet processes that use water-based inks are somewhat less forgiving of differences in surface characteristics of substrates. Water-based inks will tend to penetrate deeply into the paper fibers. This has a profound effect on the appearance of the printed images. Identical images printed by the same ink jet printer on different paper types can appear radically different from one another. This makes it necessary for thermal ink jet printer drivers to vary the screening methods used to render images on different paper types. Even though thermal ink jet printers are considered plain-paper devices, their performance is more dependent on the particular characteristics of the substrate than either laser printers or phase-change ink jet printers.

Ink-substrate interaction

Ink-substrate interactions are more variable in ink jet processes that employ water-based or other extremely low-viscosity inks. Different substrates absorb the ink at different rates, leaving more or less of the colorant on the surface. Generally, the color gamut decreases as penetration into the surface increases.

Ink-substrate interactions are far less variable in phase-change ink jet processes that employ molten wax-based inks. The ink droplets freeze instantaneously on the substrate surface and do not have a chance to penetrate into the fibers.

Some printers, such as the thermal dye diffusion printers, are only compatible with special substrates that are manufactured or OEMed by the printer maker. These substrates are so highly specialized that they are not intended be interchanged with substrates manufactured for use in other dye diffusion printers. These printers also use ribbons that are specifically designed for them. Once you own one of these printers, you are forced to buy the consumables from the same manufacturer—making thermal dye diffusion printers the digital printing equivalent of a Polaroid instant camera or a Gillette razor blade holder.

It probably comes as no surprise that plain paper tends to be far less expensive than special substrates available only from a single supplier. The finest plain paper on the market (e.g., Cranes Crest 100 percent cotton paper) can be purchased for less than a nickel a sheet, and the standard plain-paper sheet for laser printing is priced at around a penny. Special substrates for thermal dye diffusion printing, on the other end of the price spectrum, can cost several dollars a sheet. Part of the cost differential can be traced back to higher cost ingredients and more sophisticated manufacturing processes. However, if there were real competition among many suppliers of dye diffusion consumables, prices would be far lower than they are.

For this reason, the capability of printing on plain (unspecified) paper is considered a strong selling point for any printer. If a plain-paper ink jet printer were available that produced image quality on a par with the best thermal dye diffusion printers (assuming capital costs were equivalent), dye diffusion printing would be blown completely out of the market, never to be seen again.

Most digital printers sold into the office market are capable of printing on both reflective and transparent substrates. Transparent sheets for ink jet and laser printing are coated and given a surface finish that is compatible with the ink transfer and drying method employed, and are not interchangeable. These specialized substrates are considerably more expensive than plain-paper sheets, priced in the range of $0.50 to $1.00. Other specialty sub-

strates include pressure-sensitive papers and plastics with peel-off liners, polymer sheets for iron-on textile transfer printing, and preprinted stationery and business forms.

Physical properties of printed sheets

How will the printed product be used? In what environment? How durable must it be? These are important questions. A process that produces the right level of image quality, in the right format, at the right price, may well be inadequate for some applications where the durability of the output is not sufficient for the intended use. Three important attributes are lightfastness, waterfastness, and resistance to physical damage when handled.

Lightfastness is the ability of the colorants to resist fading during prolonged exposure to light—particularly ultraviolet. Generally, dye-based colorants are more prone to fading than pigmented colorants. Most printing processes employ pigment-based inks or toners. Dyes are compounds that are soluble in the ink vehicle. Pigments, however, are not soluble, and must therefore be ground to a fine powder and suspended in the vehicle. Individual dye molecules in solution are far more susceptible to the ravages of UV exposure than are relatively large pigment *boulders* containing millions of individual molecules.

In thermal ink jet printers, dyes are normally used because it is easier to get them to go through the tiny orifices. DuPont is pioneering the development of pigmented thermal ink jet inks for its partner, Hewlett Packard. The first commercially successful pigmented ink was the black ink used in Hewlett Packard's 1200C ink jet printer. Compared to standard dye-based inks, pigmented inks have much better lightfastness properties.

Waterfastness is the ability of printed images to resist exposure to moisture. Paper substrates are inherently unstable when wet. However, we generally want inks or toners printed on paper to remain stable when exposed to small amounts of moisture in the course of normal handling. When materials are intended for outdoor display, the substrate as well as the colorants must be impervious to water. Materials such as polypropylene and polyester

are compatible with a number of digital printing processes, including wide-format ink jet and electrographic printing. In some cases, printed sheets can also be laminated to improve their waterfastness.

Cost per unit as a function of run length

Digital printing processes turn the classic formula for cost of consumables, where paper is the most expensive ingredient, on its head. With digital printing processes, the paper can be a small fraction of the cost of the ink or toner. The one exception is thermal dye diffusion printing, in which the paper and ribbons are both worth their weight in gold (or at least myrrh).

When the first generation of digital presses appeared, consumable costs were very high—more than a dollar for a letter-size duplexed page with 50 percent average coverage. In the past few years, these costs have steadily declined, and they are expected to continue to decline well into the future. As the volume of usage increases, and the ink/toner business for digital processes becomes competitive, the costs will come more into line with conventional printing inks.

The cost per unit is also related to run length. In ana-

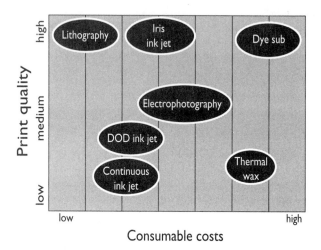

log printing processes such as lithography and flexography, the up-front costs associated with prepress, proofing, and platemaking are very high. Extremely short runs, especially of color work, are simply out of the question because of the need to amortize these costs over longer runs to get the unit cost down to a reasonable point.

The following graph shows the cost per unit of a printed piece over the first 1,000 units, given a prepress cost of $2,500 and incremental costs of $2 per unit. The cost per unit is extremely high if the run length is very small. (A run length of one unit would cost more than $2,500.) This illustration does not consider postpress fixed costs (the cost of setting up and running the finishing lines), but they must also be amortized over the length of the run. The high fixed costs associated with conventional printing processes therefore make these processes ideal for long runs.

Digital processes eliminate many of the fixed costs of analog processes—film assembly and platemaking, for example. However, preflighting and ripping electronic files can still represent a significant up-front cost that must also be amortized over the length of the run. This makes it likely that unit cost will continue to be somewhat dependent on run length for some time to come. The chart on the next page compares the relationship between run length and unit cost of lithography and a current dig-

Unit cost versus run length

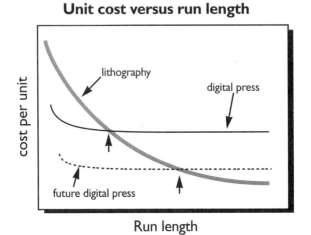

ital press. The fixed costs associated with lithography are much higher, but the unit cost is much lower for longer runs. This is because the incremental costs are far less (litho ink is a lot less expensive than toner for a Xeikon or Indigo press). In the next few years, as consumable costs come down, digital printing processes will be able to compete with analog processes for longer and longer runs.

Throughput and turnaround time

There are several ways of measuring throughput. The throughput of high-speed processes such as web offset lithography and gravure is often measured in feet per minute. The current generation of web offset presses run at speeds approaching 2,000 feet per minute. This may yield as many as 50,000 to 60,000 folded 16-page signatures per hour. This amounts to more than 480,000 duplexed letter-size color pages per hour.

Current digital presses operate at much lower speeds, producing only a few thousand duplexed color pages per hour at best. The fastest monochrome digital printers such as the continuous-array ink jet printers, operate at web speeds in excess of 500 feet per minute, which can yield more than 30,000 printed sheets per hour.

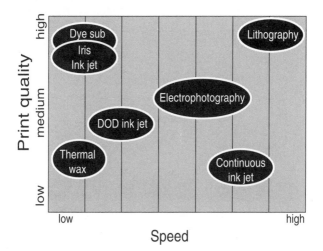

The throughput of a printing system should not be viewed separately from the cost of the equipment. A web offset lithographic press capable of producing 50,000 16-page signatures per hour is a multimillion dollar piece of equipment with hourly costs in the hundreds of dollars. A high-end color electrophotographic printer such as a Canon CLC or Scitex Spontane may only be capable of producing a few thousand sheets per hour, but costs a small fraction of what the web press does to operate. A desktop ink jet printer may produce only 50 or 60 color pages per hour, but at an hourly cost to run of only a few pennies.

Several slower, less expensive printers can be grouped together to match the throughput of a larger, more expensive device at a significantly reduced overall operation cost. This is the basic inspiration behind solutions pioneered by TR Systems which sells both color and monochrome printing systems based on parallel arrays of inexpensive printers. These systems are significantly less expensive than larger single-engine printers with comparable throughput. (The idea of matching the capabilities of a big device by organizing a parallel array of smaller devices has also been successfully implemented in the

Digital Process Summary

	image quality	run length	speed	consumable $	device $
Ink jet					
thermal ink jet	medium	short	low	medium	$nnn
piezo ink jet	medium	short	low	medium	$nnn
phase-change ink jet	medium/high	short	low	medium	$n,nnn
continuous-array ink jet	low	long	high	medium	$nn,nnn
continuous AM ink jet	high	short	low	medium	$nn,nnn
Electrostatic					
monochrome EP (desktop)	medium	short	low	low	$nnn–n,nnn
monochrome EP (volume)	medium	medium	medium	low	$nn,nnn–nnn,nnn
color EP (desktop)	medium	short	low	medium	$n,nnn
color EP (volume)	medium/high	short	low	medium	$nn,nnn
electrographic color	low	short	low	low	$nnn,nnn
electron-beam	low	long	high	low	$nn,nnn–n,nnn,nnn
Thermal					
dye diffusion	high	short	very low	very high	$n,nnn–nn,nnn
wax transfer	low/medium	short	very low	very high	$nn,nnn

image quality (low = 300 to 600 dpi binary; medium = 600 to 1,200 dpi binary; high > 1,200 dpi binary)
run length (short < 100; medium up to 5,000; long > 5,000)
speed (very low < 1 ppm; low = 1 to 10 ppm; medium = 10 to 100 ppm; high = 100 to 1,000 ppm)
consumable $ (low < $0.05 per sheet; medium = $0.05 to $0.25; high = $0.25 to 0.50; very high > $0.50)

realm of magnetic disk storage devices, where *RAID* (Redundant Arrays of Inexpensive Disk) technology has proven to be more cost-effective than single drives with comparable storage capacity.)

If we compare the cost of digital printing devices to achieve similar throughput, an interesting relationship emerges. Digital color presses deliver the *lowest* through-put per dollar invested of any printing technology cur-rently on the market.

Process	Cost of device	ppm
Digital color press	$300,000	70
Color laser	$7,000	10
Desktop ink jet	$500	2
Web offset press	$4,000,000	10,000

The digital color electrophotographic press has a throughput of 70 pages per minute (ppm), but comes with a price tag of around $300,000. The desktop electrophoto-graphic printer is one-seventh as fast as the digital color press, but only costs around $7,000. To match the throughput of the digital press, you would need seven color laser printers totalling less than $50,000.

The desktop ink jet printer delivers 1/35 the through-put of the digital color press, but 35 desktop ink jet print-ers to match the throughput of one digital color press would cost only $17,500. It is interesting to note that a web offset press still delivers the most throughput for every dollar of capital investment, delivering more than 140 times the throughput of the digital press for only slightly more than 13 times the capital investment.

Add to this the many times lower cost of ink for web offset printing and other analog processes, and it becomes clear that for high-volume applications in which the image content is fixed, analog printing will be around for a long time to come. Rather than compete with analog processes for markets where long runs and low page costs are still the norm, digital printing is charting new territo-ry in hundreds of new markets where color printing has never before been available, and where short-run, vari-able-content, demand printing is the order of the day.

Glossary

A4 size. European standard size page measuring 8.3 by 11.7 inches—a bit narrow and too long for comfortable use by North Americans.

ablation. The rapid vaporization of a solid by application of heat. Process by which a high-powered laser is employed to remove a layer of colorant from the surface of a sheet of film. The removed material can also be transferred to a receiver sheet to form an image.

accelerator. A board added to a computer to make it do something faster. Some accelerators cause computers to execute more instructions per second. Other accelerators speed up specific functions. For example, you can buy an accelerator board specially designed to speed up critical Adobe PhotoShop functions such as unsharp masking and color transformations from RGB to CMYK.

Acrobat. System developed by Adobe for creating, reading, and annotating documents in *PDF* (Portable Document Format).

additive primaries. Red, green and blue light sources. The primaries used in color television and computer displays. All colors that can be displayed on a television or computer display are combinations of red, green, and blue light emitted by phosphors coated on the inside of the tube.

addressability. The spacing of the marks that a digital printer makes, usually expressed in terms of *dpi* (dots per inch).

alias. Spatial distortions introduced when an analog signal is converted to digital. This is often associated with undersampling of the analog signal, as when an image is scanned at too low a resolution. This also occurs when outline fonts are converted into bitmaps for rendering on a digital printer and are afflicted with a condition known as "the jaggies."

amplitude-modulated halftone screening. Conventional halftone screen patterns in which spacing of dots is uniform, but size of dots varies to produce the illusion of gray scale.

anilox roller. In flexographic printing, the roller that controls the flow of ink to the plate.

ANSI. The American National Standards Institute.

anti-aliasing. Minimizing the effects of aliasing by making subtle adjustments to a displayed or printed image.

appropriate technology. In the context of digital printing, the process or processes that provide the required throughput, image quality, page cost, and product versatility for a given application.

archive. A system for storing computer data that serves as a back-up copy in case original data on the hard drive is lost or damaged. Types of data storage systems suited to this purpose include DAT drives, optical drives, and WORM drives.

argon ion laser. Blue laser of 480 nm wavelength used to expose blue-sensitive films and plates.

artifact. Repeatable defect in a printed image caused by some discrete element in the printing system. An artifact such as banding may be caused by the screening method used.

ASCII. The American Standard Code for Information Interchange. Numbers from 0 to 127 are assigned to text characters for standard encoding of American English text. The code for the upper-case A is 65. The code for the lower-case t is 116. If I send you ASCII number 65 followed by the number 116, you will decode the two numbers as the word "At".

ASIC. Application-Specific Integrated Circuit. A computer chip designed for a specific function such as graphics processing. The design can be optimized for that function,

and can be made to perform it more efficiently than a general-purpose processor of the same level of complexity.

aspect ratio. The ratio of width to height of an image, or a computer display, or the individual pixels that make up a digital image. Most digital images have square pixels with an aspect ratio of 1:1, but nonsquare pixels are also possible. If a digital image with nonsquare pixels is displayed as though the pixels were in fact square, the resulting image will be distorted in either the vertical or horizontal dimension—in other words, squeezed or squashed.

asynchronous communications. Data communication that does not rely on a synchronization of clocks at either end of the connection.

ATM. An acronym with three common meanings, none of which has anything to do with the other two. Asynchronous transfer mode is a high-speed data communications protocol. The Adobe Type Manager is a font-rendering system extension on desktop computer platforms. An automatic teller machine is a vending machine that dispenses money and other financial services.

banding. 1. Undesirable horizontal or vertical artifacts in a printed image. 2. Breaking up a digital image into horizontal stripes prior to rendering on a digital printer with limited memory.

bandwidth. The capacity of a communications medium to carry information.

Barco PrintStreamer. Front-end system for high-speed page streaming to the Xeikon DCP-1 digital press.

basis size. The size of a full sheet of paper in a given family. For example, *cover* basis size is 20 by 26 inches, *book* basis size is 25 by 38 inches, *bond* basis size is 17 by 22 inches.

basis weight. The weight of 500 sheets of paper in a standard 25 by 38 inch size for book papers and 17 by 22 inch size for bond papers. Basis weight is directly propor-

tional to the weight of the finished product printed on that paper. A book printed on 24-pound paper would weight half as much as the same book printed on 48-pound paper.

batch printing. The automatic printing of a number of jobs without human operator intervention.

baud rate. A measurement of the speed of digital communications roughly equivalent to bits per second.

beta test. Final test in an actual production environment of a software-based product prior to release.

bézier curve. Curve, named for a French mathematician, described by two end points and two control points; used to describe the outlines of graphic objects.

bidirectional communication. Two-way communication link between two devices allowing both devices to send and receive information. Many digital printers can be connected to a computer via bidirectional cable, enabling the printer to send information regarding the status of the printing job back to the computer.

bidirectional printing. In some kinds of digital printers, printing in both directions as the printhead moves back and forth across the substrate. Most desktop ink jet printers are bidirectional.

big color. Large-format digital color printing.

bilevel. Usually refers to a scanner, display, or printer capable of collecting or rendering a single bit of information per pixel.

binary file. Any digital file, such as a computer program, image, sound recording, or the like, that is not character based.

binary image. An image consisting of areas of either black or white, with no intermediate values. On film, a binary image consists of areas of low or high density with no intermediate values. Film negatives or positives used

in platemaking for lithography are binary images. Digital binary images are made up of pixels represented by single bits.

bit. Contraction of *B*inary dig*IT,* of which there are only two: 0 and 1.

bitmap. A two-dimensional arrangement of bits representing an image containing only two tones—black and white.

bitmapped font. A font made up of characters described as bitmaps.

blanket. Intermediate surface used in offset printing processes to transfer ink from plate to substrate. In offset lithography, the blanket is a smooth rubberized fabric stretched around a steel roller.

bleed. Any image that extends all the way to a cut line or into the gutter of a book. Bleeds must actually extend past the intended line to allow for slight misregister in the trimming operation or binding.

blotchies. Artifact in an electrophotographic print caused by uneven release from the fusing roll. Blotchies appear as areas of differential gloss on a print.

blind embossing. Embossing without any ink or foil transfer.

bomb. 1. Clever way a Macintosh computer leads you to believe that it is still in complete control even though the system has crashed. 2. Element in a document that causes a processor such as a RIP to crash.

bond paper. Standard uncoated sheet in 17 by 22 inch basis size.

book paper. Standard coated or uncoated sheet for book printing; also known as offset paper. In North America, the standard sheet size is 25 by 38 inches.

boustrophedonic. Back and forth as the ox plows. Originally this referred to early Greek systems of writing

that alternated the writing direction every other line. What does this have to do with digital printing? In thermal and piezoelectric ink jet printing, the printhead moves back and forth across the width of the substrate, printing in both directions. Bidirectional is a less colorful term meaning the same thing.

brightness. A measure of the whiteness or reflectance of a sheet of paper.

bubble-jet. Canon's proprietary term for its thermal ink jet printing process.

buffer. Area of computer memory used for temporary storage of portions of a data stream.

bulk. Paper thickness. If this book had only 100 pages, the publisher might have used a higher bulk paper to increase the thickness of the book.

calendered paper. Paper that is pressed between steel rollers during manufacture to increase smoothness and reduce porosity. Some electron-beam printers use pressure rollers to fuse the toner to the paper, causing the paper to become shiny or calendered. In some cases calendering is accomplished with heat alone.

caliper. The thickness of a sheet of paper.

capstan drive. Imaging device that uses pinch rollers to transport the material through the machine. Compare *internal/external drum imagesetter.*

carrier. 1. Magnetic beads used in a two-component dry electrophotographic developer. Toner particles adhere to the beads and are transported to the photoconductor. 2. Organic solvent in which toner particles are suspended in a liquid development electrophotographic system.

CCD. Charge-coupled device. CCD arrays are used in scanners and digital cameras to detect and record intensity and color values in samples taken from an original image or scene.

CCITT Fax. International Consultative Committee on Telegraph and Telephone (translated from the French). A data compression standard for line art that encodes unbroken lengths of black and white pixels based on their statistical frequency. A very short code is used to encode a full blank line of pixels, as there are usually many of these on a typical page (between the lines on this page, for example).

CD-ROM. Compact Disk with Read-Only Memory. Optical storage device that can accept more than 650 megabytes of data.

changeover. Reconfiguring a printing device between jobs. The number and duration of changeovers in a given period contribute to the percentage of *down time.*

charge agent. Material added to an electrophotographic toner to impart a positive or negative charge.

charge roller. In electrophotographic printing, the roller that applies a static charge to the photoconductor prior to imaging.

charged area development. In electrophotographic systems, development in which the toner charge is the opposite polarity of the charge applied to the photoconductor. Exposure discharges the nonimage areas and toner adheres to the image areas retaining the charge. This is sometimes called a *write white* system.

chemical-free processing. Another name for dry processing. The term was coined by marketers to underscore the environmental benefits of dry-process materials.

Chromapress. Trade name for digital color printing presses manufactured by Agfa based on print engines made by Xeikon.

CIELAB. Device-independent color space in which three variables (*L, a,* and *b*) are used to describe a color.

CLC. Acronym for Color Laser Copier printers made by Canon.

client/server. Computing paradigm where centralized computers called *servers* are connected to distributed computers called *clients*. Clients access software on the servers to perform specific tasks.

CMS. See color management system.

CMYK. Cyan, magenta, yellow, and black—the four printing colors. YMCK is a misspelling of the name of a men's association, and KCMY is probably a radio station somewhere in Nebraska, although both are used as synonyms for CMYK. In printing, the ordering of letters may imply the printing sequence in four-color work. Thus, KCMY may be used to indicate that the first ink printed is black, followed by cyan, magenta and yellow.

cockling. Paper puckering in ink jet printers using water-based inks.

color gamut. The total range of colors that can be rendered by a process color printer.

color management system (CMS). Software for calibrating the display and printing of color images.

color portability. The ability to move color information across platforms or software applications while maintaining its objective meaning.

color rendering dictionary. A lookup table residing in a PostScript RIP that converts CIELAB color specifications into CMYK values for a specific color printer.

color separation. The process of converting an original image into a format compatible with a color printing process.

color space. A three- or four-dimensional coordinate system in which each point represents a color defined as a combination of three (e.g., RGB) or four (e.g., CMYK) variables.

color transform. A transition from one color space to another (e.g., from RGB to CMYK).

colorant. Material added to ink, toner, or ribbon to impart color properties. The colorant is usually suspended in a transparent vehicle or *substrate.*

colorimetric rendering. Method of color rendering where the goal is to reproduce colors as accurately as possible.

ColorSync. Apple operating system-level color management system. ColorSync provides the basic machinery for calibrating color across input, display, and output devices.

commercial-quality printing. Print quality found in contemporary books and similar printed pieces.

comp. Rough color proof of a final printed piece.

composite black. Black produced by overprint of cyan, magenta, and yellow.

compression. Reducing the size of a digital file by some more or less complex method. Generally there are two types of compression: lossless and lossy. Lossless compression reduces the size of a file without losing any information. *Lossy compression* usually results in higher compression ratios, but does not preserve all of the original information in the file. Visually lossless compression methods preserve the visual appearance of an image even though information is lost.

compression ratio. The ratio of the original size of a file to the compressed size. A 10-to-1 compression ratio yields a compressed file one-tenth the original size.

computer-to-plate (CTP). The exposure of a printing plate by a computer-controlled laser, bypassing the need for film. Some CTP systems employ photopolymer plates that require wet processing after exposure. Others employ dry plates that do not require any processing.

consumable. Any material, such as ink, toner or paper that is used up and must be continually replenished, providing a constant revenue stream for the manufacturer.

Some color printers are sold practically at cost to generate demand for the consumables.

content-driven document. Digital document format emphasizing logical structure rather than physical appearance. Compare *layout-driven document.*

continuous forms. Paper in rolls or fanfolded sheets used for printing business forms. This paper may be preprinted or blank.

continuous ink jet. Ink jet printing processes that employ printheads that eject a continuous stream of droplets, deflecting and recirculating unwanted droplets.

continuous-tone. An image with several intermediate gray tones between highlight and shadow.

contone image. A digital raster image in which each pixel is a number representing the gray level of the image at that point.

contouring. Visible steps between adjacent gray or color values in a reproduction.

contract proof. Color proof used to secure final approval by customer before a job is printed.

cost per page. See *page cost.*

cover. Family of paper suitable for use as a book cover. Cover papers have a basis size of 20 by 26 inches.

CPM. Copies per minute.

CPSI. Adobe Configurable PostScript Interpreter. Most PostScript RIPs on the market today are based on Adobe's interpreter.

CRD. See *color rendering dictionary.*

crop marks. Lines printed at the edges of a sheet to indicate where it should be trimmed.

crusting. In ink jet printing, the tendency for ink to dry in and around the nozzles, restricting the flow of ink and adversely affecting print quality.

CTP. See *computer-to-plate.*

cut sheet. Paper that has been cut into individual sheets, and packaged as such.

cyan. Colorant with peak absorption in the red region of the spectrum. Cyan ink transmits blue and green light, and therefore appears bluish-green in color.

D2T2. Acronym for *thermal dye diffusion* printing, also called *dye thermal transfer, dye sublimation* or dye sub printing.

daisy chain. *SCSI* devices connected to one another are all accessible from the same port on a microcomputer.

data compression. Reduction of the size of a digital file. Lossless compression methods retain all of the information in the original file. Lossy methods do not.

data merge. Process in which two streams of data are combined to create a composite. In digital printing, this often refers to the merging of variable information with fixed content to personalize the end product.

data stream. An ordered succession of bits encoding images for direct processing by an output device. A digital print engine processes the data stream and renders the image.

DDES. Digital Data Exchange Specifications.

decompression. Expanding a compressed file back to its original size.

demand printing. Producing a paper document only when that document is needed.

density. The light-stopping ability of a surface, in the case of reflection density, and of a filter, in the case of transmission density.

device-dependent. Any digital representation that only makes sense when processed on a specific type of device (e.g., CMYK specification of color).

device formatting. Conversion of a document into a digital format that is compatible with a specific output device, This is normally done by a raster image processor.

device-independent. Digital representation that is not tied to the architecture of a specific device. CIELAB color specifications are device-independent.

device profile. In color management systems, a lookup table that characterizes the behavior of a specific color input or output device.

dielectric. A nonconductive material capable of isolating and holding a static charge. The basis for electron beam and electrographic printing.

dielectric paper. Paper used in electrographic printers and electrostatic plotters. The plotter deposits charges on the paper and then applies toner to form an image.

digital plate. Printing plate that can be imaged digitally with a laser or LED array.

digital press. Electronic device for printing digital images capable of sustained output.

direct-to-plate. The downloading of fully imposed digital forms from a host computer system directly to a platesetter, bypassing the making of films. Also called *computer-to-plate* or CTP.

direct-to-press. The downloading of fully imposed digital forms from a host computer system directly to a digital press.

discharged area development. In electrophotographic systems, development in which the toner charge is the same polarity as the charge applied to the photoconductor. Exposure discharges the nonimage areas; toner adheres only to these areas and is repelled from the

image areas retaining the charge. This is sometimes called a *write black* system.

display list. Ordered list of objects in a page description file. The order of the objects in the display list is the order in which they are displayed or imaged.

dithering. A method by which a binary output device simulates shades of grey by displaying or printing patterns of tiny dots. The more dots printed in a unit area, the darker the apparent tone. Ordered dithers resemble conventional halftoning methods, and diffusion dithers resemble FM screening methods.

dmax. 1. The maximum density on a particular film or printed sheet. 2. The maximum achievable density of a film type or printing process.

dmin. 1. The minimum density on a particular film or printed sheet. 2. The minimum achievable density of a film type or printing process.

doctor blade. Metal blade used to scrape excess ink from a gravure cylinder or a flexographic anilox roller.

document imaging. Term used to describe the technologies used to store and retrieve documents in digital form.

Document Type Definition (DTD). *SGML* document that describes the structure of a specific document type such as a book or manual.

document viewer. Software for viewing documents in proprietary formats such as Acrobat PDF or MS Word.

Docutech. Xerox monochrome electrophotographic digital printing press.

dot gain. The tendency of halftone dots or image elements to spread around the edges, causing rendered images to darken, especially in the midtones.

dot matrix printer. Text printer that forms images of letters by pushing an inked ribbon against the paper with tiny wires fired by computer-controlled solenoids.

double-truck. Advertisement covering a full two-page spread in a newspaper or magazine.

download. Transfer of data from one computer to another or from a computer to a device such as a printer.

downtime. Periods when a machine is not being used to manufacture product.

dpi. Dots per inch. This term can be used to describe the addressability of a digital printer or the sampling resolution of a scanner.

drop-on-demand ink jet. Thermal and piezoelectric ink jet processes that eject ink droplets only when needed to form part of the image.

droplet size. The size of the droplet ejected from an ink jet nozzle. Smaller droplets normally result in higher resolution at any given addressability.

DRUPA. A contraction of the German words *drück* (printing) and *papier* (paper). The largest of the international printing trade fairs held every five years in Düsseldorf.

dry process film. Graphic arts film that does not require wet processing.

dry toner. Most electrophotographic printing systems use dry powdered toners to produce density or color. The alternative is a wet toner process, where the colorants are suspended in liquid. Dry toners are nearly always pigment-based systems.

DSP board. A digital signal processing device installed in a computer to accelerate specific image-processing functions.

DTD. See *Document Type Definition*.

dual-component toner. Toner consisting of finely ground plastic toner particles mixed with a second metallic powder that acts as a carrier.

duplex. Printing on both sides of the substrate in one pass through the printing device.

duty cycle. The maximum number of impressions or pages that a digital printer is designed to comfortably produce in a month. This includes allowances for routine downtime for changeovers, maintenance, and repair.

dye. Colorant that is soluble in ink or toner vehicle. Dyes are also used as charge-generating materials in photoconductors used in electrophotographic processes.

dye sublimation printer. Alternative name for *thermal dye diffusion printer*, sometimes called "dye sub."

dye thermal transfer printer. Another alternative name for *thermal dye diffusion printer*.

edge enhancement. Exaggeration of the contrast of edges in a raster image to increase the apparent sharpness. This is often called unsharp masking, referring to the original camera-based method of achieving this effect.

electrographic process. Printing process in which the image is formed by writing electrostatic charge patterns directly onto a dielectric paper and then toning.

electron-beam printing. Process developed by Delphax employing cartridges containing electrodes that generate beams of electrons through an array of orifices to produce a latent image on a rotating dielectric drum at resolutions ranging from 240 to 300 dpi.

electrophotographic process. Printing process using a photoconductive surface for imaging with laser or light lens system. The process has six discrete steps: charge, expose, tone, transfer, fuse, and clean.

electrostatic printer. Generic term used to describe both electrophotographic and electrographic printers.

embossing. Pressing a relief image into a substrate to produce a raised effect. The most sophisticated embossing

is accomplished with male and female fiberglass molds, and can be combined with foil stamping or printing.

Encapsulated PostScript (EPS or EPSF). A PostScript file format expressly designed to be embedded in another PostScript stream.

engine. See *print engine.*

E-Print 1000. The first digital color press manufactured by Indigo.

EP. Acronym for electrophotography.

EPS or EPSF. *Encapsulated PostScript* file format.

error diffusion. A method of frequency-modulated screening of binary images to reproduce a continuous-tone original.

external drum imagesetter. Device that images films or printing plates while they are wrapped around the outside of a spinning drum.

facsimile. Digital image formed by binary scanning of a page; can be transmitted over a communication link.

fade-ometer. See *weather-ometer.*

fanout. In lithographic printing, the tendency of the paper to widen as it travels through the press and absorbs water. This problem does not occur with dry printing processes.

feathering. In ink jet printing, the tendency for ink to wick into the paper fibers at the edges of printed elements, causing a loss of resolution.

felt side. The side of the paper that was not in contact with the wire conveyer belt during manufacturer. See *wire side.*

Fiery. Proprietary name of a line of PostScript RIPs for color electrophotographic printiers made by EFI.

film writer. Alternative name for *filmsetter.*

filmsetter. Another name for an imagesetter, specifically designed to image graphic arts films.

firewall. Software that blocks access to specific resources on a computer attached to a public network such as the Internet. Computers connected to the Internet allow outsiders access to some resources but not to others.

flat. The film assembly used to make a printing plate by contact exposure. Computer-to-plate systems eliminate the need for flats.

flat color. See *spot color*.

flush cover. As on this book, a cover cut flush with the inside pages.

FM screening. Frequency-modulated halftoning method resulting in a pseudo-random distribution of uniform binary image elements. Also called *stochastic screening*.

folio. Page number.

FolioViews. Hypertext system for electronic publishing.

font. 1. Complete collection of text characters in a single design. ABC...Z, abc...z, 0123...9, @#$%^&, are all elements of the font used to typeset this book. 2. In halftone printing, one entire set of halftone dot shapes from highlight to shadow.

font cache. Area of computer memory maintained by a RIP for temporary storage of fonts in current use.

font downloading. Fonts not resident in a printer or RIP are transmitted from a host system and stored in RAM. This usually occurs just prior to printing a document that uses the missing font.

font embedding. Including fonts within a document file so that the document may be accurately rendered wherever it may go. The PostScript page description language does not allow font embedding, so fonts must accompany a document as external files.

font rasterization. The process by which characters in an outline font are converted to bitmaps prior to printing.

font substitution. The requested font is not available, and so you get something else. Intelligent font substitution systems attempt to retain the integrity of the original design. Unintelligent font substitution usually means that someone is in big trouble.

form. The full assemblage of images and text transferred to the substrate in a pass through a printing press. In multicolor printing, each color may be considered a separate form.

four-color printing. Printing with the three subtractive primary colors (yellow, magenta, and cyan), and black. If you happen to be printing with orange, purple, maroon, and burnt sienna inks, you would do best not to call it "four-color" even though it is. Instead, call it "special color," or "spot color" printing.

four-up. Four of the same image on a single sheet of film or plate. An 8.5 by 11 inch flyer can be printed four-up on a 17.5 by 22.5 inch sheet, leaving half an inch on each side for trim.

front end. The computer system that converts data into a format compatible with a digital printing process.

full bleed. Printed image extending to all four edges of a sheet. Because few printers are able to print to the edge of the sheet, all four edges must be trimmed.

fuser. Component in a laser printer or electrophotographic digital press that fuses the toner to the paper, usually by the application of heat.

gamut. The range of colors that can be printed or displayed by a given output device.

GCR. Gray Component Replacement. Replacing cyan, magenta, and yellow combinations with black.

gigabyte. Exactly 2^{30} or 1,073,741,824 bytes. Approximately one billion bytes.

glyph. An element of a character set. The letter A, the digit 3, and the symbol $ are all glyphs.

gray balance. The most important aspect of color reproduction. The proportions of cyan, magenta, and yellow ink or toner that produce a neutral (achromatic) gray across the tone scale.

gray scale. Digital or printed continuous or stepped ramp of gray values from highlight to shadow.

grayscale image. Image made up of single-component pixels representing gray values from highlight to shadow.

gripper margin. In many sheetfed printing processes, the portion of the lead edge of the sheet that is held in mechanical grippers as it is transported through the press; this area cannot be imaged.

GTO-DI. Waterless offset printing press with integrated laser platemaking units manufactured by Heidelberg.

GUI. Graphical user interface.

halftone. Binary image in which the illusion of a range of gray tones is created by varying the size or spacing of tiny dots of uniform density.

halftone cell. In conventional amplitude-modulated halftoning, the space allocated to each individual halftone dot.

helium neon laser. A red laser (630 nm wavelength) used to expose red-sensitive film in many film imagesetters. Sometimes written *HeNe*.

HeNe. *Helium neon laser.*

HiFi color. Extended-gamut color printing using red, green, and blue inks in addition to conventional process inks of cyan, magenta, yellow, and black.

high key. An image consisting of mostly highlight tones. Your vacation photograph of the angry polar bear in the snowstorm is a high key image.

highlight color. In digital printers capable of printing black and one other color, the one other color.

hinting. Information included in a digital font that enables pleasing rendering of the characters at small point sizes on low-resolution digital printers.

histogram. The frequency distribution of pixel values in a digital image.

holdout. In any printing process, the amount of colorant that remains on the surface of the printed substrate as opposed to that which gets pushed down into the pores or fibers.

hot-melt ink jet. Another name for *phase-change ink jet.*

HP PCL. Hewlett Packard Printer Control Language.

hue. The attribute of color perception related to the dominant wavelength of a mixture of light.

Huffman encoding. Data compression scheme based on frequency distribution of data in a file. In text, for example, the letter e occurs more frequently than z, so e has a short code and z has a longer one.

hypertext. File containing links that allow the contents to be traversed in more than just a linear way.

image. 1. The two-dimensional distribution of light-modulating points on a surface. 2. The areas of a printed form that receive the ink or toner, as opposed to nonimage areas.

image capture. Whether in an analog, digital, film or other system, refers to transforming visually understandable information into a physical or digital representation.

image voids. Areas of a print where ink or toner fails to transfer. This is usually related to paper surface irregularities.

imagesetter. Any device used to write binary images to film, paper, or plate. The term is considered by some to be too generic, and has been replaced in some quarters by *filmsetter* and *platesetter*.

imaging area. In platesetters and imagesetters, the maximum area on the film or plate that can be imaged. This is always less than the maximum dimensions of the substrate, because devices cannot image to the edges. In some cases, as with the Xeikon press, maximum print area can be increased by decreasing the pixel depth.

impact printer. Any printer, such as a dot matrix or daisy wheel device, that forms an image on the substrate by physical impact. Impact printers are required for printing on multipart forms.

imposetter. Filmsetter capable of producing fully imposed films. If a device can do this, why not just make a plate and be done with it?

imposition. Arrangement of individual pages on a press sheet. When the sheet is folded and trimmed, the pages are in the correct orientation and order.

Indigo. Israel-based manufacturer of digital printing presses.

ink film thickness. The thickness of the layer of ink applied to a substrate.

ink keys. On a conventional lithographic press, devices that control the flow of ink to the printing plate.

internal drum imagesetter. Film plotter wherein the film is held against the inside of a large metal drum and is imaged in a continuous spiral pattern with a laser.

Interpress. Page description language developed by Xerox in the 1970s. Interpress was the precursor to

PostScript. Xerox is transitioning most of its technology to PostScript.

ion deposition. Retired name for electrography. The inventors of electrographic printing thought they were depositing ions on a dielectric surface to form a latent image. They later discovered that they were depositing electrons. Now the process is called *electron-beam printing.*

Iris printer. Continuous area-modulated ink jet color printer. Iris printers produce photographic-quality color prints in sizes up to about 30 by 40 inches.

IT8 target. ISO standard color target for calibration of color imaging devices. The IT8 target comes in three forms: color print, 35mm transparency, and 4 by 5 inch transparency.

JPEG. Lossy image compression standard developed by the Joint Photographic Experts Group. JPEG has become a standard image compression method, allowing for compression ratios of approximately 10:1 before differences can be seen.

jukebox. An array of individual optical or magnetic disks that can be accessed automatically by a single disk controller, providing large amounts of storage space for images, files, and other massive data structures.

KBPS. Kilobits per second. A measure of the speed at which data can be transferred from one place to another.

kilobyte. Exactly 1,024 bytes or approximately 1,000 bytes.

Kiss impression. Nothing to do with human emotions in this context. When an inked relief plate contacts the substrate with enough pressure to transfer a uniform ink film, but not so much pressure that the resulting image is distorted.

laser ablation. Process by which a powerful laser is used to remove material from a surface. In some cases

the removed material is transferred to a receiver to form an image.

laser diode. A solid-state laser. These devices are small, robust, and require little energy to operate. All laser printers and some imagesetters use laser diodes.

laser printer. Digital electrophotographic printer using a laser to form the image.

latent image. In silver halide and electrophotographic systems, the invisible image produced by exposure that is rendered visible during development.

layout-driven document. Document created in a word processor or page layout program where the document structure primarily dictates the appearance of the information on the page. Compare *content-driven document.*

LED array. Light-emitting diode array used to image the photoconductors in some electrophotographic printing devices.

letter-size paper. Paper measuring 8.5 by 11 inches.

Level 2 PostScript. Revised *PostScript* language definition published by Adobe in 1992.

lightfastness. Resistance to fading as a result of exposure to light, especially ultraviolet (UV). Pigmented inks and toners are far more resistant to fading than dye-based materials.

lookup table. In the context of color imaging, a reference file used to convert images from one color space to another. An example is a lookup table for converting *RGB* pixels into *CMYK* pixels for printing.

loose color. Color proof of separate images, independent of other elements that may eventually appear with them on the page.

lossy compression. Any data compression method that discards information that cannot be recovered.

low key. An image consisting mostly of shadow tones.

LPI. Lines per inch. In conventional halftoning, the number of lines or rows of halftone dots per linear inch.

LUT. Lookup table.

LZW compression. Nonlossy image compression method. With grayscale and color images, LZW usually yields about a 2:1 compression ratio.

magenta. Colorant with peak absorption in the green region of the spectrum. Magenta ink transmits blue and red light, and therefore appears bluish-red in color.

magnetography. Printing process employing a rotating magnetic drum and electromagnetic writing heads to produce an image in the form of a distribution of magnetic charges that will attract magnetic toner. The magnetic image can be used to print multiple impressions. Commercial applications have been limited to high-speed, low-resolution printers made by the French computer company, Groupe Bull.

makeready. The time between the start of a press run and the first good sheet. In conventional offset lithography, this can produce a large amount of waste. Digital processes typically require little, if any, makeready.

markup. Information added to a text file that indicates how the text is to be processed.

Matchprint. Film color proofing system manufactured by 3M.

medium. The printed substrate, especially if it is something other than paper. Plural is media.

megabyte. Exactly 1,048,576 bytes or approximately one million bytes.

merge. Insertion of text or graphic elements into a printed document from a database or external file.

MICR. Magnetic Ink Character Recognition. Numbers printed using a special font and magnetic ink can be machine-read for automatic processing of checks and other financial forms.

minimum spot size. The size of the smallest spot that can be imaged. This is usually larger than the reciprocal of the addressability because of the need for overlapping.

monochromatic. Single color. A light source is mono-chromatic if it has only one wavelength. Lasers are mono-chromatic light sources. The term is also used to mean a black-and-white, as opposed to a color, image.

monochrome printer. Single-color printer.

monocomponent developer. In electrophotography, a developer that contains only toner particles, and no carrier beads or fluid.

monomer. A molecule that will bond with others of its kind to form a *polymer*.

mottle. A visible, nonuniform density pattern where none is expected or desired.

MPBF. Mean pages between failures. The average number of pages that a digital printing device can print before requiring service.

MTBF. Mean time between failures. Average time a machine will operate before something breaks. With many digital printers, the MTBF of the system is estimated to be in the tens of thousands of hours. Relatively short MTBF of components such as photoconductive drums in some digital presses contributes significantly to the page cost.

Multifunction device. A digital printer that serves also as a scanner, fax machine, and printer.

N-bit image. The number of bits of data used to represent each pixel in a raster image determines the *tonal resolution* or *pixel depth* of the image.

NCR paper. Special paper impregnated with microencapsulated dyes that are activated upon impact to form copy images without the use of carbon paper.

nonimpact printer. Any printer, such as ink jet printers, that does not physically contact the substrate. Nonimpact printers cannot be used to print on multipart forms. This term is gradually falling out of usage in favor of digital printing or electronic printing.

nonlossy compression. Any data compression method that does not result in the loss of information. The act of decompression restores the original file to its pristine state. Compare *lossy compression*.

nonwoven. Fabric-like material manufactured in a process that does not involve weaving of fibers. Tyvek is an example of a nonwoven material.

NovaJet. Series of wide-format thermal ink jet printers made by Encad.

nozzle. In ink jet printing, the orifice from which ink droplets are ejected.

nozzle array. A row of ink jet nozzles. The wider the array, the higher the printing speed of the system at the same rate of droplet generation.

Nyquist frequency. In scanning, the sampling rate must be at least two times the highest frequency information in the original image or scene that you wish to retain in the digital image.

OCR. Optical character recognition. Sophisticated technology enabling printed text to be scanned and interpreted yielding a text file.

OEM. Original equipment manufacturer. Originally referred to a company that made machinery that another company modified and marketed. Now the term is often used to refer to the ultimate seller of the equipment.

Omnius. Digital offset printing press manufactured by *Indigo* for printing on a variety of both two-dimensional and three-dimensional substrates.

opacity. Measure of the ability of a sheet of paper to scatter light internally and not allow it to pass through.

OPC. Organic photoconductor. In electrophotographic printers, the surface upon which the image is written with a laser or LED array.

OPI. Open Prepress Interface; allows print-resolution images to be stored on a file server and automatically inserted into a document in the appropriate locations at the time it is printed.

orifice plate. The metal plate containing tiny nozzles in a thermal ink jet printhead.

outline font. Font composed of characters represented by mathematical curves describing their outlines. *PostScript* and *TrueType* fonts are both outline font formats.

page cost. The cost to produce an average printed page including consumable costs as well as the cost of the equipment.

page description language (PDL). A programming language for describing documents as collections of pages described in strictly geometric terms.

page printer. A printer that outputs individual printed pages, as opposed to large sheets that must be folded and cut into final form.

page store. A large disk array where RIPped digital pages are stored prior to being printed.

Pantone color. Color designated by name and/or number corresponding to a physical ink-on-paper standard manufactured by Pantone, Inc.

paper grain direction. The direction of alignment of fibers in paper. Paper is more easily folded along this axis than perpendicular to it.

paper roughness. The average deviation from perfect smoothness of the surface profile of a paper sheet measured in micro-inches.

paper smoothness. Inverse of paper roughness.

paper weight. See *basis weight*.

paper whiteness. A measure of the spectral reflectance characteristics of a piece of paper.

PC. 1. Personal computer. 2. Photoconductor (the light-sensitive drum in a laser printer). 3. Political correctness (e.g., turning off your personal computer when not in use to conserve energy, and using recycled paper in your laser printer).

PDF. Adobe Portable Document Format.

PDL. See *page description language*.

pel. Alternative term for pixel. IBM coined this term many years ago. The world chose the poetry of *pixel* over the economy of *pel*.

pen. In a pen plotter, the meaning is obvious. In a thermal ink jet printer, the printhead is sometimes called a *pen*. The term was first used by Hewlett Packard.

perfect bound. Bookbinding method where leaves are glued together at the spine.

perfecting. Printing on both sides of the substrate simultaneously. Synonymous with *duplexing*.

personalization. Adding customer-specific information to a product. Personalization systems from digital press suppliers allow for separation of master pages and personalized areas within the page. These elements are then merged during the press run wiithout affecting the speed of the machine. The challenge is to feed data to the print

engine at its highest rated speed and never to have the press waiting for data. Percent of total page changeable is an important variable.

phase-change ink jet printer. Piezoelectric ink jet printer using molten wax-based inks. The ink is ejected in molten state through nozzles and freezes upon contact with the substrate.

photoconductor. A material that acts as a conductor when exposed to light and as an insulator when in the dark. Photoconductors are used in electrophotography, where a static charge applied in the dark is removed in areas exposed to light (either by laser or light lens system). Areas retaining the charge attract toner, which can subsequently be transferred to a substrate.

photographic color rendering. Method of rendering color images to preserve the subtle tone and hue differences from pixel to pixel in the original image.

photomultiplication. In silver-halide-based films and plates, the effect of a small amount of exposure is multiplied by a very large factor during the development process. This enables the use of low-energy lasers to image the materials.

photopolymer plate. Printing plate employing compounds that solidify or change solubility upon exposure to radiation. These materials are normally sensitive to ultraviolet and/or blue light.

piezoelectric ink jet printing. A drop-on-demand ink jet printing process whereby droplets are ejected from tiny ink chambers by physical deformation of the ink chamber wall.

piezoelectric transducer. Material that changes its physical dimensions when an electric field is applied.

pigment. An insoluble crystalline colorant that must be ground to a fine powder before being used in an ink or toner.

pixel. Picture element. The smallest distinguishable part of any image.

pixel depth. The number of bits used to represent each pixel in a digital image.

plain paper. Any paper you buy by the ream from the office supply store. Plain-paper printers are generally indifferent to the type of paper used in them.

plastic thermal transfer. A process similar to thermal wax transfer except that the colorant layer is resin-based rather than wax-based. Alps Electric manufactures small plastic thermal printheads used in devices made by Citizen, Lexmark, and GCC.

platesetter. Binary device used to image printing plates directly. Most platesetters use scanning lasers to write the image onto the plate material.

PMS. Pantone® (color) Matching System.

polymer. A long-chain organic molecule comprising individual monomers covalently bonded to one another.

porosity. A measure of how porous a sheet of paper is. Usually measured by determining how quickly a volume of air can be forced through a unit area of the paper.

PostScript. Graphics language marketed by Adobe Corporation that is now a de facto industry standard for page description.

PostScript font. Type font in the Adobe Type 1 format. The PostScript language is used to describe all of the characters and how they should be rendered.

postpress. Cutting, folding, gluing, packing and shipping. All operatons required to convert press sheets or signatures into a final product and deliver it to the ultimate user.

powder toner. Same as dry toner.

PPD. PostScript Printer Definition file. File containing information about the capabilities of a particular printer.

ppi. Pixels per inch. A measure of the sampling frequency of a scanner or the resolution of a digital image.

ppm. Pages per minute. This normally refers to single-sided pages.

prefilm proof. A digital color proof.

prepress. That part of the print production process up to the point where plates are made or a data stream is sent directly to a digital printer. In some usage, the prepress part of the process begins after the design part ends.

Presstek. Manufacturer of laser plate-imaging systems integrated in Heidelberg GTO-DI and QuickMaster digital presses.

print engine. The part of a digital printer that does the actual printing. Many different makes and models of laser printers may share the same engine.

print queue. In the context of digital printing, a line of individual jobs waiting to be printed.

print spooler. Software responsible for preparing and holding a job prior to printing. See *spooling*.

printhead. In an ink jet printer, the assembly responsible for ejecting ink. In thermal ink jet printers, the printhead is built into the disposable ink cartridge.

printing sequence. The order of application of colored ink to a press sheet in multicolor printing. In four-color printing, the sequence may be black, followed by cyan, magenta, then yellow (KCMY), or some other arrangement such as YMCK or CMYK.

process color printing. Color printing using subtractive primary colorants of cyan, magenta, and yellow, usually with the addition of black.

productivity. See *throughput*.

profile. See *device profile.*

queue. See *print queue.*

Quickmaster. Small-format waterless four-color offset press with integrated digital platemaking system and common impression cylinder made by Heidelberg.

RAID. Redundant array of inexpensive disks. A large virtual disk drive comprising a number of smaller drives accessible as one.

raster. Computer memory that is used to hold a digital image in the form of a two-dimensional array of pixels.

raster image processor (RIP). Computer program that inputs high-level page descriptions and outputs low-level data streams that can be fed directly to a digital print engine to be rendered or video board to be displayed. Following the normal evolution of the English language, the acronym became a noun which in turn became a verb, and it is now proper to say ugly things like "The RIP didn't RIP my file!"

rasterization. The process of converting graphics described at a high level into bitmaps for rendering on a monitor or digital printer.

receiver paper. Special paper used in thermal transfer processes that are not able to print on *plain paper.*

reference color space. An objective system for the numerical specification of color, such as CIELAB.

reflectance. The amount of light reflected from an illuminated surface. Reflectance is always greater than 0 and less than 1.

register mark. In color printing, a simple target repeated in the same location on each plate. When the targets overprint one another perfectly, the color is in register.

registration. In color printing, the precise overprinting of separate color layers.

rendering. Displaying or printing an image. Digital images must be rendered before people can see them.

repeatability. In laser printing, the accuracy with which the writing beam can be directed to a given point on the substrate. Typical numbers are in the .2 to .5 mil range.

resident font. A font that is stored in ROM in a printer or RIP. Nonresident fonts must be *downloaded* before they can be used.

resolution. 1. The ability of a scanner or digital camera to detect tone, color, and detail. 2. The ability of a printing system to render tone, color, and detail.

resolution enhancement technology. Any method used to increase the resolution of a digital printer beyond what is indicated by the printer's addressability.

resolution-fixed. Images in raster formats, such as TIFF and JPEG, containing a fixed number of pixels.

resolution-independent. Graphic elements described in vector format, which can be enlarged or reduced to any size without loss of detail.

RGB. The three additive primaries: red, green and blue.

RIP. See *raster image processor*.

Risography. Digital printing process employing a thermally imaged stencil through which paste ink is pushed to form a low-resolution binary image on plain paper. The digital equivalent of a mimeograph machine.

rocket scientist. You do not have to be one of these to know whatever it is you need to know to do your job, unless you are in fact a rocket scientist. In some circles, the rocket scientist is anyone who can work with numbers without breaking out in hives.

rods. Light detectors in the retina that are sensitive to low levels of illumination and not to color.

run-length encoding. A method of encoding binary images as a string of codes representing successive runs of image or nonimage pixels for the purpose of compression. Pages of text and simple binary images can be compressed dramatically by this method.

saddle stitch. Metal-staple binding method used in magazine and catalog printing.

sampling. Periodic examination of an analog or continuous signal. Sampling usually results in the generation of digital values representing the value of the analog signal at fixed intervals.

satellite drops. In ink jet printing, tiny secondary droplets that break off from the main droplets and reduce the sharpness of edges in the final print.

scan conversion. Vector-to-raster conversion of outline type and line art. A PostScript RIP scan converts PostScript objects into printer-specific bitmaps.

scanner. Device that measures an image point by point and generates a signal related to the amount and type of light reflected from or transmitted through the original. This signal is often sampled and digitized by the scanner.

Scitex. Israeli company that manufactures continuous ink jet printers in a variety of configurations, including high-speed continuous-array ink jet, large-format continuous ink jet, and continuous area-modulated ink jet.

Scitex Outboard. Large-format low-resolution ink jet printer for making large posters and billboards.

screening algorithm. Computer program that converts contone image data into halftone patterns for rendering on a binary printer.

SCSI. Small Computer Systems Interface. A standard protocol for connecting computers to peripheral devices such as scanners and printers. Several SCSI devices can be *daisy-chained* from the same port.

scum. Perhaps the ugliest word in the English language. In litho printing, ink transferring from the nonimage areas of the plate.

search engine. Software for searching a database or file system for specific content.

self-cover. A publication with a cover made of the same paper as the inside pages. An entire 16-page 8.5 by 11 inch self-cover brochure can be printed on a single 23 by 35 inch sheet.

serial printer. Any digital printer that receives input via *asynchronous* serial cable. Many printers accept several alternative forms of input.

SGML. Standard Generalized Markup Language. A standardized (ISO 8879) language for describing complex document structures.

shadow. The dark areas of a pictorial image.

show-through. In duplex printing, images printed on the reverse side of the sheet that are visible under normal viewing conditions.

silver diffusion plate. Printing plate imaged by exposure in a camera or laser imagesetter, and developed in photographic chemistry prior to being used on press.

silver halide. Light-sensitive silver salt employed in photographic imaging systems.

simplex. Printing on one side of the substrate only. Printing on both sides of the substrate is called *duplexing* or *perfecting*. In traditional printing usage, nonperfecting means the same thing as simplex printing.

SLIP. Serial Line Internet Protocol. Provides a link from a personal computer to the Internet over a modem connection. If you are running SLIP on your PC, you do not also need terminal emulation software. Because this protocol uses a serial connection, it is rather slow, and users

desiring the best performance are advised to use PPP (Point-to-Point Protocol), a newer and faster alternative.

SOHO. Small Office, Home Office. A term used by marketeers to describe a rapidly growing market segment for digital printing technology and services. As corporations downsize, the number of consultants operating out of SOHOs is predicted to continue on its upward path.

solid color. See *Pantone color.*

solid ink jet printer. Another name for a phase-change printer that employs melted wax-based inks and a piezo-electric ejection mechanism.

solvent. In the context of printing, any liquid that is hydrocarbon-based. It is important to note that water, the "universal solvent," is not considered a solvent in this context. Solvent-based materials, such as inks and processing solutions, are bad. Water-based materials, however, are good.

spatial resolution. A measure of the number of discrete picture elements in a unit area of a digital or printed image.

SPDL. Standard Page Description Language. Language very similar to *PostScript,* defined by the ISO and then left to rot.

special paper. A paper having specific properties such as smoothness, whiteness, porosity, and so on required by a particular printer. Printers requiring special paper are considered to be at a disadvantage to those that can work with *plain paper.*

spectral reflectance curve. Graph showing the reflectance of a material over a specified range of the electromagnetic spectrum. Spectral reflectance curves used in the graphic arts usually cover a range of 400 to 700 nanometers (nm) in 10 nm increments.

spooling. This word used to be an acronym, but now only a few technology-crazed sociopaths remember what it

stood for. Spooling is the process of creating and storing a print-ready file for subsequent printing in the background, freeing the workstation quickly and denying the operator a chance to go to the candy machine.

spot color. Printed color other than black, but not one of the three process colors (cyan, magenta, or yellow). In traditional printing, this may be a PMS color. In digital printing, it often refers to the second color in a two-color system.

squeegee. A funny word for a rubber blade with a handle. In screen printing, squeegees are used to push the ink through the stencil onto the substrate.

SRC. Acronym for short-run color.

stairstepping. Jaggy appearance of the edges of type and line art. See *alias.*

stochastic screening. Frequency-modulated (FM) halftoning method resulting in a pseudo-random distribution of uniform binary image elements.

streaking. Undesirable printing artifacts caused by linear irregularities in ink or toner transfer.

stream. See *data stream.*

Structured PostScript. PostScript that adheres to Adobe's published Document Structuring Conventions.

substrate. 1. Material printed on. 2. Support layer upon which some material, such as silver halide or heat-sensitive dye, used in an imaging process is coated.

subtractive primaries. Cyan, magenta, and yellow. Magenta absorbs green light, cyan absorbs red light, and yellow absorbs blue light.

supercells. Method of computing halftone screens such that the angular orientation of the screen is set with great precision, thereby reducing moiré patterns to a minimum in multicolor printing.

Supra. Adobe production printing architecture for fast processing of PostScript and PDF documents.

SWOP. Specifications for Web Offset Publications. Set of standards used in web offset printing containing specifications for ink, paper, print densities, and other variables in the printing process.

TCP/IP. Transmission Control Protocol/Internet Protocol. A set of protocols that standardizes the transmission of data over the Internet. A TCP/IP program running on your PC takes care of low-level exchanges of data with the Internet. Browsers such as NetScape and Mosaic present user interfaces to the Internet and rely on TCP/IP to do the grunt work.

thermal array. A device used in thermal printing processes consisting of a line of tiny heating elements that are individually controllable by a computer.

thermal dye diffusion printing. Digital printing process that forms images by applying heat from a thermal array to transfer dye from a ribbon donor to a substrate.

thermal ink jet printing. The most common form of drop-on-demand ink jet printing, which employs tiny heating elements to rapidly vaporize a portion of the ink in small cavities, ejecting droplets through an array of nozzles to form an image on a moving substrate.

thermal paper. Chemically coated paper that undergoes a color change (usually from white to black) when exposed to heat.

thermal plates. Printing plates that are imaged by exposure to heat.

thermal transfer printing. Printing process employing an array of heating elements to transfer colorant from thin plastic ribbons to a substrate. Thermal wax transfer printing transfers a layer of wax from the ribbon to produce a binary image. Thermal dye diffusion printing

transfers dye from the ribbon to produce a continuous-tone image.

throughput. The number of pages that can be printed in a given amount of time. This is a function of all of the components in a system.

TIFF. Tagged Image File Format. A de facto standard format for raster images. TIFF supports binary, grayscale, RGB, and CMYK images.

tile. Printing a big picture on a small printer in multiple panels that can then be assembled offline.

tonal resolution. A measure of the number of gray levels or colors possible in each discrete element in a digital or printed image.

toner. The marking material in an electrophotographic printing system consisting of a polymer binder, pigmented colorant, and charge agent.

toner particle size. The average diameter of toner particles in an electrophotographic printing system. In color electrophotography, toner particle size currently ranges from about 5 to 10 microns. In general, smaller particle size enables higher quality printing.

TonerJet. A direct printing process whereby charged toner particles are deposited directly onto a plain-paper surface to form a visible image. This process has been developed by Array Printers AB, a Swedish company.

transfer. Movement of a physical image from one surface to another. In electrophotography, the image is transferred from the photoconductive surface to the paper.

transmittance. The percentage of light transmitted through a material.

trapping. Slight intentional overlapping of the edges of contiguous print elements to compensate for minor variations in color registration. Automatic trapping can be

done when *PostScript* is written, or when a job reaches the *raster image processor*.

trilevel xerography. Electrophotographic process using three charge states and two different toners to accomplish two-color printing in a single pass.

TrueDoc. A font-embedding technology that recreates the outlines of only those characters used in a document. This reduces the size of the embedded font and circumvents copyright problems associated with the use of *PostScript* or *TrueType* fonts for both document design and rendering.

TrueType. The other font standard. The alternative is *PostScript*. Font manufacturers produce both TrueType and PostScript fonts for Macintosh and PC platforms for a total of four different formats. This is absurd, but so is life.

TruMatch. Color matching system similar to Pantone Matching System.

turnaround. The time that elapses between the electronic submission of a job and delivery of the final printed product.

variable data. Data that changes from page to page in a digital printing operation.

vector. A line, described in mathematical terms and represented in digital form. The shape of a character can be described in digital form as a collection of vectors. These vectors can be straight line segments or curves.

video printer. Digital printer, typcally of the dye diffusion type, especially designed to make prints at the resolution of a video signal.

vignette. Graphic object containing densities or colors that vary continuously from one to another. Vignettes are especially difficult to render smoothly, and are therefore always included in test pages used for assessing the performance of digital printers.

waterfastness. Resistance to dissolution in water. This is an especially important feature of thermal ink jet inks, which are water-based.

watermark. Impression of wet paper during manufacturing with an image that is visible when the finished paper is held up to the light. Watermarks can be simulated or forged by application of a varnish to the finished paper.

wax thermal printer. Alternative name for thermal wax transfer printer.

weather-ometer. Device used for controlled testing of the deterioration of materials when exposed to light, heat, and humidity. A principal use of such an instrument is to test the lightfastness of printed products.

web. 1. A roll of paper. Some presses are web fed and others are sheetfed. 2. The World Wide Web, an Internet-based network of computers.

web browser. Software used to view and download information from the World Wide Web. Web browsers interpret HTML documents and display them on a computer monitor.

web printing. Sending documents to remote printers using the World Wide Web as the medium of communication.

white point. 1. The whitest white that a monitor can display. 2. The lightest highlight in a digital image.

wicking. The rapid absorption of water-based ink jet inks into the fibers in paper, which causes a loss of sharpness.

wire side. The side of the paper that lies against the wire mesh conveyer belt on the papermaking machine. The wire side will exhibit different print characteristics than the other side, which is called the *felt side.*

write black. Electrophotographic system in which image areas are exposed and discharged prior to development. See *discharged area development.*

write white. Electrophotographic system in which non-image areas are exposed and discharged prior to development. See *charged area development.*

WYSIWYG. What You See Is What You Get. This usually refers to the fidelity of images on a computer display to the appearance of the final print.

Xeikon. Belgian manufacturer of color electrophotographic printing presses.

xerography. From either Greek *xeros* (dry) or American *Xerox* (large company) and *graphien* (writing). Another name for *electrophotography.* The printing process employing charged photoconductive surfaces that are selectively discharged by projection of an image through a lens system. The areas retaining charge attract powdered or liquid toner which is transferred to a paper or plastic substrate to form an image. The basis for all modern analog photocopying machines.

XPLOR. Association of high-speed digital printer users.

yellow. Colorant with peak absorption in the blue region of the spectrum. One of the subtractive primaries.